MW01054359

black
beauty

a history and a celebration

black
beauty

a history and a celebration

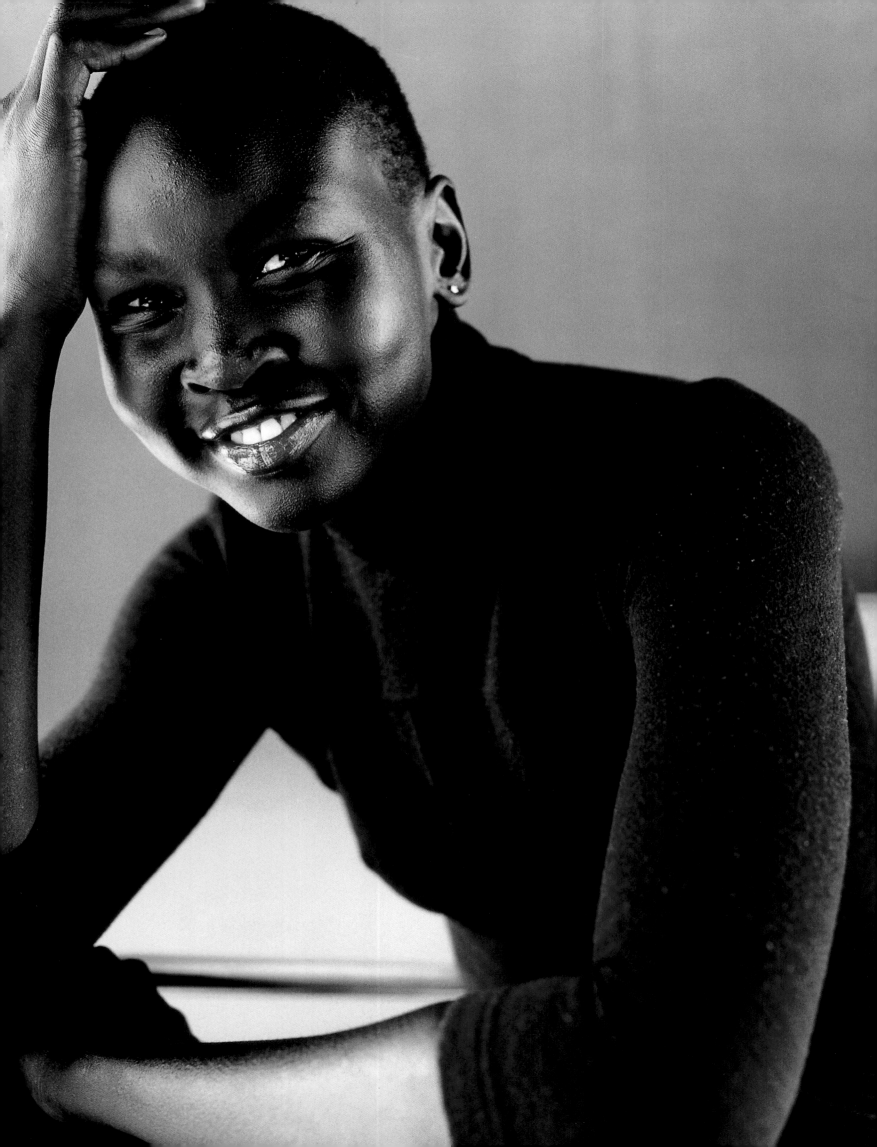

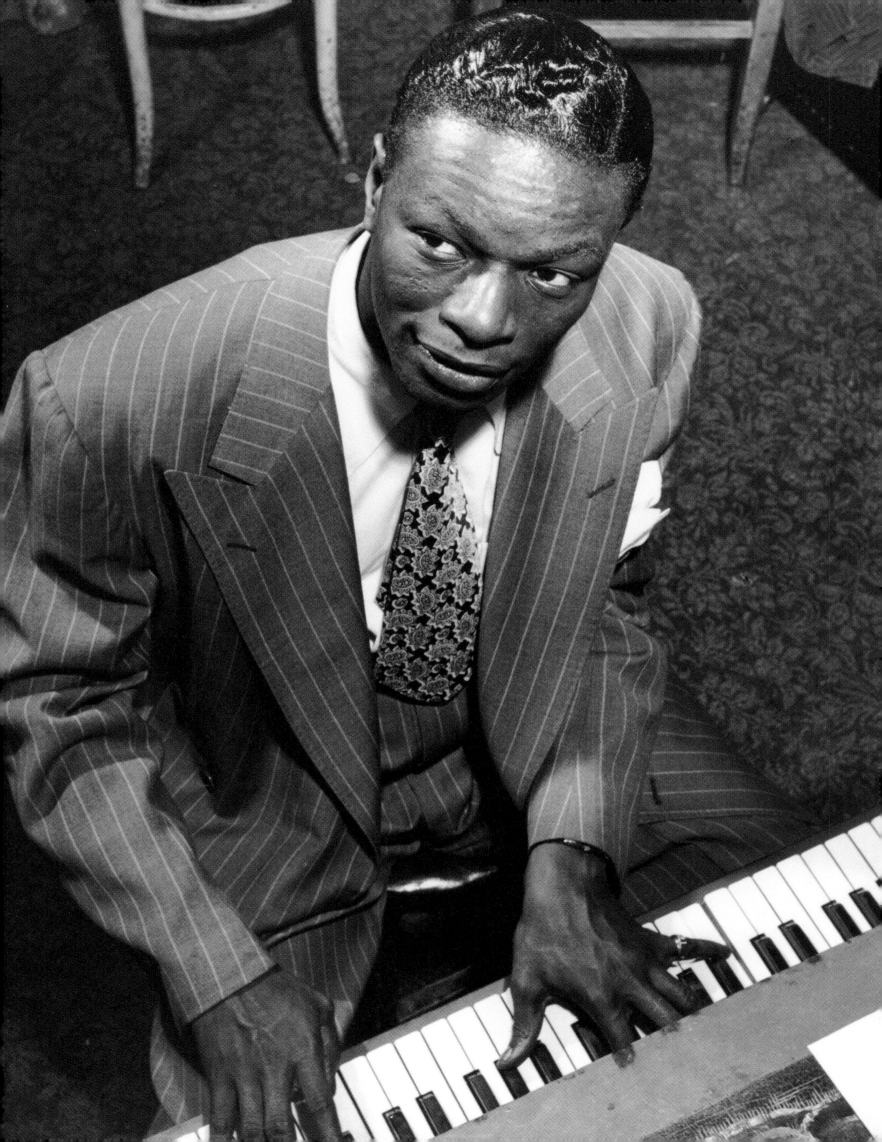

For Mr & Mrs Arogundade, 'Small Boy' Zak & Madeleine

black
beauty

a history and a celebration

ben
arogundade

THUNDER'S
MOUTH
PRESS

Published in the United States by
Thunder's Mouth Press
841 Broadway, Fourth Floor
New York, NY 10003

First published in Great Britain in 2000 by
Pavilion Books Ltd.
London House, Great Eastern Wharf
Parkgate Road, London SW11 4NQ

Text © Ben Arogundade 2000
Design and layout © Pavilion Books Ltd.

The moral right of the author has been asserted

Designed by Mark Thomson, International Design UK Ltd.
Picture Research by Heather Vickers.

All rights reserved. No part of this publication may be
reproduced, stored in a retrieval system, or transmitted,
in any form or by any means, electronic, mechanical,
photocopying, recording or otherwise, without the prior
permission of the copyright holder.

Library of Congress Card Number: 00–104002

ISBN 1–56025–276–6

Set in FFScalaSans
Printed in Italy by Conti Tipocolor
Origination by Alliance Graphics, Bedford and Singapore

2 4 6 8 10 9 7 5 3 1

Distributed by Publishers Group West

contents

preface

IT ALL STARTED BY ACCIDENT in the cavernous white vault of an underground auditorium in the center of Paris. It was Fashion Week, February 1998 and I was a freelance journalist reporting backstage at a ready-to-wear show. There, solitary within the hustle and bustle, the waiting and the preening, stood an abandoned rack of clothes. Attached to the rail was the composite card of a male model who had failed to show, his chiseled face staring defiantly at nothing, as if somehow only this cardboard representation knew the secret of his absence. Then, fifteen minutes from showtime, I heard frantic voices calling my name, and before I knew what was happening I was being thrust into garments from the abandoned rail with cries of "Come on, come on, let's go, let's go!" I hardly had time to speak. Incredibly, they fitted, and minutes later I was out on the runway like a reluctant post-modern Cinderella who got to go to the ball after all.

When I returned to London I found myself a model agent and started going to castings. It wasn't long before I realized that non-white models existed in a different aesthetic space from the one inhabited by white mannequins. We were much lower down the hierarchy. I started investigating and writing about this order of beauty and the politics that lay behind it. This evolved into the idea for *Black Beauty*.

But the question is, what is black beauty? It is perhaps the most complex ethnic denomination to define. If there were such a thing as *The Oxford English Dictionary of Beauty*, it might classify it as: "The physiognomical and bodily aesthetic of people of color as the subject of desire, pleasantness, or favor." This works as a rough guide, although throughout the last century its meaning has focused primarily on the question of hair and skin-tone. Namely, is straight hair "good" and Afro hair "bad?" and is light skin more beautiful than dark skin?

In literary terms, black beauty remains a cause without a portfolio. That is why it is missing as a topic from studies of the black experience. What is beauty after all, but a low priority compared to the weighty issues of negritude? Who can really talk of the folly of beauty when there are still so many other battles to be won?

But beauty is also a battle. And the right to be beautiful and to be acknowledged as such, whoever you are, and wherever you are from, is not so much a folly as a human-rights issue. In writing the history of the black experience, did we forget something important? Did we forget about beauty?

My research seemed to suggest we did, as there were no books that encapsulated the whole black aesthetic experience. There were definitive texts on slavery, civil rights, black politics, and arts, but very little on this most visual of subjects. And predictably, within the mainstream fashion press and beauty journals it has received scant mention.

What I did find were dissertations by intellectuals such as Kobena Mercer, Lisa Jones, Jan Pieterse, and bell hooks. There were biographies by ex-models such as Naomi Sims, Beverly Johnson and Barbara Summers, plus various texts on the plethora of musicians and performers. There was a diversity of mainly Afro-American lifestyle magazines from *Ebony* to *Vibe*, and a world of data on black hair and beauty tips, not to mention the reams and reams of magazine and newspaper cuttings.

Pages 2–3:
ERAS OF BEAUTY
Left: Alek Wek, Millennial model, with her trademark dark skin and cropped boyish hair.
Right: 1950s crooner Nat King Cole. His slick conk was "as smooth as a cooling lava flow."

Black Beauty traces the black aesthetic via the twentieth century's most significant icons of film, television, music, sport, and fashion. It profiles some of the greatest names in history — everybody's favorite superstars from Muhammed Ali to Lauryn Hill, from Josephine Baker to Denzel Washington. The list forms a unique compilation in that it focuses on the aesthetic significance of these icons as opposed to their achievements as artists. This is perhaps the only thing left to say about them that hasn't already been said. These stars have acted as unofficial aesthetic missionaries for blacks across the diaspora, and in doing so they affirmed that people of color have a place in the world.

The scope of the work is confined to the Western hemisphere. It will focus on the aesthetic experience of peoples of African descent who, as a result of the transatlantic slave trade or voluntary migration, reside within the black diasporas of the West, particularly the United States. This is not to negate the experience of the African continent, for example, but rather to acknowledge that it demands a dedicated and separate treatment of its own.

Most of all, this book is a tribute to the glittering array of black stars of the twentieth century, who have dazzled us, enchanted us, and brought hope and joy to people of all colors.

Pages 10–11:
SISTERS IN TIME
Left: The inimitable Josephine Baker, brightest star of the Roaring Twenties.
Right: Nineties supermodel Veronica Webb.

Pages 12–13:
HOLLYWOOD BEAUTY
Left: An earthy Wesley Snipes in Nubian profile.
Right: Halle Berry attends the New York premier of the Dorothy Dandridge biopic in 1999.

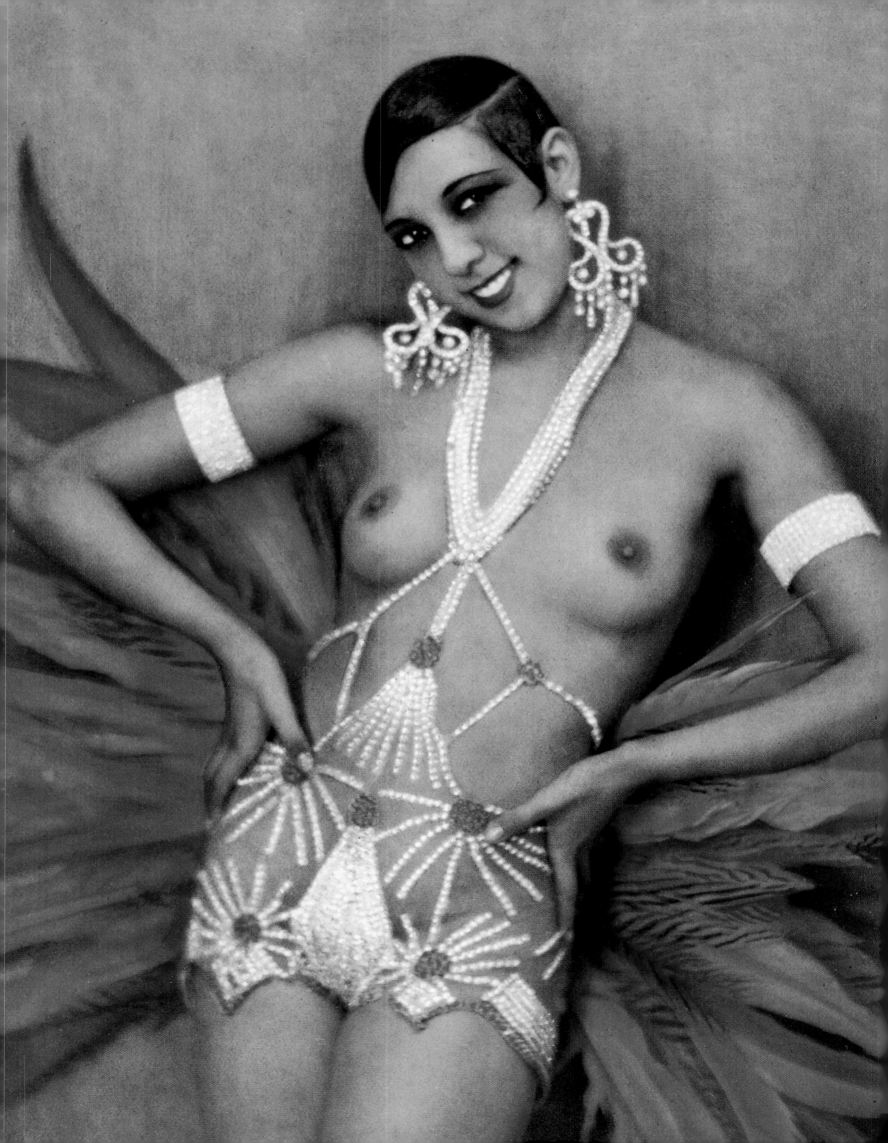

Photo: Peter Lindbergh

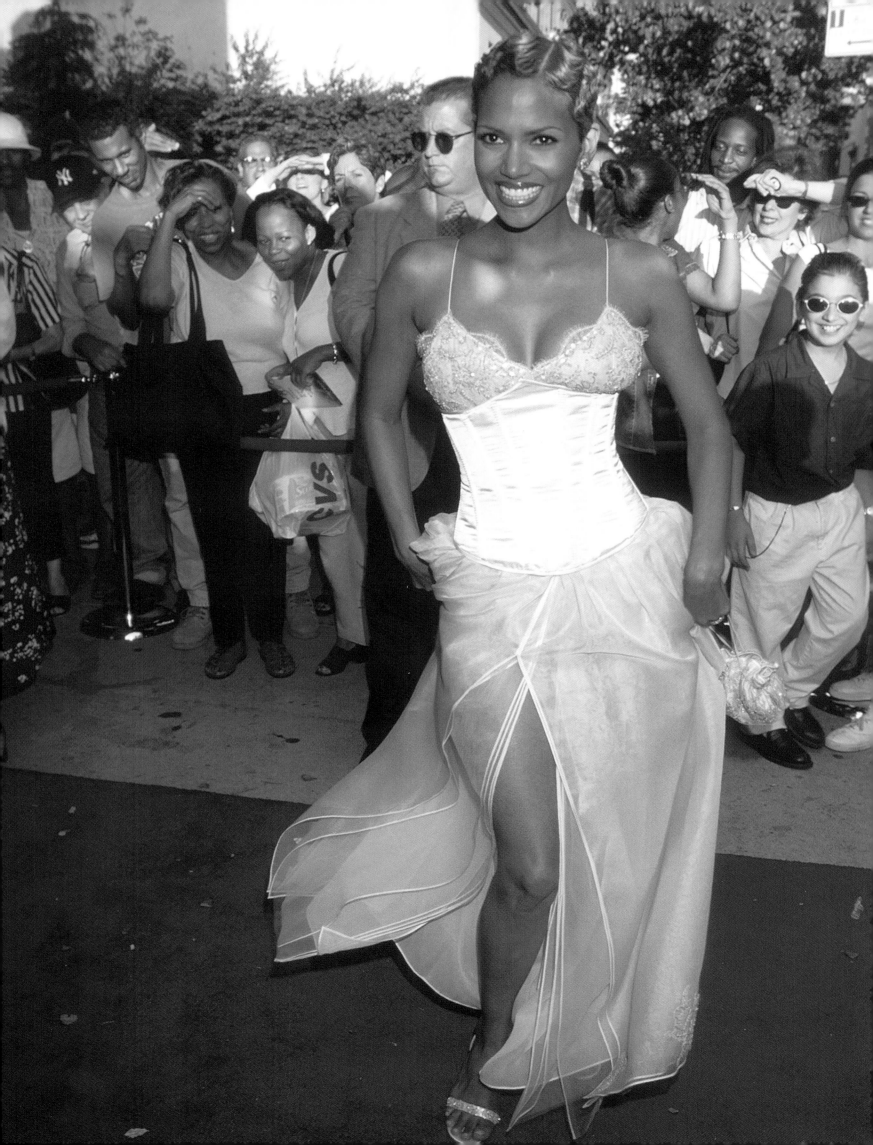

1

black
is
(not)
beautiful

IN 1810 THE NAKED, CAGED BODY OF Saartje Baartman – a 25-year-old slave from the Cape Colony – was put on display in London and Paris. The so-called "Hottentot Venus" with her notorious cantilevered behind and extended labia – the "Hottentot apron" – was paraded as a typical example of the anatomy of the African female, and people came from miles around to ogle at her. She was presented as a biological curiosity – a black equivalent of the Elephant Man – exploited to support the contention that blacks were aliens, unrelated to humankind. She epitomized the Euro-notion of "the beast from the dark continent," brought back to civilization for the world to behold. When she died five years later her body was dissected and her genitalia displayed in floating chunks inside glass jars of formaldehyde at the Musée de l'homme in Paris. Even in death she was still an exhibit.

Throughout the centuries the black look has been both derided and eulogized. There were days when black beauties graced the courts of kings and the look was extolled within fine art and literature; days when blackface Madonnas and Venuses were exalted on high and European society lusted after black beauty. There were other days when the black look was simply mocked, criminalized, and uglified; days when people of color were equated with prostitutes, devils, and animals.

The earliest representations of the color black date back to Ancient Egypt, a time in which it had a positive meaning equated with nature, as the hue of earth and fertility. The color first took on negative connotations relating to sin and darkness in the third century, through the writings of the early Christian Fathers. Origen, head of the catechetical school in Alexandria, introduced the theme of darkness as the enemy of spiritual light. This original symbolism had nothing to do with skin color, but over time it acquired that connotation. During the era of Islamic dominance the image of the black demon was used by Christians to mark Muslims as enemies. In early medieval paintings black devils are shown as Christ's tormentors during the Passion. Blackness represented not only the anti-aesthetic, but also the anti-Christ.

This association gave way to a more positive image between the twelfth and fifteenth centuries, but the negative iconography resurfaced with the biblical legacy of the story of Canaan, the outcast and cursed grandson of Noah (Genesis 9:18: 27). The curse of Canaan was first equated with blackness in medieval Talmudic texts. The Christians subsequently adopted and perpetuated this theme throughout the sixteenth and seventeenth centuries, thereby establishing black as the color of sin. This theological assessment was used as the primary justification for slavery.

From here on, perceptions of black and white crystallized into polar opposites. Black skin represented sinfulness, dirtiness, the devil, ugliness, and deviancy, while white stood for goodness, cleanliness, godliness, beauty, and chastity.

European folklore is littered with derogatory references to blackness, both as a color and a state of being. Greek legend has it that Phaeton's chariot had drawn the sun too close to earth and that the heat blackened the faces of Ethiopians, while Oliver Goldsmith described blacks as the "gloomy race of mankind." Religious folklore spoke of sin turning men black; there were

BODY EXHIBIT
An artist's impression of African slave Saartje Baartman, the so-called Hottentot Venus, with her exaggerated behind. Her body was displayed in London and Paris in 1810.

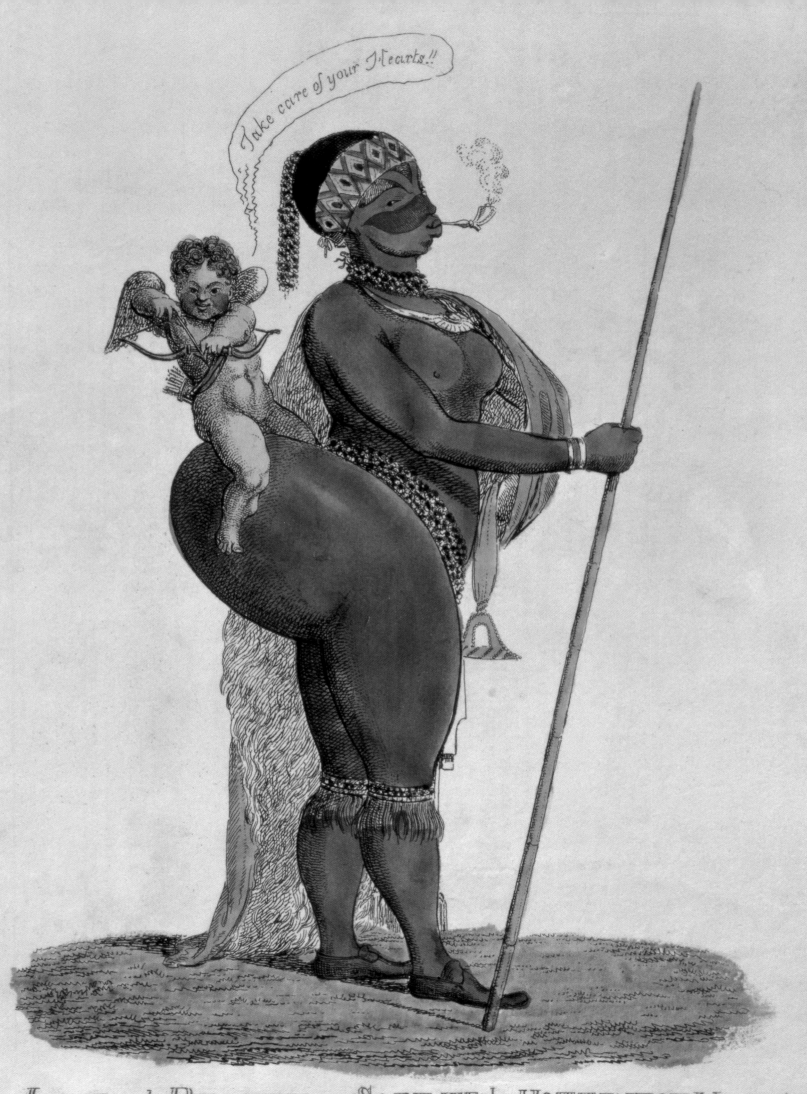

Take care of your Hearts!!

LOVE and BEAUTY — SARTJEE the HOTTENTOT VENUS.

stories of black races born in hell, and of Ormazd and Ahriman – the Children of Light and the Children of Darkness. There was the Black Death, there was Othello the black Moor, there were black Saracens, the black devil, black magic, black arts, black humor, blackmail, blacklists, and black sheep.

In 270 BC the poet Asclepiades wrote of a black beauty who had "ravaged my heart. Alas I melt as wax at the sight of her beauty. She is Black, it is true, but what matters? Coals are Black; but when they are alight they glow like rose cups." The tone here is bittersweet. The lady is said to be beautiful despite being black – blackness being synonymous with ugliness at that time.

"Negative blackness" manifested itself in the theme of washing blacks white. In the Iberian peninsula in the year 711, a black soldier from the Muslim army was captured by the Goths at the siege of Cordoba. They had never seen a black man before and so proceeded to attempt to scrub off his color. Similarly, in the sixteenth century, the Italian illustrator Andrea Alciati depicted a scene (subsequently much-copied) in which two whites attempted the same ritual. This racial slur continued into the nineteenth century, when it was particularly drawn upon for the advertising of soap.

This notion of cleansing blackness was a metaphor for eradicating the difference between black and white – for rubbing out ethnicity. "By washing the negro, they try to make him like themselves," said Jan Pieterse in *White On Black*.

The black queens, goddesses, and Madonna figures of ancient times have carried the iconography of black beauty throughout European antiquity and beyond. Legendary African rulers of Ethiopia and Egypt such as Andromeda, the Candaces, and Hatshepsut, and famous queens such as Nefertiti, Cleopatra, and Makeda – otherwise known as the Queen of Sheba – despite strong evidence that suggests they were black, have often been presented as white goddesses. In 1230, the Queen of Sheba was rendered as a European beauty in the cathedral of Chartres. Also, Cleopatra has often been depicted as a white woman of Greek origin – a misconception reinforced by Elizabeth Taylor's portrayal of the black beauty in the 1963 movie.

Blackface goddesses have also been appropriated and worshipped throughout Greek mythology. Isis, for example, originated in the Nile Valley and Diana of Attica was of Ethiopian origin. Not only were they sexualized, they also had high status. Minerva was the goddess of wisdom and Artemis the goddess of chastity, the latter contravening European conventions of the eighteenth and nineteenth centuries that assigned chasteness and purity to white skin.

One of the most famous European black goddess figures was the sixteenth-century Venus carved by the Italian artist Alessandro Vittoria but the earliest manifestation was the Venus of Willendorf, found near Vienna, Austria and dated 10,000–15,000 BC. It was carved by the Grimaldis – a race of black Europeans – and is thought to be one of the oldest known representations of the human body.

The iconography of the blackface Madonna and Child has also been a dominant feature of European religious antiquity that pre-dates Christianity. Isis, the African Madonna figure, became the prototype for subsequent versions that have appeared throughout Europe, as far

afield as Russia. Interestingly, the coloring of the various Madonnas varies from light brown to deep black, mirroring the actual skin-tone spectrum of people of color.

References to black male beauty in European antiquity have focused on warriors and folk heroes such as Saint Maurice, the black knight of the Roman army and patron saint of the Crusade against the Slavs, who was portrayed in a statue in Magdeburg in 1245. In Sicily and other parts of the Mediterranean, black saints such as San Benedetto of Palermo – the pioneering son of freed slaves – made their appearance. In the fourteenth and fifteenth centuries the African ruler Caspar, King of the Moors, was depicted as a handsome nobleman in paintings and plays. White actors blackened their faces to portray him, as they did in sixteenth-century performances of Shakespeare's *Othello*, with its derogatory references to the "lascivious Moor," his "thick lips," the blackness of his skin, and an uncontrolled sexuality, likened to a "black ram." In 1820s London, Ira Aldridge, England's first black actor, played the role of the Moor, attracting controversy for the scenes in which he touched the white actress Ellen Tree.

Many of Shakespeare's works reveal him to be an admirer of the black aesthetic. His sonnets were written at the end of the sixteenth century – a time when there were many African women living in London who were hotly pursued by white noblemen, artists, and the well-to-do, albeit as courtesans rather than as partners. The beautiful "Dark Lady" of poems is widely thought to have been Lucy Morgan, an African courtesan from Clerkenwell, London. In his "Sonnet to a Dark Lady" he wrote:

> *In the old age, Black was not counted fair*
> *Or if it were, it bore not beauty's name;*
> *But is Black beauty's successful heir*

Shakespeare also recognized black men as beauty figures. "Black men are pearls in beauteous ladies' eyes," says Proteus in *The Two Gentlemen of Verona*.

The clearest and most obvious acknowledgment that black was beautiful during this time was the appropriation of African women as sex objects. Throughout the centuries it was almost a matter of routine for European royalty to have women of color as mistresses and concubines. During the seventeenth and eighteenth centuries Louis xiv, Louis xv, and Louis xvi of France followed on from Afonso iii of Portugal (1210–1279) and Francis i of France (1497–1547) in having black lovers.

During the reign of Louis xv, Isabeau, an African slave from a Haitian plantation, found her way to Paris, where her beauty caused a sensation. She became one of the most sought after women in France – a "prequel" to Josephine Baker. Among her many admirers was the Comte d'Artois, the future King Louis xvi. "Whenever she came...to see the king at dinner," said her white rival Madame du Barry, "there was a great crowd to see her."

The sexual favors of African men were also sought in the bedchambers of queens. The wife of Louis xiv, Queen Maria Theresa of Spain, caused a national scandal when she gave birth to

BLACK BEAUTY IN ANTIQUITY
Overleaf, left: Images of the black Madonna and child, such as this example from eighteenth-century France, are present throughout European history. *Overleaf, right:* German-born Queen Charlotte Sophia of Mecklenburg-Strelitz, the black wife of England's George iii and a distant relative of the British Royal family. She was described as having "a true mulatto face."

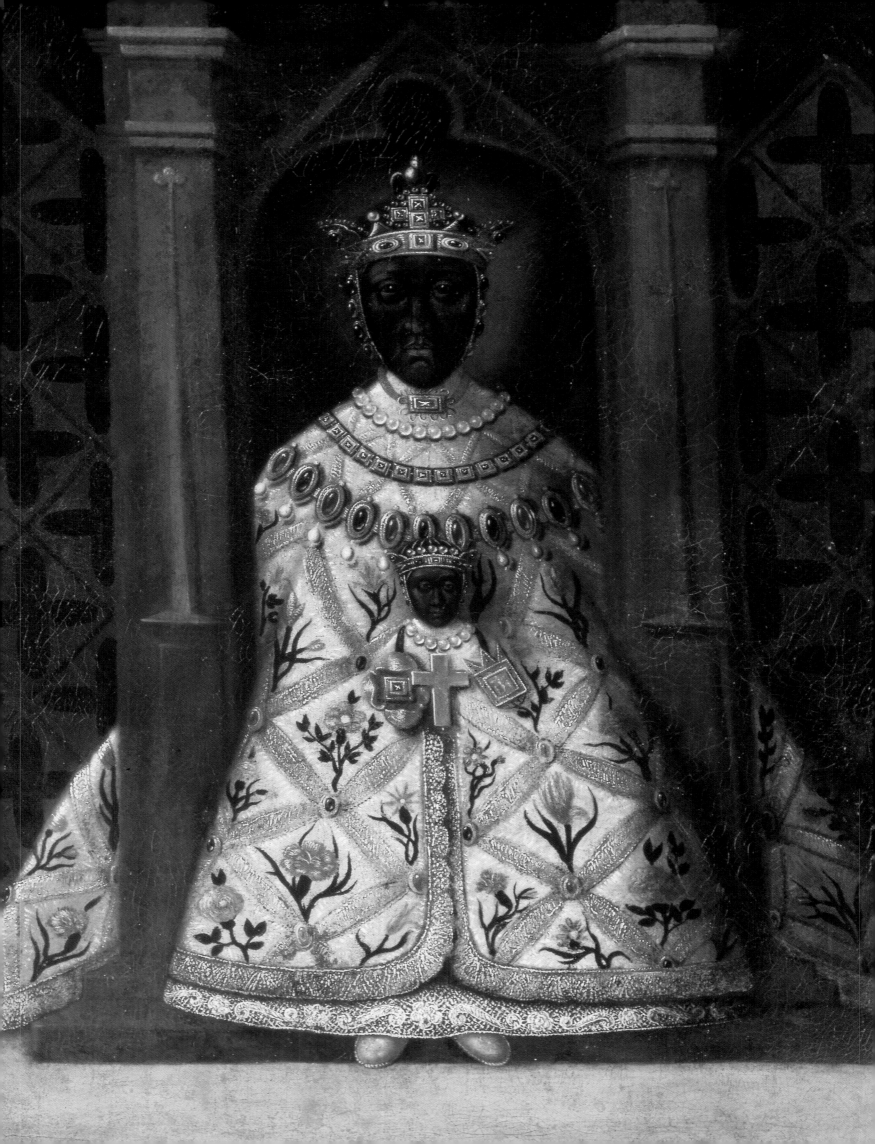

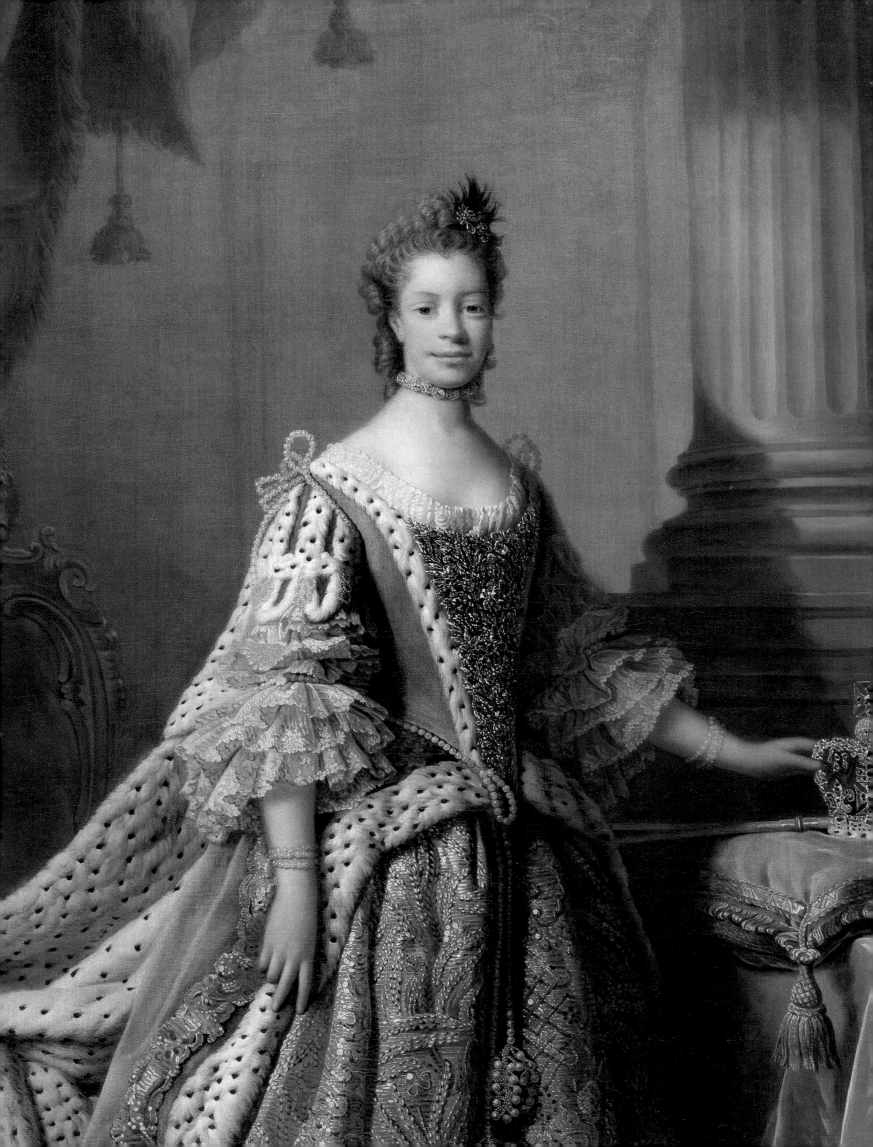

an illegitimate child who was the coloured product of an affair with her teenage African slave, Nabo.

Mixed-race children born of the liaisons between Africans and European nobility have been present throughout the royal families of Europe for centuries. In thirteenth-century France there was Jean d'Eppes, grandson of William II, while in sixteenth-century Italy there was Alessandro de Medici, the Duke of Florence, whose African mother, Anna, was dubbed "the Italian Cleopatra." In eighteenth-century France there was Saint Hilaire, illegitimate son of Louis XV, as well as Louise-Marie, otherwise known as The Black Nun of Moret, illegitimate daughter of the wife of Louis XIV.

German-born Queen Charlotte Sophia (1744–1818) was the mixed-race wife of England's George III, and an ancestor of Queen Elizabeth and the British Royal Family. Boston-based genealogist Mario Valdes traced her lineage back to the fifth king of Portugal, Afonso III, who conquered Madrem, the Moorish king of the Algarve, in the mid-thirteenth century, and subsequently had an illegitimate son with the conquered King's daughter Madelena Gil. Although six lines of descent separate her from Queen Charlotte, the German queen's black-style features are nonetheless clearly delineated within her physiognomy. She was described by her physician as having "a true mulatto face" and was depicted thus in many portraits. But her face was not considered beautiful in some quarters. Court observer Horace Walpole described her as "Not a beauty, the nostrils spreading too wide; mouth has the same fault.'

Black beauty was first graded into hierarchical strands during slavery, which established a socio-economic caste system – what Kobena Mercer calls a "pigmentocracy" – based on skin-tone. Lightness acquired a value that effectively relegated the physiognomic components considered most African – i.e. darkness of skin, ethnic features, and Afrohair – to a lower beauty rating. Mixed-race slaves, with their more European countenance, were favored by whites as the closer approximation to their own beauty ideal. Thus mulattoes were often first in line for the role of "house-negro," while dark-skinned blacks toiled in the fields. At the same time, greater numbers of mixed-race women than black males became runaways during slavery, partly because their lighter skin gave them a better chance of passing for white.

In the early nineteenth century Thomas Jefferson compounded the color issue further when he devised a crude mathematical formula for dividing blacks of mixed parentage into sub-racial categories. A half-mix was termed "mulatto," a quarter-mix "quadroon," and an eighth-mix an "octoroon." This sub-human classification came from the man who coined the phrase "All men are created equal." Effectively these sub-classifications meant nothing, for sociologically even a drop of black blood fixed the carrier as "black," regardless of the proportional mix. Indeed, in certain American states at this time one-sixteenth of black blood certified the carrier as mulatto.

The aesthetic discrimination within slavery was carried over after abolition, and many of the genetic recipients of lightness exploited its potential for an easier, more charmed kind of black life. Mixed-race beauties – either by virtue of passing for white, or simply by representing the "acceptable" face of blackness – continued to be promoted ahead of their tonally blacker

counterparts. Marrying "light" became a form of social climbing. In colonial Brazil, there was a saying: "White women are for marriage, mulattoes for fornication, and Negresses for work." On a scale from "blue-black to "high-yellar," lightness topped black beauty's league table. The birthright of the light-skinned beauty became high currency.

Before Hollywood invented the blond bombshell for the twentieth century, the mulatto was the original "blonde." Just as the blond was considered more attractive than the brunette within Western culture, and was envied for this, so the mixed-race woman had similar status over her dark-skinned counterpart. The desire to be mulatto was also a desire for the social privileges that were awarded to those people. Thus before there was ever "blonde ambition" there was mulatto ambition.

Conversely, the mulatto beauty was perpetually caught between the possibility of being "too light" for "genuine" black folks, while being rejected by whites for her "black" blood.

But in similar fashion to the tastes of European royalty, blackness was also desired by white slavemasters and colonialists. The rape of African female slaves was not only a routine marker of subjugation aimed at the humiliation of black women and their men, but also provided terrifying proof of the irresistible desirability of people of color. "Few colored girls reach the age of sixteen without receiving advances from them [white men] – maybe from a "young upstart," and often from a man old enough to be their father," the American magazine *The Independent* reported in 1904.

The idea that white males expressed a liking for black beauty was a social embarrassment, as it ran contrary to popular thinking that branded blacks as aesthetically and racially inferior, and also acted as a snub to the paradigm of white womanhood. Consequently, ashamed of their lust, white males attempted to conceal their savagery in a cloak of lies and secrecy. One measure was to classify the mixed-race offspring of their indiscretions as "Negro," partly in a lame attempt to deny that any contact had taken place, despite the family resemblance clearly visible in the faces of the illegitimate children.

In America these indiscretions went right to the top involving society's most respected leaders. Recent DNA evidence has revealed that Thomas Jefferson (1743–1826), founding Father of the American Constitution, secretly fathered illegitimate children with his slave Sally Hemmings. This was despite the fact that in his publication, *Notes on Virginia* (1784) he stated his dislike for what he termed the "eternal monotony" of blackness, and that whites were superior in looks to Africans. His apparent hypocrisy may be explained by the fact that Hemmings was of mixed-race, and according to John Chester Miller in *Wolf By The Ears*, "bore little trace of her African ancestry." Perhaps her "white" blood humanized her in Jefferson's eyes, making her attractive enough by European standards for him to contradict his beliefs about the innate ugliness of the African race.

It was slavery that first imbued the physical architecture of blackness – hair, skin, facial features, backside, and penis – with a series of derisory codings. The eighteenth and nineteenth centuries were a period of aesthetic sabotage in which so-called "race-science" and the proportions of facial beauty devised by artists were used to portray blackness as the paradigm

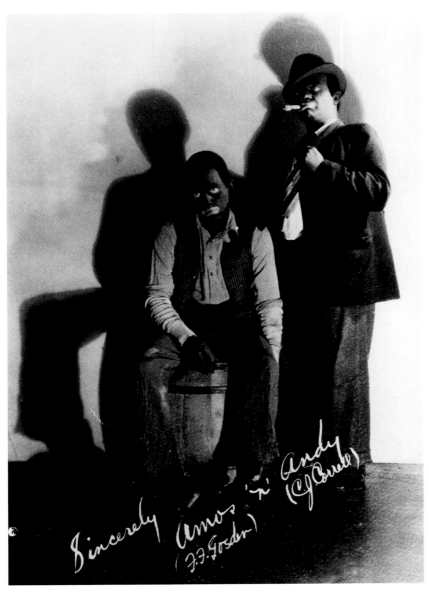

IMITATING THE IMITATOR
Early Afro-American minstrel stars such as Amos 'n' Andy appropriated the grotesque facial caricature invented by their white counterparts.

of ugliness or as a marker of innate criminality, sexual deformity, or relation to animals – particularly primates.

In the late eighteenth century, an English judge and slaveowner, Edward Long, the most rabidly racist commentator of his era, savaged the black physiognomy, referring to blacks as having "tumid nostrils" and describing Afrohair as a "bestial fleece." He maintained that Europeans and blacks did not belong to the same species, and that "...they are libidinous and shameless as monkeys, or baboons." Similarly, the Swiss anatomist Georges Cuvier contended that "The projection of the lower parts of the [Negro] face, and the thick lips, evidently approximate it to the monkey tribe."

The German Johann Fredrich Blumenbach invented the word "Caucasian" in 1795, as he believed the slopes of the Caucasus mountains of Eastern Europe to be the original home of beautiful whites. He published an influential dissertation in which he declared the white race the "...most handsome and becoming," and derided blacks as having a "...head narrow, compressed at the sides; forehead knotty, uneven, molar bones protruding outward; eyes very prominent; nose thick, mixed up as it were with wide jaws..."

No doubt such theories influenced the Italian criminologist Cesare Lombroso, who in 1874 published a study of the alleged links between physiognomy and innate criminality. In *L'homme criminel*, he contended that the lips of rapists and murderers were "...fleshy, swollen and protruding, as in Negroes."

Of course, this dehumanizing labeling – what Ron Dellums calls "the niggering process" – is not historically confined to blacks but is a typical xenophobic reflex to the presence of "outsiders" or conquered peoples, regardless of ethnicity. In the late nineteenth century, for example, the Irish were caricatured alongside blacks in popular illustrations in British and American satirical magazines such as *Punch* and *Harper's Weekly*, which routinely referred to them as "savages" and "apes." Cartoonists rendered them with low foreheads and grotesque features. In 1862 an article in *Punch* on Irish immigration stated that an Irishman was "a creature manifestly between the Gorilla and the Negro..."

But the cod-science of the eighteenth-century aesthetes was no beauty conspiracy. Rather, in delineating the architecture of the black physiognomy these scholars actually believed blacks to be racially and aesthetically inferior. Their work was dedicated in its professional madness, and

their findings were appropriated by others to assassinate the black aesthetic and to support notions of white superiority. Their brilliantly evil texts formed part of a network that spanned continents. Edward Long's *History of Jamaica* (1774) – a diatribe of insults against blackness – was reprinted in New York in 1788, and used by white hegemonists to reinforce the case for slavery. Everybody joined in the chorus that said blacks were ugly – in body as well as face.

Like the Hottentot Venus, the myth of the oversized black phallus was used to suggest that blacks were sexually deviant and grossly deformed. The earliest references to this sexual stereotype can be traced back to early seventeenth-century England, where a sea captain, Richard Jobson, attributed what he alleged to be the uncontrolled sexuality of Africans to the size of "the African penis." According to Jobson in 1623, they were "furnisht with such members as are after a short while burthensome unto them." The popular view amongst Europeans was that this was the result of God's curse upon the African race. Jobson believed that blacks had spawned from the Biblical figure of Canaan, who "uncovering his Father's Nakedness, had a Curse laid upon that Part, and applies to them the Words of Ezekiel, Chap. XXII. 20." The black male was described as a "walking phallus," and the size of the member took on the status of an extra limb, thus evoking the imagery of the black male as monster or three-legged alien. This stereotype was further perpetuated in 1745, in volume II of *Astley's Voyages – A New General Collection of Voyages and Travels*. A report entitled *An account of the Mandingoes*, stated that "The Reason of the (African) Women abstaining from Coition after Pregnancy is the Danger of Abortion from the enormous Size of the virile Member among the Negros."

This derogatory marking was thought to have a two-fold rationale: firstly, slavery was easier to justify on the grounds that blacks were not human, and secondly, it acted in protection of the aesthetic and sexual perogatives of white males, whose agenda was also to dissuade white females from thoughts of "crossing." White males worked hard to keep black men and white women apart, and these early signs of "locker room-phobia" precipitated other oppressive curbs such as the passing of American legislation (1691–1725) prohibiting interracial relationships, as well as incidents of post-slavery lynchings in which a number of the victims were castrated.

The iconographic myths of the extended phallus and the "taillike" behind of the black physique have implanted themselves firmly within the white cultural psyche, always in association with notions of a heightened sexuality. Both examples keenly illustrate how racial stereotypes can gain credence, purely on the basis of the unscientific ramblings of crackpot commentators such as Jobson or Edward Long.

In the 1830s the entertainment industry took over from race-science as the primary vehicle for degrading blackness, as the minstrel show became America's national pastime. Minstrels consisted of white caricatures of the archetypal plantation-slave entertainer who performed in the master's house, or outside for his fellow slaves. They presented a racist song-and-dance imitation of blacks in a "theatre of the grotesque," dedicated to mock and ridicule.

Minstrel shows reflected society's view of blacks as ugly and coded them according to blackened faces of the minstrel performers. Using burnt cork for make-up, these actors' faces

BLACK DANDY
Like all minstrels,
black or white,
Eugene Stratton
used burnt cork for
make-up.
Aesthetically, the
concept was: the
blacker the skin-tone
the uglier and more
comical the look.

were not just black, but superblack – the connotation being that the deeper the tone (and therefore the furthest from white) the uglier and more comical the look. "Deep-black" also provided the best contrast for the bulbous white eyeballs and the trademark oversized white lips of the minstrel look.

In a strange twist of circumstance, blacks began forming their own minstrel shows in the 1860s, appropriating the mask of their detractors. They presented "an imitation of an imitation," as they painted and blackened their already black faces in identical style to the white minstrels.

Simultaneously, in the American South, the monotone contrast of white eyeballs and teeth within a black face precipitated the derisory term "coon" – taken from the raccoon, with its trademark black-and-white coloring. By the 1890s this insult had metamorphosed into a cartoonlike illustration associated with the promotion of black music. Like the black minstrels, performers of color also participated in the propogation of this new stereotype, as the black vaudeville entertainer and composer Ernest Hogan illustrated with his popular 1896 song, "All Coons Look Alike to Me."

Outside America the coon had its Euro-equivalents. Britain had the "Gollywog," France had "Banania," Holland had "Black Peter," Germany had the "Sarotti-Mohr," and Spain, Italy, and Finland had their own equivalents. Many of them still feature today as logos on confectionery packaging.

These clown figures were both childlike and masculine in nature. As well as being generally derogatory to black beauty, they were more specifically aimed at the aesthetic humiliation of black men. They marked the first moment in history in which this uglified image became enshrined within the black performance tradition. It established a trend which would run throughout twentieth-century Hollywood and the music industry in which black men were required to look as ugly or as comical as possible, and black women were required to look as white as possible in order to cross over. Early black revues of the 1890s such as *The Creole Show* and *The Octoroon* were cast exclusively with light-skinned, Euro-featured black women. The pressure on black female entertainers to cross over saw them succumb to white beauty values in the wearing of straight wigs made of horsehair in the vaudeville performances of the late nineteenth century. This effectively crystallized the archetypal aesthetic of today's wig/weave-wearing black female singer.

The arts have traditionally endorsed conflicting views of black beauty. Shakespeare may have been an admirer of the black aesthetic, but many eminent wordsmiths did not share his view. Nineteenth-century writers such as Carlyle, Ruskin, and Tennyson routinely demonized and vilified blackness in their works. Charles Dickens referred to blacks as "sambos" and "savages."

In late nineteenth-century France the black aesthetic featured within prominent literary works. The poet Baudelaire and the playwright Adolphe Belot both scribed exotic fantasies to *La Vénus Noire*, whom Baudelaire described as a "strange goddess, dark as the nights." In 1881

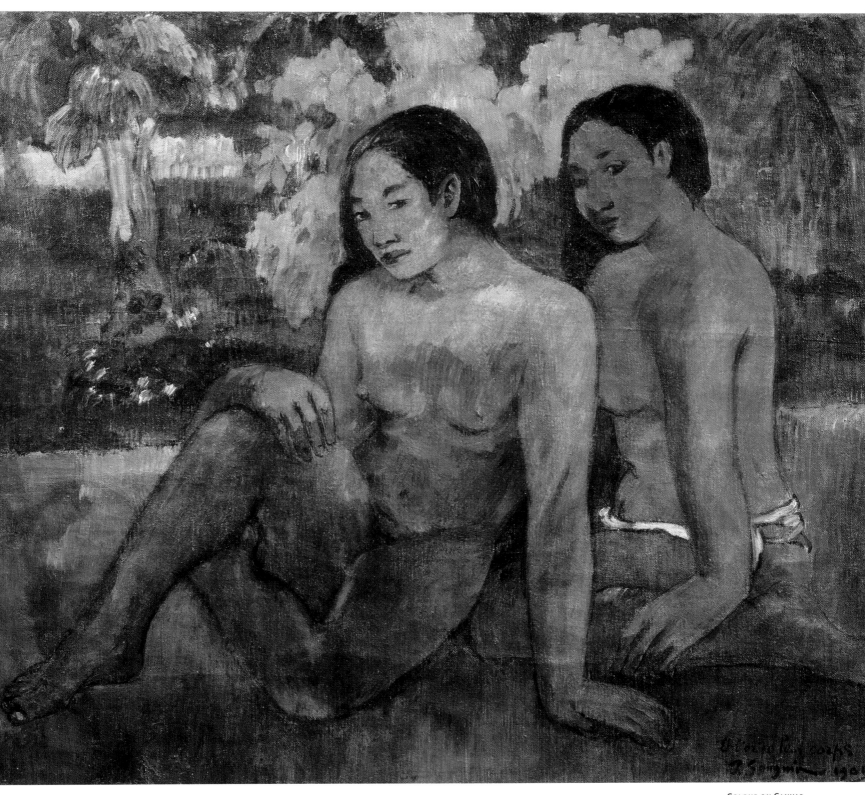

COLOUR ON CANVAS
French artist Paul
Gauguin captured
the dignified beauty
of Tahitian women of
color in works such
as *The Gold of Their
Bodies* (1896).

the author Pierre Loti summed up the way in which the sexual and aesthetic admiration of the black form often strayed into racist stereotypes. In his novel *Roman d'un Spahi* he described his black heroine as possessing "the mysterious beauty of an idol in shining ebony...a black grace, a sensual charm, something undefinable which seemed to stem at the same time from the ape, the young virgin and the tigress."

People of color also have a long history within the European fine-art tradition. Artists such as Rubens, Rembrandt, Van Dyck, Hogarth, Gainsborough, and others featured black beauty in a multitude of guises, though mainly as servants or courtesans. The German artist Frank Buchser painted black female nudes in *Negermädchen im Bach* (1867) and *Nackte Sklavin* (1880), while the French sculptor Charles Cordier produced his famous bust, *Vénus Africaine* in 1851. In Manet's *Olympia* (1863) a black servant waits on a reclining white prostitute in a role-play of sexual complicity. At the end of the nineteenth century Paul Gauguin captured the dignified beauty of Tahitian women in works such as *Ancestors of Tehamana* (1893) and *The Gold of Their Bodies* (1896).

The black physiognomy as represented in Ancient African sculpture had a profound influence on European artists. In 1886 a Berlin museum mounted a huge exhibit of 10,000 African tribal objects, including many masks. Similar shows were also staged in France and London. These facial renderings began attracting the attention of the European Masters, and by the early 1900s Picasso, Matisse, Braque, and Dérain were all avid collectors, incorporating black physiognomical motifs in their work. Ironically, this took place at the very same moment that cultural commentators were busy coding the black face as ugly.

The earliest representations of blacks as models began appearing in the 1850s, and reflected slavery's established stereotypes. People of color were depicted not as beauties or consumers, but as servants, entertainers, or decorative elements – just as they were within fine art. Facially, they were caricatured – swollen-lipped, bug-eyed, uglified. The only exceptions were the sexualized creole beauties who adorned the labels of liquor bottles. Mostly, people of color were used to promote "colonial products" such as cocoa, chocolate, rum, and coffee, which were perpetually associated with the color black and with black servitude. Illustrations of black faces began appearing on food packaging in the 1890s. The first black model, Nancy Green, an ex-slave from Kentucky, became one of America's earliest iconic logos in 1889 when her smiling visage was rendered as the first "Aunt Jemima" on packets of pancake mix.

The abolition of slavery was a turning point for black beauty. It meant that people of color were now "free" to exercise their own aesthetic perogatives, which would effectively stimulate the development of a black cosmetics industry. They were also able to lobby for aesthetic representation within society's new order. However, the beauty standards of blackness were still firmly controlled by whites, who adhered to the same hierarchies established during slavery.

SELLING BLACKNESS
The earliest black models conformed to slavery's servile stereotypes. In 1889 Nancy Green appeared as Aunt Jemima on packets of pancake mix.

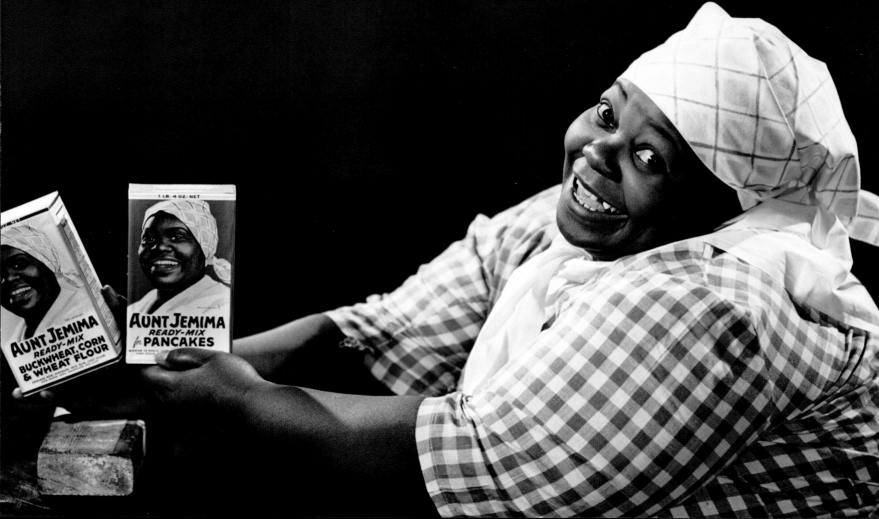

2

black 'n' tan

1900–1920

Now, if you're white, you're alright,
And if you're brown, stick around.
But if you're black, oh, brother,
Get back! Get back! Get back!

'Black, Brown & White Blues', Big Bill Broonzy

IN THE LATE NINETEENTH CENTURY a story was told about a young black woman, born blacker than she wanted to be. Too black to be sexy. Ravaged by insecurity and low self-esteem, she applied a crude skin-lightening emulsion to her face, the ingredients of which were no better than house paint. As her skin eroded and ingested the lead, the "privileges of whiteness" that she sought faded away with her pigment as gradually the fatal marinade was killing her softly. Soon she would be lightly and sunlessly tanned, but dead – and by the turn of the twentieth century a new range of specially formulated skin-bleaching creams would be on sale.

At the beginning of the twentieth century the aesthetic codes that would govern black beauty through to the next millennium were set in place. To the soundtrack of the blues, the cosmetics baron Madame C.J. Walker, Jamaican Nationalist Marcus Garvey, songstress Ma Rainey, boxer Jack Johnson, and the black characterizations within the movies of early Hollywood defined the first two decades.

Physically cut off and culturally removed from an African homeland they did not know, and unwanted and derided in the post-slavery West, blacks were a people without a country. The early decades of the new century were a period of "making home" in the only place they knew. Blackness was a dual-culture experience – physically they were Africans, but they belonged to the New World. These newborn Afro-Americans were busy migrating north to cities, formulating identities and exercising their newly found aesthetic perogatives. Self-invention was what being an American was all about, and adopting New World values was tantamount to an application for citizenship.

And just about everybody was waiting in line. The Chinese, the Jews, the Irish, and the rest of the immigrant population were also busy contriving their identities – changing their hair, their clothes, the way they spoke, their names, the place they came from, and the nationality of their parents in order to become Americans.

They were in denial but they didn't care. Denial was not the dirty word that it is today. Everybody was giving himself or herself a personal makeover. Nobody wanted to be real. Real was boring. Real reminded them of the bad times – the times they wanted to escape from. It was time for something new.

Simultaneously, the "aesthetic sabotage" of slavery had successfully discredited black hair and skin, while showing a bias toward the "mulatto aesthetic." The media derided blackness, and with a lack of beauty role models or iconic imagery to draw upon, people of color automatically aspired to the values of the dominant class. They made themselves over because

BEAUTY CATALYST Cosmetics baron Madame C.J. Walker *(left)* being tended to by a beautician. Walker's range of beauty products set the aesthetic standard for black women which has remained in place for a century.

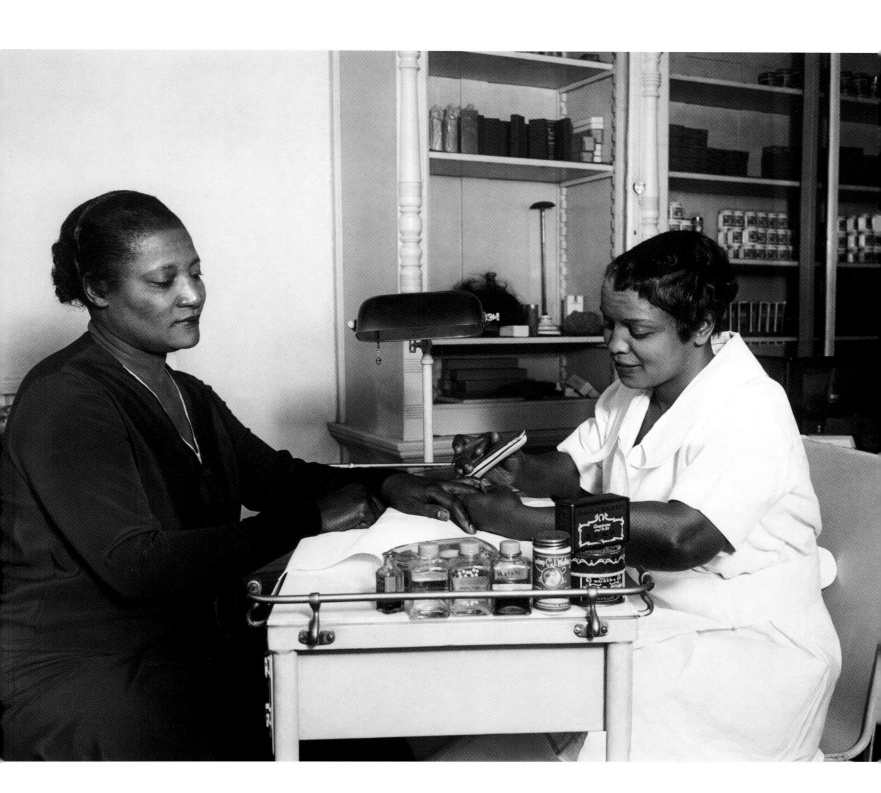

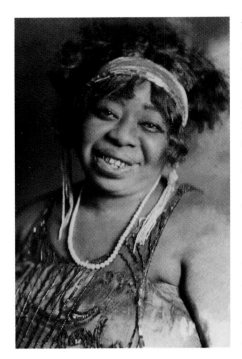

HEAD GIRL
Early entertainers
such as blues singer
Ma Rainey wore wigs
made of horsehair.
They pioneered the
culture of straight
hair amongst black
female performers.

they, too, wanted to be thought of as chic, sexy and desirable. This was less about any romantic desire on their part to want to actually be white and more about a desire to acquire the right to be considered beautiful that they had been hitherto denied, first as slaves and now as citizens.

Unsurprisingly then, the black cosmetics industry that emerged in Harlem in the 1890s was founded on "ethnicity-altering" skin-lightening and hair-straightening products. This demonstrated the extent to which black beauty values had become conditioned by the dominant white aesthetic paradigms. These products acted as a form of ideological vaccine for the problem of unfashionable Afro beauty.

The pursuit of lightness detonated demand for skin-bleaching creams amongst those in the darker tonal range. Early product lines carried anti-ethnic names such as "Black No More," "Fair-Plex," "Lucky Brown Bleaching Cream," and "Cocotone Skin Whitener."

At this time both blacks and whites ironically shared the same desire to look paler. For Caucasians in pursuit of their own beauty standard, the vogue was to be whiter than white. For 2000 years European make-up consisted of a mask of white lead mixed with chalk or combined in a paste with vinegar and egg-whites. This was still the fashion in the early twentieth century, when wealthy society doyennes from New York to Paris wore "toilet powder" thick as face packs to social functions. Less harmful than their predecessors, these powders were made of powdered milk of magnesia, rice powder, French chalk, or Venetian talc. Blacks subsequently copied whites in the development of their own face-whiteners.

People of color also appropriated their own versions of white hair styles via wig wearing and hair-straightening products. In order to straighten Afro hair a specially heated "hot comb" – first popularized by beauty entrepreneur Madame C.J. Walker – was used. It consisted of a fine-toothed, thick metal instrument which was heated on a stove until it was as hot as a branding iron, before being raked through Afro hair, fusing it straight on contact, like an iron through the creases of a shirt. The hair was then greased and styled. "Processed" hair gave black women new manageability and versatility. Suddenly they had hair that moved.

Black female vaudeville and minstrel entertainers had been wearing straight-haired wigs made of horsehair since the late nineteenth century. Ada Overton Walker and Sissieretta Jones and her troupe – otherwise known as Black Patti and the Troubadours – wore wigs cut according to fashionable European styles. This effectively established the aesthetic blueprint for the black female singers and models we see today.

In the early 1900s Alabama-born blues songstress, Ma Rainey, the so-called "ugliest woman in showbusiness," cut a radical figure in her mop-top horsehair wig, complete with a mouthful of gold teeth that would put any gangsta rapper to shame. She epitomized the emerging genre of "the big momma" with an assertive, rough-and-ready sexuality. She was loud and rowdy, she drank hard, and she liked her men. Sometimes she got into physical fights with them, too – and won. She also liked her women, and was a self-confessed bisexual long before such an orientation was deemed acceptable.

In 1918 Clara Smith fronted the vaudeville group The Dixie Steppers, sporting a short red wig that became her trademark. It combined Caucasian-style straight hair and styling with non-

standard coloring. The color red, as opposed to the more common blond or brunette, suggested that Smith was not intending merely to emulate whiteness, but to innovate further. The resulting style was not black, not white, but "Other." It was third-category hair – devised to create an onstage sensation. Wigs and hot-combed hair were the first dual-culture hairstyles of the New World. They represented the junction at which African aesthetics met European styling.

Wig technology was developing fast. In 1910 American companies such as Manhattan's Adorable Hair-Do began importing and processing real hair from China for sale to the Caucasian markets for wigs, hair extensions, and medical and theatrical purposes. Soon they would acquire upmarket black customers seeking real hair for bespoke wigs.

Black males also emulated Euro-centric styles. Side or front partings were razored into short hair, and "grease-and-water" or "cold-soap" waves were achieved with the help of narrow-toothed combs, stiff brushes, and cloth headwraps – do-rags – tied tightly enough to achieve a pressurized temporary wave pattern.

As well as blacks appropriating Caucasian styles, whites, too, began appropriating black aesthetic signatures. As women of color sought straight hair, white females appropriated the black-style frizzy look typical of mixed-race beauties when the French hairdresser Marcel Gateau invented his famous "Marcel Wave" by applying hot tongs to curl straight hair.

This fashion in which beauty styles were swapped between races marked the beginnings of the culture of aesthetic transfer. But at its core a beauty hierarchy was still at work. In the same way that the historical appropriation of black musical styles has often paid greater dividends for white artistes than for black, recontextualizing blackness within a white face suddenly sanctioned it as beautiful. Curly hair on the heads of the privileged white class was considered chic, while naturally curly black hair on the heads of people of color was still degraded and marked as ugly by the dominant culture.

Amid the fashion for wigs and processed styles, Texas-born Jack Johnson, the first black heavyweight boxing champion of the world, established the Nubian-style shaved head as the low-tech look of choice for sporting gladiators, and a symbol of black rebellion that preceded both the Afro and dreadlocks.

In his 1908 championship bout, the man the London press noted for his "golden smile" broke his opponent Tommy Burns's nose in the second round. But that wasn't the only thing that was broken. He enraged white America by flaunting its segregation laws in having white girlfriends. The fact that he was the champ is the only thing that saved him from becoming the "Strange Fruit" of the white lynch mobs. He was hated and hounded by those fearful and envious of his awesome talent, his physique, and the chilling fact that their women lusted after him. He was the century's first black autonomous renegade – a sexual and aesthetic thorn in the side of white America.

The revolution in the development of black hair and beauty products was pioneered by the renowned American entrepreneur Madame C.J. Walker. Born to former slaves on a Louisiana cotton plantation two days before Christmas in 1867, Walker was married at 14 and widowed

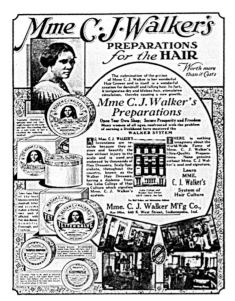

SELLING BEAUTY
An ad for Madame
C.J. Walker's
cosmetics range.
Her promotions
influenced the entire
genre of black hair
and beauty
advertising to the
present day.

four years later. She worked as a domestic-house servant until 1905, when she began producing a cosmetics range for black women that included shampoos, hair-restorers, and dandruff and eczema treatments. But it was her skin-lightening products and "hot-comb" that were to attract controversy.

Despite its purpose, Walker denied that her comb was a straightening tool. "Right here let me correct the erroneous assumption held by some that I claim to straighten the hair," she told the *Indianapolis Recorder* in 1919. "I want the great masses of my people to take greater pride in their personal appearance and give to their hair proper attention."

Her product packaging also aligned her with the values of straight hair. The label on her Glossine Hair Pomade read: "It will make short, harsh, kinky hair behave and stay in place." This notion of black hair as inherently defective and in need of "fixing" or "taming," echoed the exact sentiments of eighteenth-century European racists such as Edward Long, who routinely referred to black hair as a "bestial fleece."

"Uncivilized hair" was just one component within Walker's advertising stance. Her skin-lightening emulsion was antagonistically titled Tan-Off. The label inscription read: "Recommended for brightening sallow or dark skin, for the treatment of tan, freckle, skin blotch and for clearing the complexion."

Walker's premise – that altering blackness is the starting point for success – has influenced the entire genre of black hair and beauty advertising to the present day. It struck at the heart of black aesthetic insecurity and low self-esteem at a moment when ethnicity was still being systematically degraded throughout popular culture. Walker appropriated and repackaged light skin and straight hair and marketed them to blacks as the ultimate in chic. With her skin-bleach she sold black women hope in a jar – the hope of a better life through lighter skin. Her hair formulas bridged the gap between the kind of black woman you were and the kind of black woman you wanted to be. They were the ideal solution to the problem of what to do if every day was a bad hair day.

So successful was Walker that by 1916 she had amassed a staggering 20,000 agents selling her formulas across 29 countries worldwide, plus a network of beauty-culture colleges stretching from D.C. to Dallas. As a pure business proposition governed by the laws of supply and demand, the timing was excellent. So much so that she became the world's first female self-made millionaire.

Walker's legacy is bittersweet. History has been kind to her because, aside from being a cosmetics baron, she was also a philanthropist and activist who donated large sums to the National Association for the Advancement of Colored People (NAACP), campaigned against lynching, invested in the community, and provided thousands of jobs for people of color. "I have made it possible for many women to abandon the washtub for a more pleasant and profitable occupation," she stated. It is true to say that she did not instill the desire of blacks to look paler and straighter – her products certainly were not first into the marketplace – but she did commercialize the industry and, in doing so, she established a new beauty standard for black women that remains unchanged to this day.

CLOSE SHAVE
The mighty Jack
Johnson, the first
black heavyweight
boxing champion of
the world, estab-
lished the Nubian-
style bald head as
the low-tech look for
black men, which
preceded the Afro
and dreadlocks.

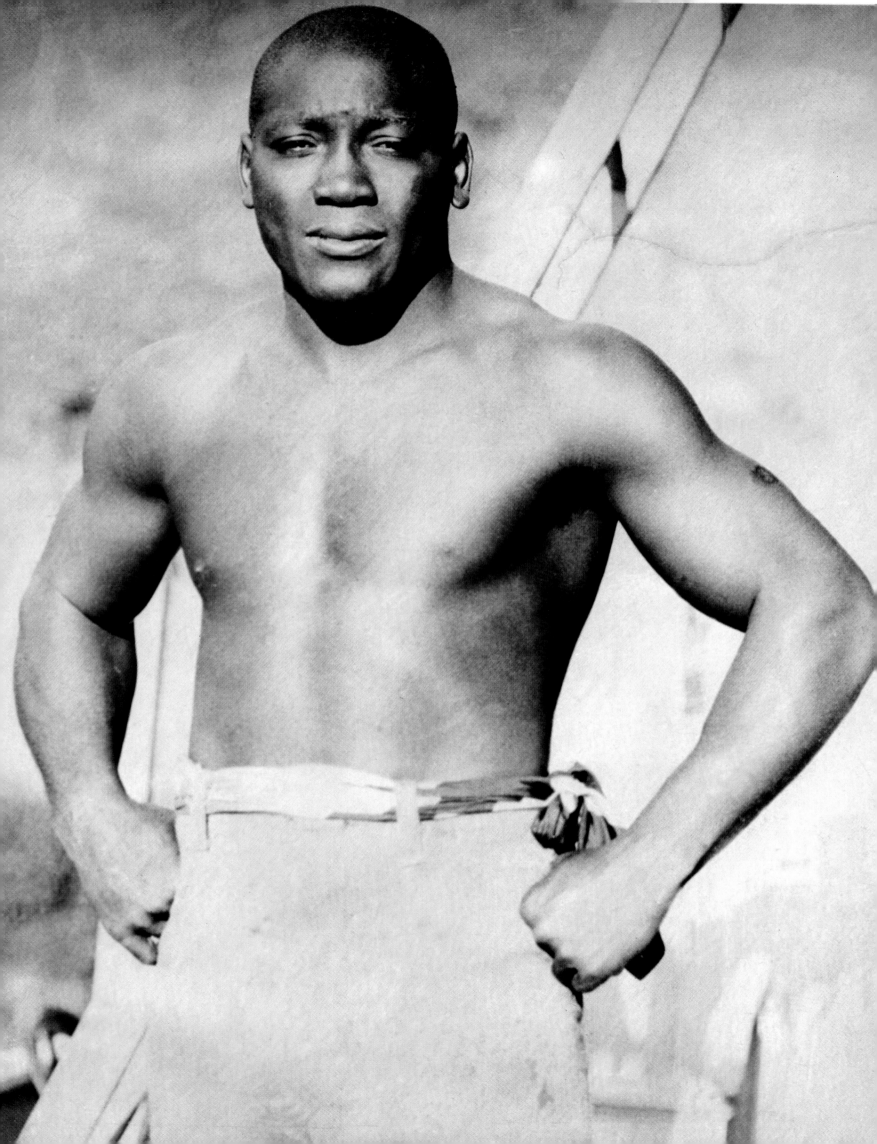

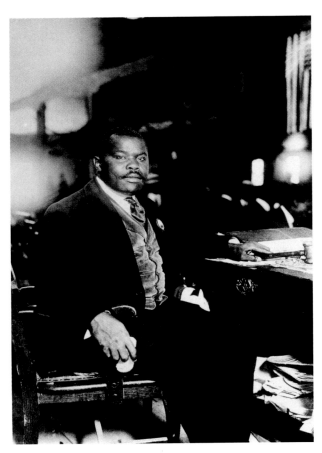

THE ADVOCATE
Nationalist leader
Marcus Garvey
lobbied against the
influence of
European beauty
values on the black
consciousness.

In 1916 a new man in New York city, the Jamaican Nationalist Marcus Garvey, gazed down upon the processed heads of his people, and there he saw processed minds, too, marinated in white beauty values. He called for repatriation, but to where? Africa was as unfamiliar a geography to blacks as it was to any white man. The New World was the only "Africa" they knew, and it was home, for better or for worse. "I was not Africa," said Langston Hughes. "I was Chicago and Kansas City and Broadway, and Harlem."

Garvey's United Negro Improvement Association (UNIA), initiated an education program aimed at the promotion of images of black beauty to counter Eurocentric hegemony. Garvey showed children pictures of black angels and issued them with black dolls manufactured by his organization. He also targeted adults. "Take down the pictures of white women from your walls," he urged. "Elevate your own women to that place of honor." But when he lobbied the Afro-American press to cease carrying ads for skin-bleaching and hair-straightening formulas, his demands fell on deaf ears, as the press relied heavily on the advertising revenue they generated.

Garvey famously fell out with the renowned NAACP leader W.E.B Du Bois. In a heated exchange the pair put politics aside and donned their aesthetic boxing gloves in a bout of "Black vs Tan." In round one the lightly tanned Du Bois described Garvey as "a little, fat black man, ugly, but with intelligent eyes and a big head." In round two a dark-skinned Garvey – who, from his experiences in Jamaica, mistrusted light-skinned upper-class blacks who he believed looked down upon their darker-skinned counterparts – retaliated by mocking Du Bois's light skin-tone and accusing him of wanting to be white. He also accused Du Bois of deliberately populating the NAACP offices exclusively with light-skinned workers.

The earliest black models to permeate the mainstream were employed in stereotypical roles in the promotion of products associated with slavery, colonialism and servitude. In 1918 South African-born Maurice Hunter became the first black male model, earning $25 per job playing various butlers, chauffeurs, and porters in ads for cigarettes and alcohol. Black newspapers such as *The Messenger, Opportunity*, and the NAACP's *The Crisis*, began to provide new opportunities for Afro-American models advertising consumer products for blacks, such as C.J. Walker's cosmetics line.

The emerging movie industry became the primary vehicle for defining beauty and sexuality, and as far as blacks were concerned Hollywood propagated the same aesthetic and sexual hierarchies inherited from slavery, which favored light skin and Euro-style features, and also suppressed the sexuality of men of color.

Black males were cast either as sexless clowns ("coons"), and submissively loyal servants ("Toms"), or as hyper-libidinous, bestial renegades ("bucks"). Following in the minstrel

tradition, these characters were unanimously dark-skinned – i.e. "ugly," with caricatured features or expressions, and until the 1920s were played by white actors in blackface. Bucks – the only male characterization with a sexual personality – were imbued with a grotesque sexuality, designed to evoke fear and shock rather than desire. These characterizations reflected white male society's fears of black male sexuality and of racial mixture that had spawned aggressive post-slavery legislation such as the "Jim Crow" laws, which banned interracial marriage and consorting between different races. Once again, coding the black male as universally ugly and either sexless or oversexed, was the industry's way of protecting the sexual perogatives of white males and deterring white women from finding them sexually attractive.

The archetypal figure of the abrasive house-servant known as the "mammy" was Hollywood's female equivalent of the "coon" or "Tom." She, too, was superblack and sexless, and her wide-bodied form contrasted with the slimline form and porcelain-faced beauty of the white woman of the house.

Following on from the hierarchy of slavery, the mulatto – complete with her lighter skin and closer physiognomical approximation to white – was coded by Hollywood as the quintessential representation of black beauty and sexuality – obviously the result of the "beautifying" biology of her "white" blood. Her cinematic characterization was that of a desirable sex object for white males – though her partial blackness ultimately acted as an insuperable barrier to her complete acceptance by them.

All these typologies were played out for the first time in the controversial *Birth of A Nation* (1915), the movie directed by D.W. Griffiths, based on the Thomas Dixon novel, *The Clansman*. This white supremacist tale of the Old South, Civil War, and the birth of the Ku Klux Klan, although admired for its technical artistry and groundbreaking cinematography – it pre-dated *Citizen Kane* by 26 years – constituted the era's most rabidly racist portrayal of blackness. In customary fashion, all the black characters were played by white actors in blackface, except Lydia, the "tragic mulatto," played by Mary Alden. Physiognomically, only the grossest caricatures of facial gesture were used. Walter Long played the role of Gus, the renegade buck, and like some demented facial contortionist he mastered the stereotypically grotesque, rubber-lipped, boggle-eyed look of surprise that would have been the pride of any minstrel show.

The film marked the beginning of Hollywood's hierarchical coding of the color black. The "mammy" character was rendered superblack – as was Long's character, Gus – whereas the black characterization of Lydia – the mistress of a white carpetbagger – was cast as a "café-au-lait" colored beauty. In Hollywood superblack was too black to be beautiful, and this rule became the standard from here on.

BLACK CARICATURE IN WHITEFACE Caucasian actor Walter Long as the black renegade Gus in D.W. Griffiths's groundbreaking movie *Birth Of A Nation*, 1915. "...he mastered the stereotypically grotesque, boggle-eyed look of surprise that would have been the pride of any minstrel show."

3

black heat

1920–1940

AVENUE MONTAIGNE, PARIS, 2 OCTOBER 1925. The Theater des Champs Elysées, set amid a promenade of luxury hotels and exclusive couturiers, was struggling to make ends meet – an anomaly in an area that was all about money. But help was at hand. That night the atmosphere crackled with anticipation of the debut of the dancer with the electric body and the cinnamon skin. With her hair pressed flat as a swimming hat and slicked shiny as Bakelite, and naked but for a pair of satin panties covered in pink flamingo feathers, Josephine Baker, the 19-year-old washerwoman's daughter from St. Louis, took to the stage for the premiere of *La Revue Nègre*, and the audience lost their minds in a cacophony of high-pitched howls of appreciation. As bug-eyed journalists gazed upon the spectacle, they began pre-cooking their adjectives for the morning reviews – "savage," "exotic," "animal," "jungle," and "Livingstone" would all be served up. Europe's "imagined Africa" came to Paris that night, and instantly a new star was born.

The 1920s and 1930s were a golden age for black beauty that witnessed a new wave of superstars break into the mainstream, propelled by the energy of jazz and gospel. Blackness became hip as Josephine Baker, Paul Robeson, Nina Mae McKinney, Fredi Washington, Hattie McDaniel, Billie Holiday, and film director Oscar Micheaux ushered in new aesthetic paradigms.

In the Roaring Twenties, Harlem and Paris became twin epicenters of a vibrant music scene fronted by a bevy of black beauties. It had "the world's most glamorous atmosphere," said Duke Ellington when he first arrived in Harlem in 1923. Manhattan sophisticates flocked to the new culture zones, pulling up in their cars with their slicked-down hair and their white collars and long cigars, eager to rejuvenate their lame social lives. They came for the girls, the jazz and the razzmatazz. "I was never out of Harlem in the early Twenties," declared *Vogue* grand dame Diana Vreeland.

Clubs such as The Plantation, The Cotton Club, Small's Paradise, The Shuffle Club, and The Savoy played host to the era of the Afro-American chorusgirl and the all-black revue. In order to appeal to white patrons, the showgirls were exclusively light-skinned, or "high-yellar," with straight hair and Euro-style features. Dark-skinned dancers never made the final call – no matter how talented or beautiful. When Josephine Baker joined the musical *Shuffle Along* in 1921 she had to "pale-up" in order to blend in with the skin-tone of her co-dancers. For black male performers in the troupe this aesthetic was reversed, for men of color, non-sexualized by the prevailing culture, were chosen for their dark – i.e. ugly – skin.

Paris, with its post-war mood of optimism and economic prosperity, became a bubbling metropolis enraptured in a love affair with imported Afro-American culture. One such import was the dance craze the "Black Bottom," which refocused white attention on the eroticized stereotype of the black female "superass" for the first time since the Hottentot Venus back in 1810. Phyllis Rose in *Jazz Cleopatra* describes how she was mesmerized by Josephine Baker's rear action. "She handled it as though it were an instrument, a rattle, something apart from herself that she could shake ... With Baker's triumph, the erotic gaze of a nation moved downward: she had uncovered a new region for desire." This "new region" was in fact an old one, reheated for the times.

HARLEM NIGHTS
The showgirls of The Cotton Club in full swing. The dancers were selected according to the lightness of their skin color.

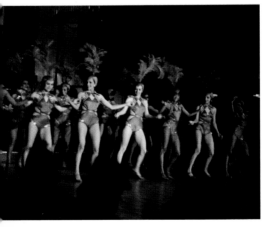

THE DANCER
The inimitable Josephine Baker was known for her electric moves, her supernatural "skull-cap" hairdo and the jungle stereotypes incorporated into her act. Behind the scenes she rubbed her body every day with half a lemon to lighten her skin.

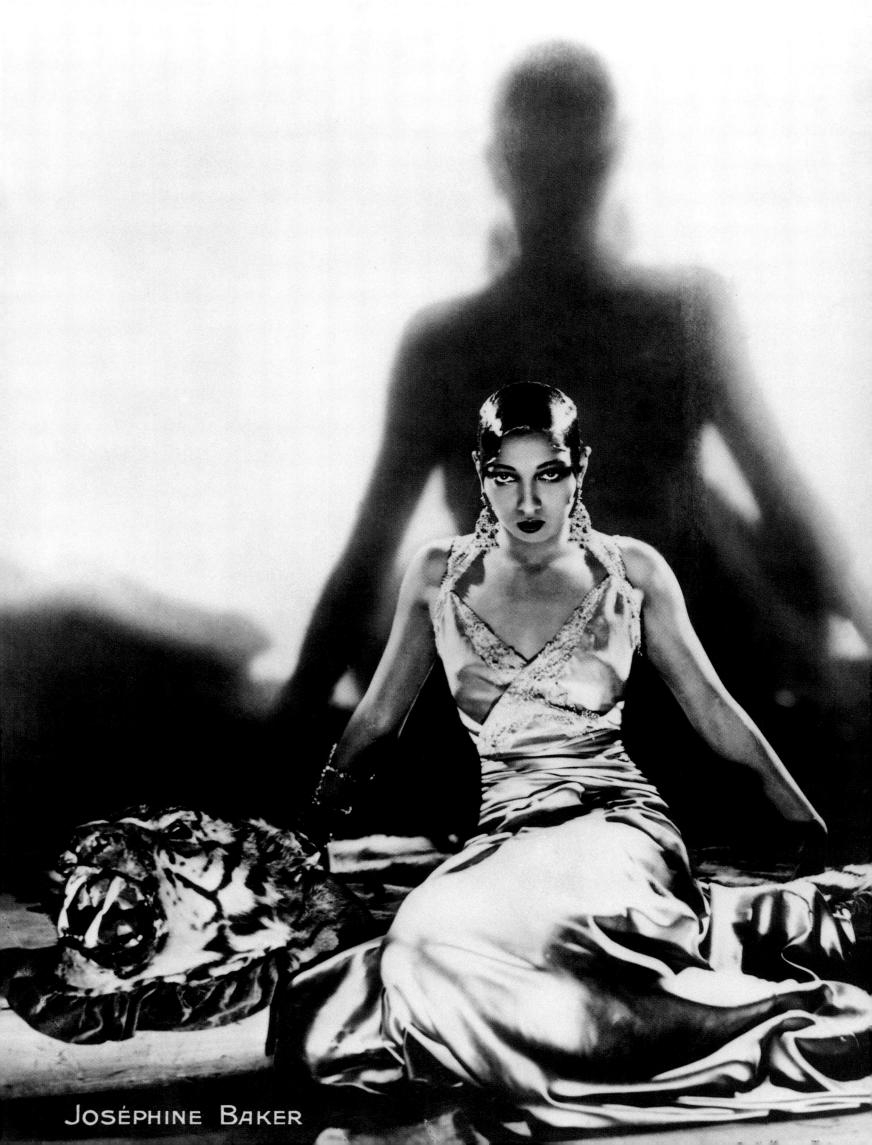

JOSÉPHINE BAKER

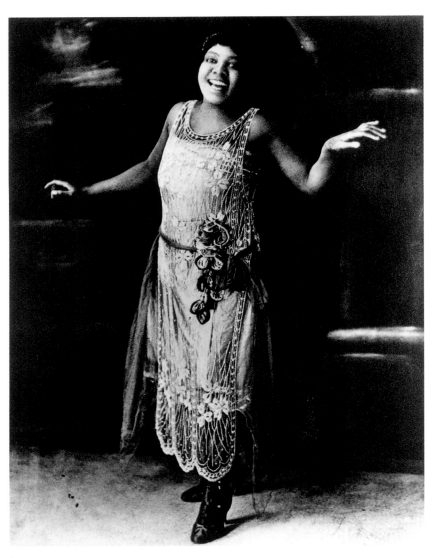

BEAUTY AND THE BLUES
Bisexual blues songstress Bessie Smith. She was known for her range of hairstyles, from horsehair wigs to straightened styles, to flamboyant hats.

The popularity of black beauty coincided with the color black becoming fashion's favorite hue. "Black remains – even when we are told black is démodé – always becoming, always distinguished," stated *Vogue* in March 1927. Was this a subliminal ode to black skin? Did it illuminate the secret desires of whites to be black?

Hair-straightening had become routine among black women – as common as high-heeled shoes. Indeed, the women who retained their curly Afro hair were often the ones who were considered unusual. Blacks copied the hairstyles of white celebrities straight from the silver screen and from newspapers and magazines. The most popular style was hot-combed hair, slicked back off the face and worn flat against the skull, or dropped short into a bob with a centerparting. Others used a heated curling iron to transform straightened hair into a cluster of swirls.

Josephine Baker devised her own unique hairstyle. She wore it short, straightened and smoothed against her skull, with Medusa-like curls framing her face, and applied egg-white to give it its high sheen and stiffness. The result was third-category hair – not white, not black, but simply spectacular. At her Paris debut every jaw in the audience dropped at the sight of it. "Is it real hair, or is it painted on?" they gasped. "Her hair had been done ... like a Greek boy's," said Diana Vreeland, "and pressed into her flat black curls were white silk butterflies. She had the chic of Gay Paree."

Baker also experimented with make-up. She used kohl on her eyes and adopted the Islamic fashion of applying henna to her hands, although she abandoned it when she discovered that it smeared her outfits. She even considered permanently tattooing her lips red to save time when doing her make-up, but decided against it when she realized how painful it would be.

But lurking in the background was a sinister and ever-present reminder that success for the black female artiste often came at the expense of her ethnicity. "I had to succeed," she said. "That's why I spent 30 minutes each morning rubbing my body with half a lemon to lighten my skin and just as long preparing a mixture for my hair. I couldn't afford to take chances."

Wigs and hairpieces remained in vogue. Bessie Smith continued the legacy of bisexual blues singers and their horsehair wigs, though she also sported an array of flamboyant hats. She later switched to wearing her own hair in the fashionable slicked-back style. Chorusgirl Florence Mills

pushed back the barriers of style in the mid-1920s when she took to the Broadway stage in a high-top, blond Afro wig. It was a bold crossracial juxtaposition of Africa meets America. This fusion of styles was spectacular enough to entertain and 50 years ahead of its time in its promotion of the Afro wig, which was not due until the late 1960s.

In 1932 Marlene Dietrich reciprocated in the movie *Blonde Venus*, in which she appeared in a nightclub scene as an "Africanized blond," wearing the same piece of headgear as Mills.

In the 1930s Billie Holiday opted for subtlety when she wore a gardenia in pulled-back straight hair. Allegedly, she first adopted her trademark look to hide a section of scalp that she had burned accidentally. She curled her short hair herself with a can of Sterno and a curling iron "to the point where her scalp sizzled," said press agent Greer Johnson. She boosted her short hair with a hairpiece that was prone to fall off when she got into her numerous fights. She was inconsistent about wearing it. "If you come out for one set with your hair long, and then the next with your hair short, and then again with it long, they're going to catch on," warned husband Louis McKay in *Wishing on a Moon – The Life and Times of Billie Holiday*. She'd just laugh and say, "It's my hair; I paid for it."

In July 1939 "Strange Fruit" was at number 16 in the charts, and Lady Day looked set to become a legend. The torch chanteuse whom Duke Ellington dubbed "the essence of black cool" began her career singing in the Harlem clubs of the early 1930s, and soon she was performing with the jazz combos of the day. Her light skin-tone caused problems with promoters who thought audiences might think she was white. When she played New York's Fox Theater with Count Basie's all-black band, she had to "blacken-up" with dark grease paint.

Holiday's barrel-bodied frame made her an unlikely sex symbol at a time when the only roles for big black women were as Hollywood's asexual mammies. Yet the music and performance tradition allowed her to prove that "big was beautiful." "She was one of the most beautiful women I had ever seen," said pianist and friend Jimmy Rowles. "Watching her was like watching a dream walk through the room.'

Unprocessed hair was the norm for black men until the early 1920s, when they, too, began straightening. While black male icons such as Paul Robeson, Marcus Garvey, Robert Johnson, and Jesse Owens maintained short Afro styles, sophisticated jazzheads Cab Calloway, Count Basie, Louis Armstrong, and The Duke sported the slicked-back patent-leather look, smooth as dark chocolate. Calloway's Marcel Wave literally fell on to his face during his frenetic displays. These jazz pioneers elevated the concept of male grooming to new heights. They were always clean-shaven, the mustaches finely clipped, the hair perfect, the suits beautifully pressed. They put as much love into contriving their immaculate beauty as they put into performing their various tunes.

But it was the style known as "the conk," "process" or "do" that became the favored look of the 1920s for Afro-American males. It consisted of artificially straightened Afro hair, groomed to a white style – short on the sides and back, and coiffed higher on top. Like Florence Mills's Afro wig the look was a hybrid that occupied the furrow between races, fusing ethnicity with the

HAIR PIONEER
Roaring Twenties chorusgirl Florence Mills. She crossed aesthetic barriers by wearing a blonde Afro wig on stage.

SLICK SOPHISTICATE
Duke Ellington and
the jazz pioneers of
the Roaring Twenties
straightened their
hair and wore it
combed back for that
shiny bakelite look.

aesthetic transfer of Western styling, and it quickly established itself as a progressive, urbanizing status symbol for black males.

Constructing the conk involved a sometimes painful initiation ceremony. Afro hair was chemically straightened with a home-mixed recipe called congalene – a caustic sauce made from lye, potatoes, and raw eggs. The thick cream was combed through the hair and left on for several minutes to take effect. The process was routinely painful, as the cream reacted with the scalp, causing burning, as illustrated in the famous scene in the Spike Lee movie *Malcolm X*. The substance was then shampooed out, leaving the hair permanently straight, with a built-in lacquered sheen. It was then greased and styled.

The conk craze caught on with boxers, bluesmen, DJs, and preachers. The era saw black male grooming take on a feminine twist, as men fussed and worried over their hair, spending an inordinate amount of time and money preening. The conk was a high-maintenance do – difficult and expensive to keep up, and black men slept with turban-like head wraps, called "do-rags," to keep their coifs fresh. This was women's territory: they had been going to bed wearing hairnets for years.

Before salons came into being, hot-combing and conking were homespun hairdos, administered via makeshift kits and assisted by mother, sister, or skilled friend. By the late 1920s the burning smell of sizzling scalps came wafting out of black neighborhoods, as hair boutiques and conking shops sprouted up in Harlem, Boston, Chicago, and other local diasporas, their window displays advertising "conk-experts." Entrepreneurs began manufacturing straightening creams with "anti-ethnic" sounding names such as Kinkilla and Kink-No-More.

While Americans were going conk-crazy, the wearing of dreadlocks first came to prominence in Jamaica in the 1930s, as a component within Rastafarianism, the religion founded by Tafari Makonnen, otherwise known as the Emperor Haile Selassie I of Ethiopia. Rasta fuses religious prophecy (adherants believe Haile Selassie to be the living god, as predicted by Marcus Garvey) with Pan-Africanism, through the Black Power manifestos of Walter Rodney and Garvey, with the political symbolism of hair, and, in later years, with the defiance of reggae music. Rastas follow the teachings of Leviticus 21:5, and thus are forbidden to comb or cut their hair. Left to its own devices the hair forms into dreadlocks, which, for Rastas, are also symbolic of Selassie's "Conquering Lion of the Tribe of Judah", which features on his flag.

The origin of the style is the subject of some dispute. Some experts contend that it was appropriated from pictures of Africa's Mau Mau, whom Rastas admired for their fight against English colonialism, while Barry Chevannes in *Rastafari – Roots and Ideology* maintains that it originated in Jamaica among a Rasta group called the Youth Black Faith.

Aesthetic transfer developed a stage further in 1928 when the white actress Clara Bow's "bee-stung" lips started a vogue, eulogized as they were for their fullness and shape. Suddenly full lips were sanctioned as beautiful – but only within a white face. Simultaneously the fullness and

SHADE OF THE LADY
Billie Holiday on
stage. When she
played the club
circuit her light skin-
tone often caused
problems with
promoters who
thought audiences
might think she
was white.

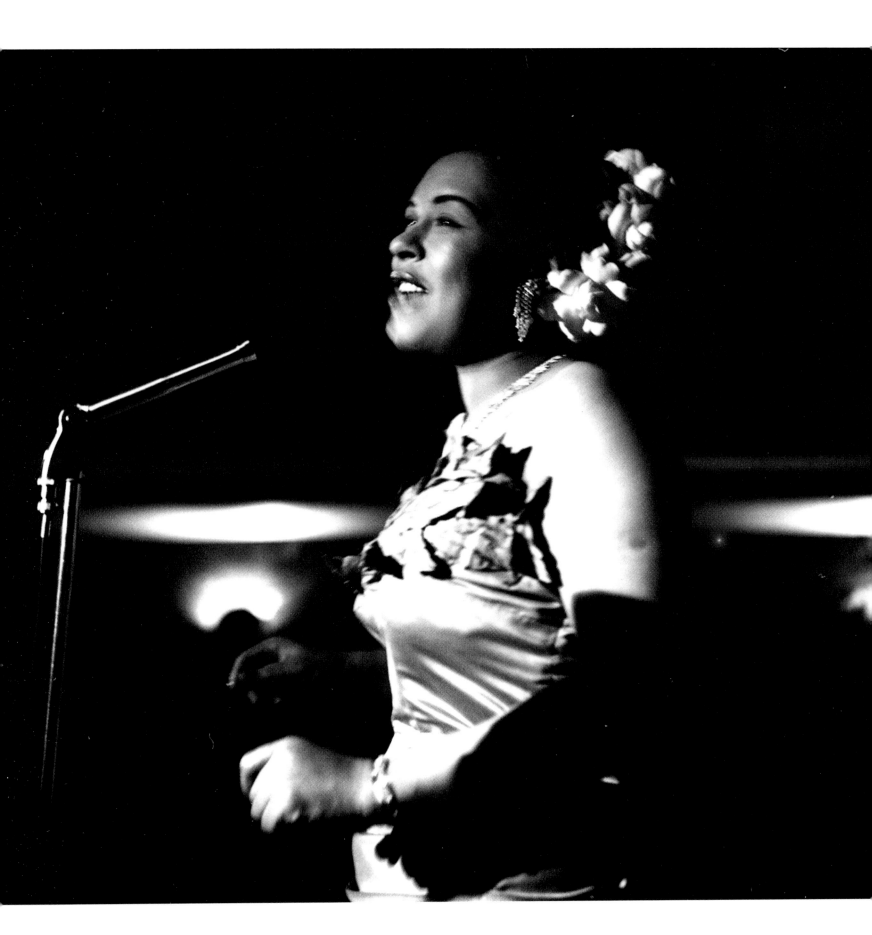

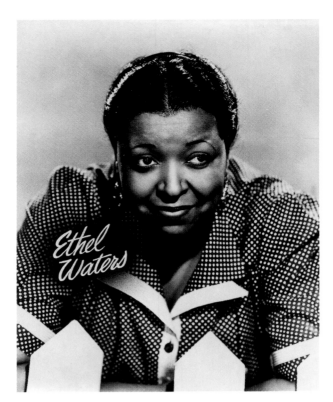

Skin Wars
Singer and actress
Ethel Waters. She
became embroiled in
an argument over
skin-lightness with
rival Josephine
Baker.

shape of black lips – derided and declared ugly during a hundred years of "coon" images and minstrel shows – continued to be caricatured throughout popular culture.

In 1923 dark skin also became the subject of aesthetic transfer when Coco Chanel popularized suntanning. For centuries porcelain skin had been the paradigm of beauty and chastity, and right until the 1920s, tanned white skin was associated with poverty and servitude. Only peasants had suntans, as they toiled outdoors, and they also had dark hands from laboring, whereas the privileged classes remained pale thanks to their position as masters who resided in the shade. Coco Chanel, a sporty outdoors type, began the trend for facial tanning in 1918, and soon brown skin became equated with notions of health and vitality. By 1923 the rich were flocking to the French Riviera and the beaches of the South of France to brown up. By 1927 we had suntan oil, and by the end of the decade pale skin was out for good. Brown was beautiful – but again, only on a white face.

As whites exhibited brown ambition, aesthetically insecure blacks continued to "lighten-up" via the use of skin-bleaching creams. Each group was chasing a look midway between the two: people wanted color, but not "too much." Superblack was still regarded as the ugliest hue in the beauty palate. Too extreme to be sexy.

"A white producer had visited our show looking for someone to use in a film, but none of us would do," said Josephine Baker in her autobiography. "He wanted someone extremely dark-skinned to play the part of a harem girl. Our girls, who were the most beautiful café-au-lait color imaginable, were furious. Some of them even had blue eyes and naturally blond hair, due to their mixed blood. I was gradually learning that there was discrimination between blacks as well: the darkest versus the lightest, pale skin versus black. It made me want to turn and run. Wasn't there any place in the world where color didn't matter?"

As well as being rejected for not being black enough, the teenage chorusgirl was also turned down for not being light enough when she auditioned for the vaudeville troupe The Dixie Steppers in 1918. "To the whites I looked like chocolate, to the blacks like a "pinky" [mulatto]: there was no place I belonged."

In 1924, while dancing at the downtown Broadway club The Plantation, Baker became embroiled in her own private skin-war with resident blues singer Ethel Waters. The show director said that Ethel "was lighter and prettier." Then Baker said that Waters muttered something like "stupid darky" to her.

It was against this backdrop that Josephine was invited to France by show producer Caroline Dudley to appear in the famous *Revue Nègre*. Paris welcomed Baker, and after that legendary opening night, the world had its first black sex symbol. "What a wonderful revenge for an ugly duckling," said Baker.

As far as the Roaring Twenties were concerned, she was the star of the party, and everybody who was anybody flocked to see her – Cocteau, Einstein, Diana Vreeland … Le Corbusier even burst into tears at one of her shows. She received 2,000 marriage proposals and 46,000 fan letters in two years. For the first time ever, universal beauty had a black face.

The media's response to Baker's gravity-defying performances was bittersweet, for she was labeled both Venus and animal. The publication *Magazin Candide*, described her debut as "a return to the morals of primal times," while the critic Andre Levinson described her movements as "apelike," and imbued with a "wild and superb bestiality." But in the next breath he dubbed her "the black Venus." Simultaneously Picasso called her "the Nefertiti of now," and Ernest Hemingway pronounced her "the most sensational woman anybody ever saw – or ever will."

Portraying Baker as a jungle animal was a clever and carefully constructed gimmick masterminded by her various svengali managers and image-makers. Her alter-ego of "the African savage" drew its inspiration from the racist cliché of the black woman as a wild, libidinous creature.

This image was bolstered by her famous skirt of 16 bananas that she wore in 1926, as well as her jewel-collared pet leopard, Chiquita, which she paraded along the Champs Elysées for the Paris media. The whole effect was backed up by the graphic artist and collaborator Paul Colin, who created the promotional posters for Baker's shows. In time-honoured tradition he rendered black musicians with caricatured "coon" faces, with Baker inset as a primal, caged animal.

At first she was unwilling to play the role devised for her. When she was originally told she had to dance topless for her Paris debut, she threatened to quit and return home, but the 19 year old was badgered until she succumbed. Hers was a battle to be a success while retaining her dignity. "Since I personified the savage on the stage," she said, "I tried to be as civilized as possible in daily life.'

Baker understood the extent to which the role of the performing animal appealed to the "imagined Africa" and exotic fantasies of white Europeans, and so she played her audience, faking her jungle act, just as black dining-car waiters and Pullman porters faked "Uncle Tomming" to win better tips. "We were in that world of Negroes who are both servants and psychologists," explained Malcolm X.

Hollywood continued with its dual portrayal of the thick-bodied, asexual, superblack mammy as epitomized by Hattie McDaniel and Louise Beavers and the beautified, sexualized, light-skinned diva. Beavers, in fact, was required to go on eating binges in order to stay large for her mammy roles. She often lost weight during hectic filming schedules and had to be padded out. Academy Award-winning arch-mammy and *Gone With the Wind* star Hattie McDaniel – who reputedly earned a staggering $7,000 a week from a career playing maids – consistently starred opposite the quintessential white sex symbols of the day such as Jean Harlow, Vivien Leigh, Barbara Stanwyck, and Olivia de Havilland. She was the eternal ugly duckling who would never be a swan. Hollywood needed black, ugly, sexless characters as counterpoints for white women to define themselves against.

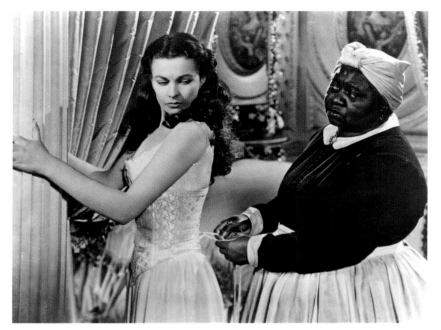

HOLLYWOOD'S NON-
BEAUTY
Academy Award-
winning Hattie
McDaniel in *Gone
With The Wind*,
1939. She earned
$7,000-a-week from
a career playing
wide-bodied, asexual
mammies opposite
white sex symbols
such as Vivien Leigh.

At the opposite end of the aesthetic scale, with her light skin, delicate frame and cute girl-next-door looks, 17-year-old South Carolina belle Nina Mae McKinney became Hollywood's first black female sex symbol when she graduated from the chorus line to star in *Hallelujah* (1929). She was the earliest paradigm of the mulatto-style diva so favored by a color-fixated Hollywood. Hers was the aesthetic they would promote as the quintessential racial example of black beauty throughout the movie-making century. Had the darker-skinned Ethel Waters – who was also up for the lead in *Hallelujah* – been given the part, the entire aesthetic basis of Hollywood's black leading ladies might have been significantly different.

Ex-convent girl Fredi Washington was the first to inherit McKinney's mantel. The ex-chorusgirl from Savannah, Georgia was very light-skinned, with naturally straight hair and green eyes. "You would never know she was Negro," declared Earl Conrad in *The Chicago Defender*.

The lightness of Washington's skin was a hot talking point throughout her career. Press releases described her as French- or Italian-looking. French millionaire Otto Kahn even tried to persuade her to pass for French in order to ensure her stardom. "I want to be what I am," she insisted. But what she was to Hollywood was the archetypal mixed-race femme fatale who tries to pass as white. Her most famous performance was as Peola in the 1934 movie *Imitation of Life*.

In 1933 she starred in *The Emperor Jones* with Paul Robeson. Love scenes between the pair allegedly had to be reshot with Washington looking distinctly darker, as movie executives were concerned that she looked too white in contrast to Robeson's dark skin, and that Caucasian audiences might think he was committing the ultimate sin of fraternising with a white woman.

In sharp contrast to the industry's light-skinned beauties, Hollywood was virtually a "mulatto-free" zone for black male actors. Apprehensions about black male sexuality meant that men of color were selected on the basis of their perceived "unattractiveness." They were dark-skinned, with overtly African features. Stepin Fetchit, Daniel Haynes, Willie Best, Mantan Moreland, Eddie "Rochester" Anderson, Clarence Muse, and tapdancer Bill "Bojangles" Robinson were all cast in roles as sexless servants and clowns.

The New Jersey-born actor and singer Paul Robeson provided one of the era's only exceptions to this rule, although, like Josephine Baker, it was Europe that proved to be the catalyst for his success. He moved to England in 1928, quickly establishing himself on the London stage playing *Othello* in 1930. A devastating ex-football pro, Robeson was built like a family-sized fridge, with a whiplash smile that was anything but icy. With his six-foot-three frame, African face and big, expressive features, he wasn't just a hunk, he was a slab, who was

THE GIRL NEXT DOOR
Doe-eyed Nina Mae
McKinney was
Hollywood's first
female Afro-American
sex symbol. Her
"mulatto-style"
beauty established
the aesthetic
blueprint for black
leading ladies, which
is still adhered to
today.

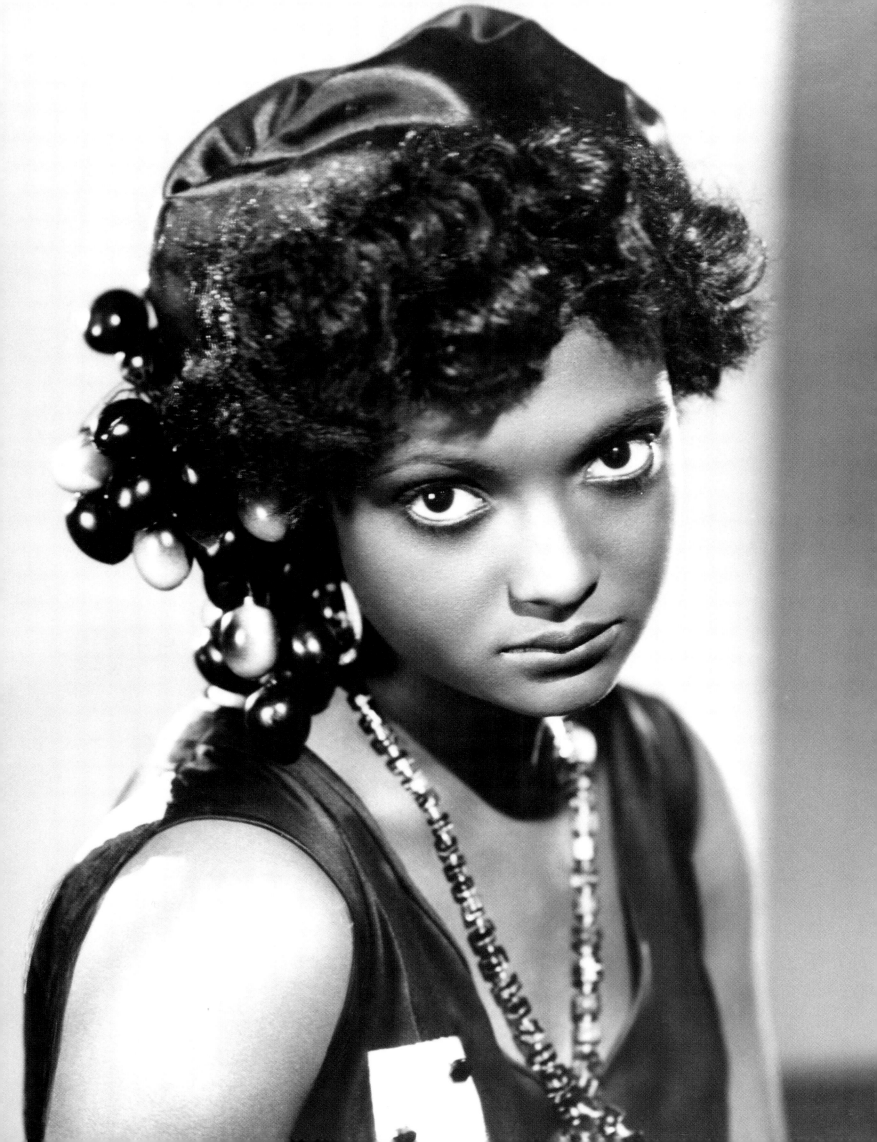

HOLLYWOOD
LIGHTSHADE
Fredi Washington
(right) with Louise
Beavers in *Imitation
Of Life*, 1934. She
was cast as the
archetypal mixed-
race femme fatale
who tries to pass for
white.

able to play virile, masculine roles in movies such as *The Emperor Jones*
(1933) and *Song of Freedom* (1938).

The independent black film scene of the 1920s and 1930s reacted against
Hollywood's scant portrayals of black beauty by promoting its own stars.
Director, writer and producer Oscar Micheaux headhunted actors from black
companies such as New York's Lafayette Players, and sometimes took them
directly off the street. They were handpicked according to their apparent
resemblance to white Hollywood stars – a marketing ploy he used to make
his movies more appealing to audiences and also to help sell them to
theaters. The comparisons were strongly emphasized. The fair-skinned Ethel
Moses was billed as "the Negro Harlow," Bee Freeman was called "the sepia
Mae West," Lorenzo Tucker "the black Valentino," and Slick Chester "the
colored Cagney." In movies such as *Temptation* (1936) and *God's
Stepchildren* (1937) these early black sex symbols operated in a parallel
universe, outside the Hollywood mainframe, and became stars within the community.

Unlike Hollywood, Micheaux depicted black male characters in beauty roles with sexual
personalities, and in doing so he provided a focal point for the uncatered-for sexual gaze of
black women. He also cast people of color in challenging and diverse roles that went beyond the
stereotypes. In *10 Minutes to Live* (1932) he inverted the prevailing color-caste hierarchy by
casting a light-skinned beauty as villain.

However, the director was criticized for perpetuating many of Hollywood's prevailing
aesthetic stereotypes. Most of his leads were in fact played by light-skinned beauties, just as
they were in Hollywood, and Donald Bogle noted what he termed the "shameless promotion of
the world of hair-straighteners and skin-lighteners."

MAN MOUNTAIN
Film-making's first
male Afro-American
sex symbol, Paul
Robeson 1933.

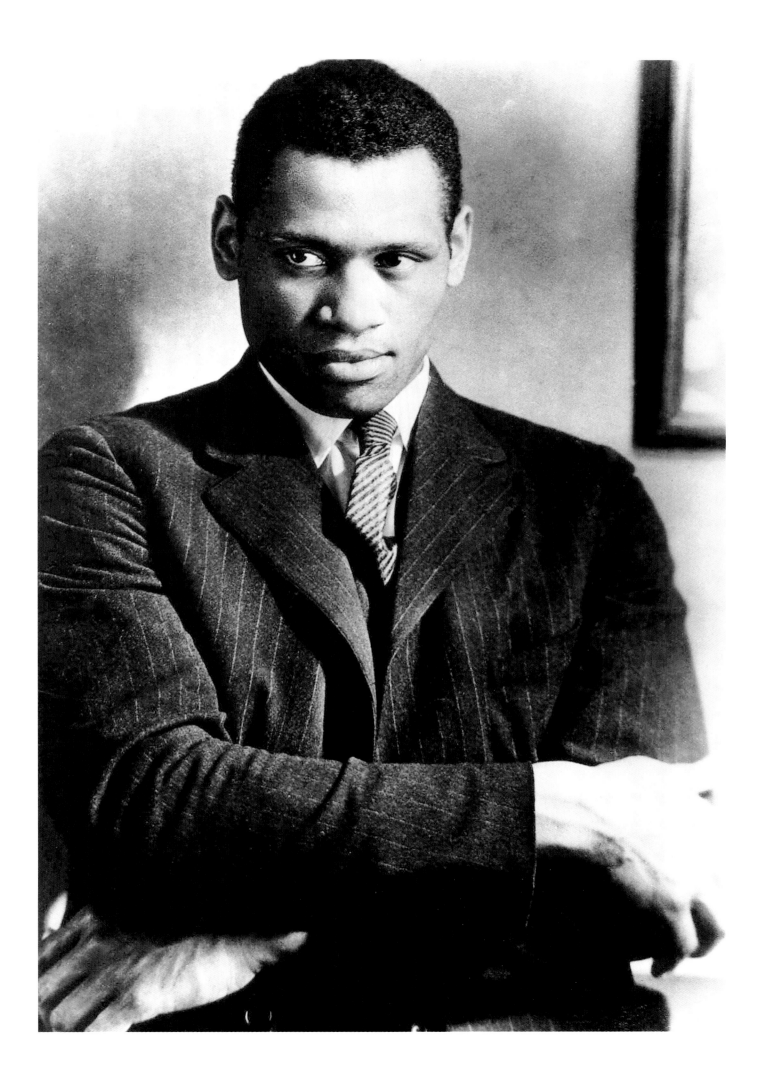

4

black venus

THERE WAS A PERIOD IN THE 1950s when any voluptuous black female sex symbol was dubbed "the black Marilyn Monroe." Dorothy Dandridge was so titled, as was Joyce Bryant, the singing sensation from a San Francisco family of devout Seventh Day Adventists. Her background was at odds with her reputation as a smouldering sex siren, and her records were deemed too raunchy for radio, but she was too nervous to worry about that one night in 1953 when she was due to appear on the same bill as the legendary Josephine Baker. Looking for a way of setting herself apart from the superstar supreme, she cottoned onto a gimmick. She poured a tin of silver radiator paint over her straightened hair, and in less time than it took for the gunk to set in, she had reinvented herself as "The Silver Goddess." Complete with matching skintight silver dress, floor-length silver mink and silver nails, she took to the stage that night like the glittering vision of a futuristic mermaid. "I stopped everything," she said. The press gasped, she stole the show, and her career soared into the stratosphere.

The 1940s and 1950s brought a fresh injection of color into the beauty landscape. As rock 'n' roll supercharged the airwaves, silver chanteuse Joyce Bryant lined up next to Dorothy Dandridge and Lena Horne, while the first black fashion models Ophelia DeVore, Dorothea Towles, and Helen Williams broke through. Black men also had the beauty call in the form of Little Richard, Chuck Berry, and Harry Belafonte. Meanwhile the invention of television provided a new conduit for black beauty, and the first Afro-American lifestyle magazines promoted the look to the community nationwide.

In contrast to the razzmatazz of the 1920s and 1930s, the mood became serious. The Second World War provided a reality check for the times, and the winds of change swept across America as the government supported de-segregation and fuller employment opportunities for Afro-Americans. Black faces began to permeate the mainstream like never before, as Jackie Robinson and Ray Campanella made it into major league baseball, and opera singer Marian Anderson and ballerina Janet Collins debuted at the Met. In 1955 the US government dispatched Federal troops to Little Rock, Arkansas to enforce the de-segregation of public schools and in Alabama, Rosa Parks sparked off the Civil Rights Movement by refusing to give up her seat on a bus. Black rage focused on Mississippi, where 14-year-old Emmett Till was alleged to have committed the fatal act of looking at a white woman and letting out a whistle. He was found later in the Tallahatchie River with a bullet in his head and his testicles missing.

The period witnessed the second wave of Afro-American migration to northern cities. Following on from the first urban settlers, the new arrivals made themselves over for the New World. People continued to attempt to pass for one thing when really they were something else. Light-skinned blacks passed for whites, Jews passed for non-Jews, European immigrants passed for natural-born Americans, gays passed for straight, and brunettes passed for blonds. Big women wore corsets to achieve that hourglass look and false hairpieces were sold out of boxes like rugs of hairy candy. People were faking it in a multitude of small ways in order to assimilate, and every section of the population made strenuous efforts in pursuit of the ideal.

SMOULDERING
BEAUTY
The quintessential
Dorothy Dandridge.
"She holds the eye
like a match burning
steadily in a
tornado," said one
critic.

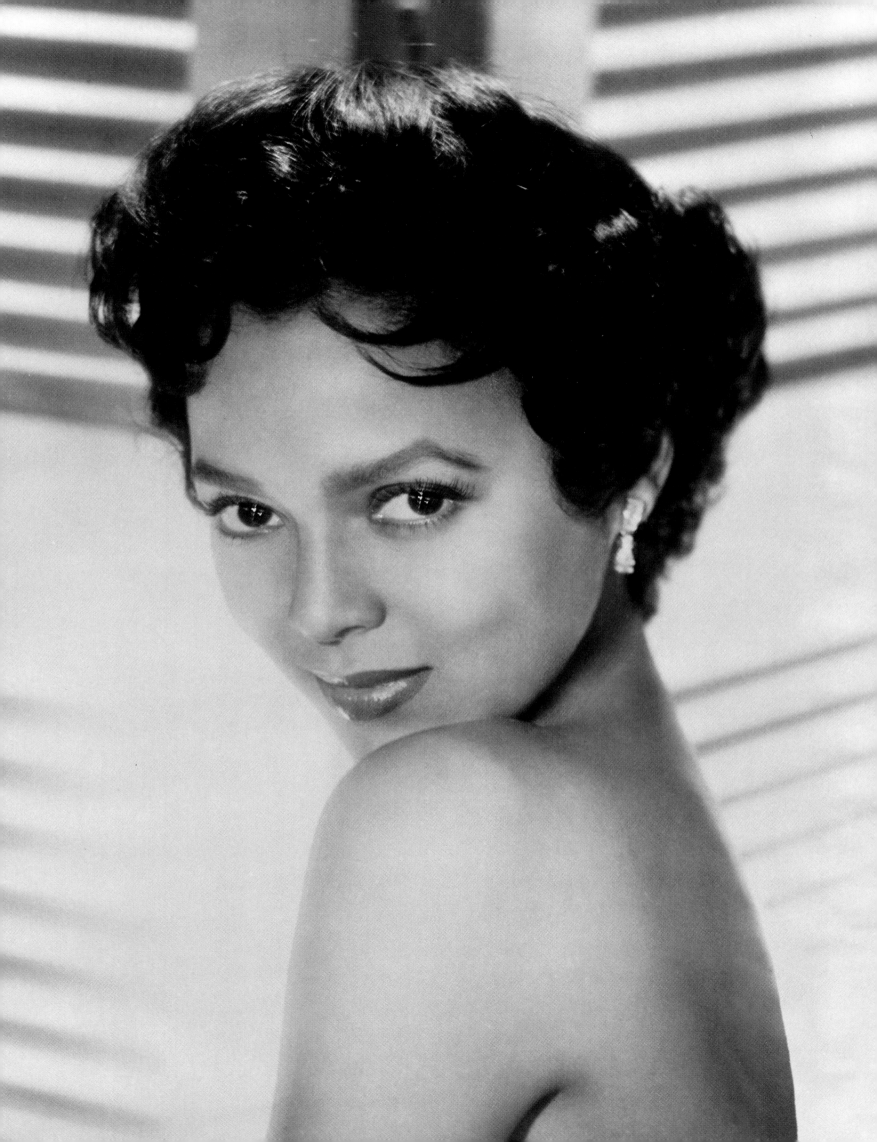

Beauty was increasingly seen as a product of nurture rather than nature – a commodity to be acquired via cosmetics and a certain work ethic. "There are no ugly women, only lazy ones," said cosmeticist Helena Rubinstein. While blacks were vilified by the Nationalists for their chemically constructed, white-influenced beauty preferences, whites themselves, without the constricting chains of 400 years of institutionalized aesthetic shame to contend with, were free to be as cosmetically constructed as they liked. Marilyn Monroe had her nose re-shaped, her hair dyed blond, and her jaw realigned. She made a complete mockery of the romantic ideal of "natural" beauty.

The vogue for straightened hairstyles and lighter skin continued apace. With no make-up ranges yet available for dark skins, black entertainers often used white brands that made them look pale. In the early 1940s MGM called on cosmeticist Max Factor to devise a shade especially for actress Lena Horne. He invented a hue called "light-Egyptian," which was also used on white actresses who played mulatto roles. This hue was in sharp contrast to the burnt-cork first used by the minstrels of the 1820s.

New York dermatologists reported increases in the numbers of black women coming to see them because they disliked the darkness of their skin. This would have brought a smile to the faces of the manufacturers of skin-bleaching creams who were busy using the Afro-American lifestyle press to propagate the beauty of lightness. "Few men can resist the charm of a honey-light complexion," promised a light-skinned model in a 1952 ad for Nadinola Bleaching Cream. Another, for Black & White Bleaching Cream (1949), said, "Those moments when he tenderly draws you closer for your triumph before his admiring eyes, that's when shades lighter skin becomes a priceless treasure."

In 1950, at the black debutantes ball at New York's Waldorf Astoria Hotel, every female head was a "process," and the most popular girls had the lightest skin. In contrast to the short, flattened, straightened styles of the past, the look became longer, fuller and more bouffant-inspired. Eartha Kitt, actress and comedienne Pearl Bailey, jazz-pianist Hazel Scott, opera singer Marian Anderson, dancer/choreographer Katherine Dunham, and singers Carmen McCrae, Della Reese, Mahalia Jackson, and Clara Ward all adopted the thicker coif. Joyce Bryant's innovative silver hair – which sparked off a brief trend among the most avant-garde women of color – eventually began to fall out owing to overprocessing.

This focused the growing demand for more professional hair and beauty advice, products and aftercare, which fostered a boom in the black salon industry within Afro-American conurbations across the United States. In London the first black hair-straightening salons were opened by Afro-Caribbeans in the mid-1950s, catering for the first immigrants from the Commonwealth nations.

Straight-haired wigs were cut according to popular white styles such as the "beehive" or "bob" and were still the rage with black female entertainers such as Sarah Vaughan, La Vern Baker, Ella Fitzgerald, Dinah Washington, and seminal girl-bands The Chantals and The Shirelles. Black men continued to appropriate traditionally feminine grooming habits as they, too, began to wear wigs. The tour-valet and musician Gorgeous George was known for his blond

THE RIGHTNESS OF
LIGHTNESS
Ads for skin-
bleaching creams
such as Nadinola
actively encouraged
aesthetic insecurity
among dark-skinned
blacks.

SPECIAL INTRODUCTORY HALF-PRICE SALE!
Get $2 worth of NADINOLA'S amazing
beauty benefits for just $1

NADINOLA
DeLuxe Bleaching Cream

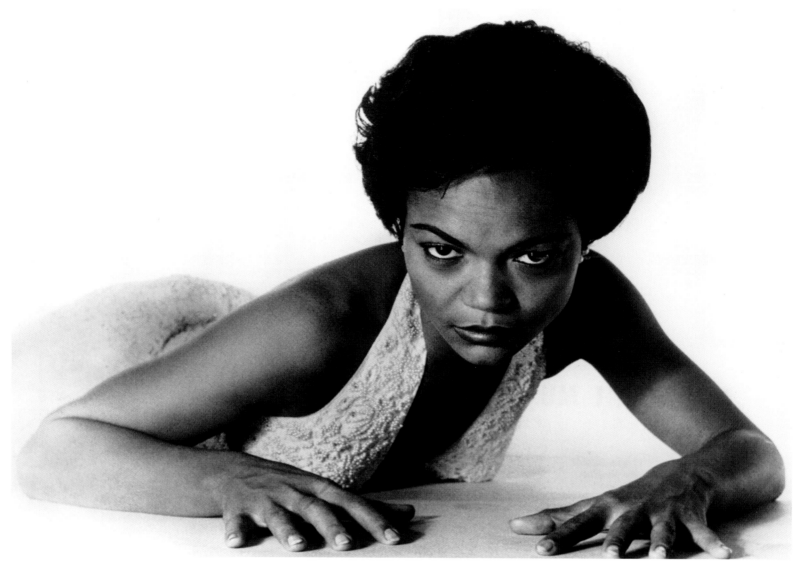

CATWOMAN
The feline charm of
Eartha Kitt, complete
with her bouffant
fluff. Her act
sustained similar
animal stereotypes
to Josephine Baker.

bouffant, and on the sleeve of one of his early recordings Little Richard is sporting a wig pulled so low that it covers his eyebrows.

Wigs and straightened hairstyles were an institutionalized part of modelling from as early as the 1940s. Model agencies followed the directive of their advertising and fashion clients in not accepting the Afro hair of their black models. The profession has always regarded African hair as an ugly puzzle, and the straight-haired Euro-centric look was demanded in order for them to crossover, just as it was in the music industry. Dorothea Towles and Helen Williams were the first to be affected by the oppression of white beauty values. "I thought, here I'm ready for a chance of a lifetime, and my hair is going to hold me back," said Towles. And so she "fixed" it by means of straightening. From this moment on, almost the entire lineage of black models has been required to conform to this all-pervasive rule.

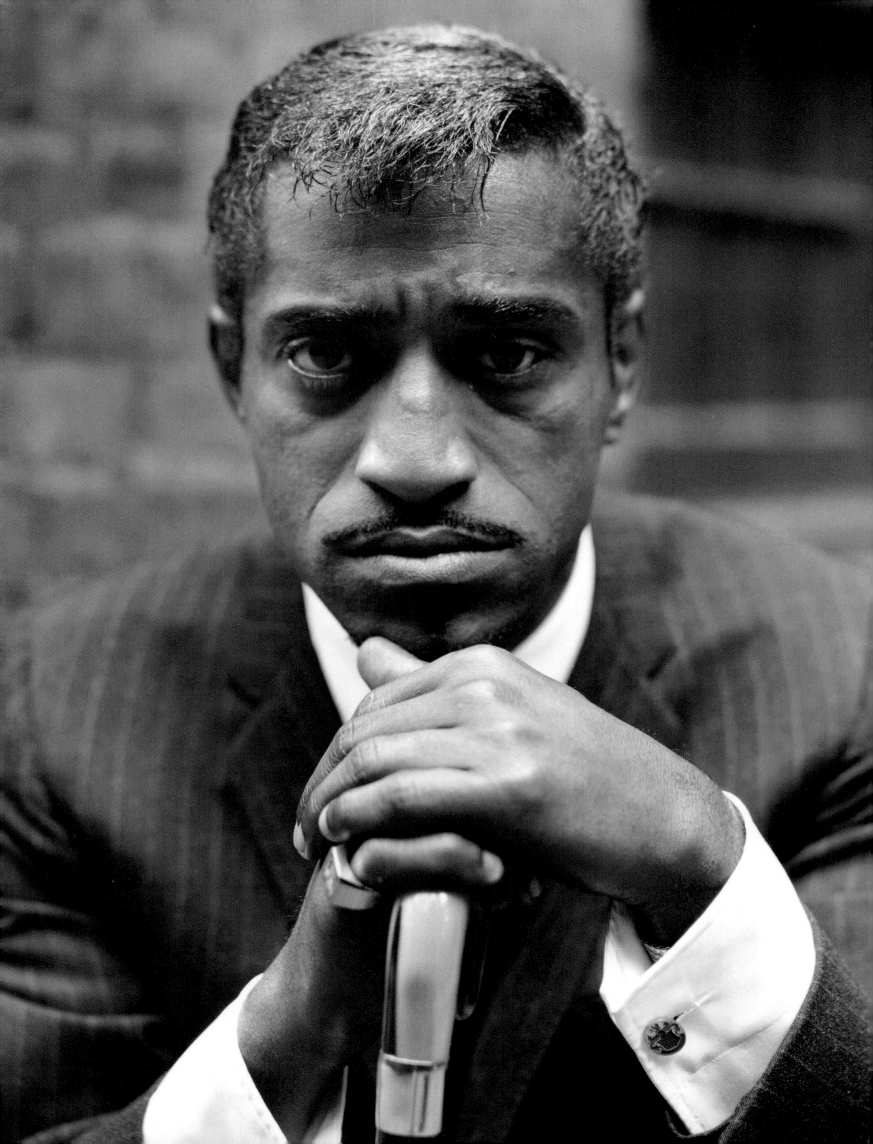

The 1950s eulogized the blond as the epitome of Western beauty, bolstered by the arrival of the revolution in home-dyeing, launched by Miss Clairol in 1956. It gave women the ability to color their hair easily at home, and they rushed to reinvent themselves as bottle-blondes for the New Age. "Does she, or doesn't she?" became an immortal mantra. "If I've only one life, let me live it as a blond!" yearned the slogan for Lady Clairol. These ads were not conceived with blacks in mind, but the overwhelming force of blond ambition was indiscriminate in marinating the heads of anyone within its reach, and Afro-Americans became early adopters. The era produced the first "black-blondes" – Joycen Bryant, model Dorothea Towles, and songstress Dinah Washington – the latter two of whom appeared on the cover of the Afro-American lifestyle magazine *Sepia* in 1959, for its November and December editions respectively.

Towles went plantinum after it was suggested to her by French fashion designer Pierre Balmain. "I got it done at Jean Clement's salon in Paris," she said. "I'm light-skinned, so the hairdo made me look like a natural blonde with a tan. Paris had never seen anything like it. I stopped traffic on the Champs Elysées."

At the same time – 30 years after Marcus Garvey first produced a line of black dolls for children of color – Barbie was launched. Barbie Number One, as she was called, reflected the beauty law of the real world – there was blond Barbie and there was brunette Barbie, but the tracks ended there. Black beauty didn't exist in Barbie world. It was just like life.

Throughout the 1940s and 1950s the conk maintained its curve as the hairstyle of choice for black male musicians. Jackie Wilson, Sam Cooke, Jimi Hendrix, Little Richard, Billy Wright, Ike Turner, James Brown, Chuck Berry, Fats Domino, Nat King Cole, Sammy Davis Jr., Muddy Waters, Bo Diddley, Howlin' Wolf, Miles Davis, and Marvin Gaye all had "the process." With his chocolate skin, Eurasian-style eyes, and just-woke-up-in-the-morning face, sophisticated crooner Nat King Cole wore the contented grin of a cat with a full belly. This eternal picture of casual bonhomie had a conk that was perfectly formed and smooth as a cooling lava flow. It was better than Bing Crosby's. Elsewhere, Sammy Davis Jr.'s was a match-up with the coifs of his Rat Pack buddies Dean Martin and Frank Sinatra. This crew did everything the same – same hair, same clothes, identical smoking style (cigarettes held between the same two fingers of the same right hand). Davis and Sinatra even slept with the same woman – Ava Gardner.

Davis's face was a construction of racism and pure bad luck. He was unlucky when he lost his left eye in a car accident in 1954, and he owed his boxer's nose to his days in the army when Southern racists beat him up every two days, breaking his nose so many times that it became permanently flattened. If a face told a story, then Davis's was a mini-series. "God...hit him in the face with a shovel," commented the *New York Daily News* columnist Bob Sylvester.

With their razor-like pencil mustaches and thick "mutton-chop" sideburns, Chuck Berry and Little Richard looked like a duo from the same band. Until these rock 'n' rollers arrived on the scene most conks were just conks – unspectacular copies of white styles. But these two pompadoured poseurs pioneered the "superconk," which went for fullness and height. They epitomized the age of extraordinary hair, when size mattered and cantilevering curvature was

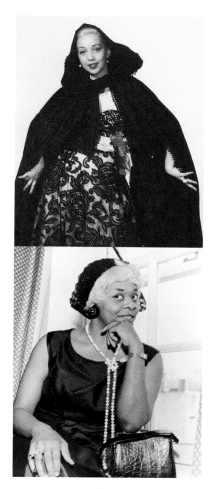

BLACK & BLONDE
Model Dorothea Towles *(top)* and songstress Dinah Washington *(bottom)* were among the first ever black-blondes – forerunners to hip-hop's Lil' Kim and Mary J. Blige.

Left:
THE FACE TELLS A STORY
Sammy Davis Jr.'s face was a construction of circumstance. He lost his eye in a car accident in 1954, and his boxer's nose was the result of repeated beatings from Southern racists during his days in the army.

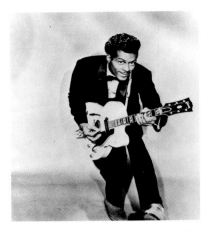

BIG HAIR DAYS
Chuck Berry was one
of the first black
male entertainers to
have long hair, in the
popular style known
as "the conk."

PIONEER OF MALE
BEAUTY
Little Richard blurred
gender lines and
color lines as the
first man to wear
women's make-up.
Also known for his
superconk, his style
influenced a
generation of
performers, from
Bowie to Prince.

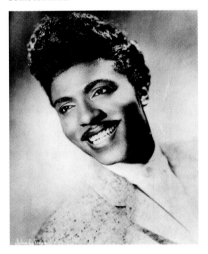

everything. Chuck Berry's head was an oilslick. Big hair went along with a big personality and a big sound. It was the ultimate status symbol, equated with having a bigger penis or driving a bigger car than your peers. High hair denoted three very important things: one – that the wearer had the time to lovingly cultivate it; two – he had the cash to keep it right; and three – he had the brazen confidence to carry it off.

Little Richard was the first male diva, setting new standards for male beauty and sexuality. He wore make-up when men didn't. He had long hair when men didn't. He was bisexual when this was still taboo. He was better at beauty than most women and in his early career he wore dresses onstage. His look blurred gender lines and color lines. He was the most radical male beauty of his era, and daddy to an entire generation of artistes, from Bowie to Prince.

And he wasn't shy in letting the world know just how gorgeous he was. Almost a decade before Ali proclaimed, "I'm so pretty," Little Richard, in a precursuor to "Black is beautiful," said "I'd stand on stage and tell them how beautiful I was, and they'd agree with me."

Hair was the center of Little Richard's universe. He was vertically coiffed when Don King was still nursing a mini-Afro. His pompadour was a supernatural status symbol he deliberately sculpted to be more out-of-this-world than anybody else's. "I had to be different for people to know me," he said. "Other guys looked more macho, so I made my hair higher and wore make-up so people didn't know where I was coming from." Richard's coif – originally influenced by the performer Billy Wright – had more in common with the bouffants of Elizabeth Taylor or Marilyn Monroe than anything a man was wearing, but it even outdid those. It wasn't just a conk, it was more like several conks layered one on top of another, and the curling arc of its bouffant splendour was like a frozen tidalwave, caught at the apex of its cantilever.

But not everybody was happy about the conk craze, especially white Southerners. When he played El Paso in Texas, the police arrested the pompadoured performer for having long hair, and warned him that they were also after Elvis. But Richard's conk was somehow beyond the law, and getting rousted for having long hair simply made him the first hippie.

Conking was also seen as a threatening sign of black attempts to assimilate. Around the same time, during Marvin Gaye's early tours with Big Joe Turner and Etta James, the entourage "...ran into all kinds of racist shit," said Gaye's friend and co-hort, Reese Palmer. "They didn't like the way we wore our hair."

Malcolm X didn't like it either. He had his first "process" in Boston in 1940, during his days as a petty criminal; "...the transformation, after a lifetime of kinks, is staggering," he recalled in his autobiography. But later, with the awakening of his political consciousness, he was scathing about the days when he was conk-crazy. "This was my first really big step toward self-degradation," he said, "when I endured all that pain, literally burning my flesh with lye, in order to cook my natural hair until it was limp, to have it look like a white man's hair. I had joined that multitude of Negro men and women in America who are brainwashed into believing that black people are 'inferior' – and white people 'superior.'"

As the militant leader reverted to "natural" he developed an affinity with black stars who also resisted the trend for chemical processing. "One of the reasons I've especially admired some of

them [black entertainers] like Lionel Hampton and Sidney Poitier," he said, "is that they have kept their natural hair and fought to the top." Ornette Coleman, Sonny Rollins, folk singer Odetta, Harry Belafonte, and the young Bill Cosby, star of *I-Spy*, also featured in the rollcall of Afro-headed loyalists. Odetta was the first songstress to break the mold of the straight-haired, wig-wearing female entertainer that had set the standard since the turn of the century.

At least a decade before the Afro became a symbol of 1960s race-pride, early style innovators were already sporting the look. The model Pat Evans was wearing Afros as early as 1957, while a Chicago crew called The Rangers Gang sported an afro-bouffant called the Ranger Bush. In 1959 the Black Panther Huey Newton recalled his student friend Richard Thorne wearing an early high-top. "His appearance caused awe in some people and frightened others," he said.

In November 1945 there was much fanfare when *Ebony* – the black equivalent of *Life* magazine – was launched by the entrepreneur John H. Johnson. But right from the start the publication was plagued by one glaring contradiction. While the editorial featured black stars, promoted black pride, and railed against the notion that black beauty was inferior, its pages also carried ads promoting ethnicity-altering skin and hair formulas that exploited black aesthetic insecurity and low self-esteem. "Don't Be Wire-Haired Willie, The Man Nobody Loves," screamed one ad for a chemical straightener. "Have Handsome Hair the Amazing New Snow-White Way."

Ebony and other publications like it were caught between a rock and a hard place. Advertising of any kind was hard to come by for Afro-American publications, and the revenue was crucial for their survival. This effectively meant that they couldn't afford to be politically correct and stay in business. Something had to give.

The magazine left a bittersweet legacy, for it undoubtedly made an important contribution to the Afro-American community and to black beauty. "By spotlighting the Negro market," wrote John H. Johnson in his autobiography, "we helped create new jobs for Blacks in advertising and related fields...Back then there were no Black ad agencies or Black models...We helped change all that...We stressed the importance of using Black models."

Modeling had operated an apartheid system since the first agency opened in New York in 1923. Black models only ever crossed the line to play servants in ads. White-owned agencies such as Ford, and the premier fashion titles *Vogue* and *Harper's Bazaar*, were strictly off limits to black beauties. The skin game was ruled by an infantry of Nordic "high-blondes" whose image terrorized blacks and brunettes alike.

The answer was self-help. Afro-Americans started their own agencies. Brandford Models opened in New York in 1946, and the next year the Grace Del Marco agency, founded by ex-model Ophelia DeVore, followed suit; in 1956 American Models completed a trilogy. Blacks also staged their own community beauty pageants and runway shows in the church halls and various venues of Harlem. The lifestyle magazines *Our World*, *Ebony*, and *Sepia* provided editorial exposure for early starters such as actress Diahann Carroll and Juanita Hardy, Sidney Poitier's first wife, who graced the cover of *Ebony* in 1951. These magazines also featured them

First Model
Ophelia DeVore, the first black fashion model. Like the mulatto showgirls of the 1920s, the earliest pioneers were required to have light skin and crossover features.

THE NUBIAN
WARRIOR
The dome-headed
Woody Strode in *The
Deserter*, 1971. He
was best known for
his role in *Spartacus*,
1960, with Kirk
Douglas.

in a number of black versions of mainstream ads, as well as ones promoting black cosmetics.

"They didn't know I was black," said Ophelia DeVore, the first black fashion model, of when she enrolled at New York's Vogue School of Modeling at the tender age of 14. "Unbelievably, I photographed white. I found out later they basically thought I had a suntan..." DeVore, a pillow-lipped girl from South Carolina, was a triracial combo of Afro-American, Native-American, and French. In similar fashion to Harlem's mixed-race chorusgirls of the 1920s, the first black models to break through conformed to white beauty values. They had straight hair, Euro-centric features and were light enough to pass as white. To many, they were not seen as "black." They were "exotic" or "dusky," and were routinely mistaken for being Spanish, Italian, Hawaiian, Tahitian, or Polynesian.

Like DeVore, light-skinned Texan college graduate Dorothea Towles was also mistaken for white when she enrolled at LA's Dorothey Farrier Charm and Modeling School. By 1949 the pushy youngster had decamped to post-liberation Paris, arriving with just enough cash for three months. Soon she breached modeling's apartheid system through the back door, landing a job as a stand-in house model at Christian Dior, the biggest designer of the day. Towles was the first black model to work for a mainstream fashion house. "The people I worked with did not seem to care that I was American and looked different," she recalled in Barbara Summer's book *Skin Deep*. "I had the bone structure they were looking for at the time. They only wanted to see how you looked in the clothes."

The New Jersey drama student Helen Williams was the Afro-American model of the 1950s. With her bouffant wig, L-shaped eyebrows, and giraffelike neck, she worked the specialist markets, moving into mainstream ads and editorial for *Life* and *Redbook* after drawing media attention to modeling's continuing exclusive apartheid system. Fashion's lily-white membrane had finally been breached.

This was a pivotal moment in black beauty, as Williams was dark-skinned at a time when the fashionable hue was strictly "café-au-lait." "Elitists in our group would laugh at somebody if they were totally black," said model-turned-agent Ophelia DeVore. "And when she [Williams] came along she was very self-conscious because she was dark...She gave people who were Black...the opportunity to know that if they applied themselves they could reach certain goals..." Williams was the first beauty to break the 400-year chain that had branded dark skin as ugly. The same dark skin that was rendered second-class during slavery, the same dark skin that the minstrels once ridiculed, the same dark skin that had relegated Hollywood's actors to roles as servants and clowns, was suddenly beautiful.

Modeling was ahead of the game.

Meanwhile China Machado became the first Eurasian beauty to break through when she became a house model for Givenchy in Paris in 1956. Within two years she was doing runway for

SHEER MAGNETISM
Actor and matinee
idol Harry Belafonte.
Promotional pictures
of him were torn
from their frames by
adoring female fans.

Valentino, Dior, and Pierre Cardin, where she was spotted by designer Oleg Cassini, who took her to America. "China was like a cat, with slanted eyes, and dark, beautiful skin," he said. "She was stunning." In 1959 photographer Richard Avedon was so struck by her that he threatened to quit *Harper's Bazaar* after the magazine objected to him using her to shoot the international fashion collections.

At first, the new genre of television merely perpetuated the old stereotypes of blacks as clowns, entertainers, servants, and asexual non-beauties, re-treading the line that Hollywood laid down in its early years. Strict rules concerning aesthetics were rigidly upheld. In 1957 Sidney Poitier appeared on prime-time television in a play called *A Man Is Ten Feet Tall*. After the broadcast, irate white viewers jammed the station switchboard protesting about the decision to allow Poitier to have a white girlfriend in the production. In fact, the actress in question – Hilda Simms – was a black actress with light skin.

Hollywood's continued fears of black male sexuality effectively put paid to the potential of bright new stars such as William Marshall, James Edwards, and Juano Hernandez. But former LA Rams football hero Woody Strode did break through when he starred in *Androcles and the Lion* (1952) and *Spartacus* (1960) with Kirk Douglas. Stripped to the torso, with bulging muscles, Nubian-shaved head and killer cheekbones sharp enough to cut plastic, he became one of the era's only black male sex symbols.

In addition, Hollywood was quick to recognize the sexual heat of a certain matinee idol called Harry Belafonte. "When Belafonte's on stage, with shirt collar open, he moves his body in a tantalizing manner that makes women feel like doing crazy things," said a female reporter. In 1956, at a sell-out concert at the Lewisohm Stadium, the show sponsor came rushing backstage, screaming frantically, "Get scarce, kid, the guards can't hold back that mob of girls any longer!" On another occasion, during an engagement at The Riviera in Las Vegas, the management had to replace a large picture of him displayed in the lobby 13 times in one week, as it was torn from its frame by adoring female fans.

In 1957 he became the first Afro-American male to star in a romantic role opposite a white woman, the blond Joan Fontaine, in *Island in the Sun*. It was no accident that the man Hollywood chose to make history was the light-skinned, fine-featured Belafonte, rather than the superblack, overtly African-looking Sidney Poitier.

Even so, the movie still hit trouble. Fontaine received hate mail during filming, and the US Defense Department was inundated with requests that the movie not be shown to the Armed Forces. The South Carolina Legislature introduced a Bill to levy a $5,000 fine on any theater that screened the movie. Belafonte's smouldering sex appeal proved too hot for Hollywood, and eventually the movie became a missed opportunity, as the key passionate scenes between the two stars were removed from the final edit.

During the Second World War, while white GIs were getting themselves hot for nothing over pin-ups of Rita Hayworth and Betty Grable, Afro-American soldiers in the next bunk had Lena

Left:
THE FIRST DIVA
The mercurial Lena Horne. "With her long, cascading hair, slender features and flawless skin, she was actually closer to the Western beauty standard than the odd white stars Joan Crawford and Bette Davis."

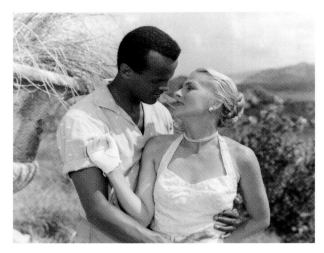

Hollywood in Black & White Harry Belafonte was the first Afro-American male to appear in a romantic role with a white woman, Joan Fontaine in *Island In The Sun*, 1957. Fontaine received hate mail during filming, and intimate scenes were edited from the final cut.

Horne on their walls, as if they were all coming home to her when the war was over. She was born in 1917 in a small Brooklyn hospital, and as excited nurses carried the newborn child through the ward they marveled at her "unusual copper color." It was an omen, for time would prove they were right to single out that particular child. The ex-Cotton Club chorusgirl's crossover looks and singing talent made her the black beauty of the 1940s. With her long, cascading hair, slender features, and flawless skin she was actually closer to the Western beauty standard than the odd white stars Joan Crawford and Bette Davis.

But in terms of roles, the old refrain about a lack of qualitative parts still rang true. Even as a cinnamon-skinned beauty Lena Horne was passed over for Ava Gardner for the mulatto role of Julie in *Show Boat* (1951). Most of Horne's roles ended up being singing cameos, though her best year was 1943, when she starred in *Cabin in the Sky* and *Stormy Weather*, becoming the first Afro-American woman to appear on the covers of *Time*, *Newsweek*, and *Life* within the same week.

Horne later lamented the nature of the success her particular look brought. "I was unique in that I was the kind of black that white people would accept," she said in *I Dream A World*. "I was their daydream. I had the worst kind of acceptance because it was never for how great I was or what I contributed. It was because of the way I looked."

Movie-makers of the 1950s were obsessed with blonds and mulattos. The mulatto has always been the "blonde" of her race. Just as her look took precedence over the dark-skinned Afro-aesthetic, so the blond was favored over the darker brunette. During this era of movie-making, these two privileged categories ran parallel. Both were the sex bombs of their class. Not only were they the most desired, they also got into the most trouble, and were always nothing less than the center of attention.

The media was quick to compare the two groups. The quintessential mulatto beauty Dorothy Dandridge was likened, not to brunette megastars such as Elizabeth Taylor or Natalie Wood, but to the quintessentially blond Marilyn Monroe. Aside from the fact that the two had similarly tragic lives cut short in drug-related circumstances, they also had similar hairstyles, similar bodacious curves, and between them they generated enough sexual heat to power a small generator. Moreover, the movies that defined their status as icons – *Gentlemen Prefer Blondes* (1953) and *Carmen* (1954) – were released at virtually the same moment.

But ultimately it was the blond who came out on top in the overall beauty stakes – universally desired and never quite as "tragic" as the mulatto.

"She holds the eye like a match burning steadily in a tornado," said one critic of Dorothy Dandridge's Academy Award-nominated performance in *Carmen* (1954) the biggest black movie of the 1950s. But big was not necessarily better, as Hollywood continually cast her in roles that acknowledged prevailing white male fantasies about black beauty – that "café-au-lait girls" were desired and required only as sex objects and concubines. In *Island In The Sun* (1957) she became the first black woman ever to be held in the sexual embrace of a white man in an American

Standing Tall Academy Award nominated for her role in *Carmen*, 1954, Dorothy Dandridge was packaged as "the black Marilyn Monroe," but a drought of follow-up roles eventually stalled her career.

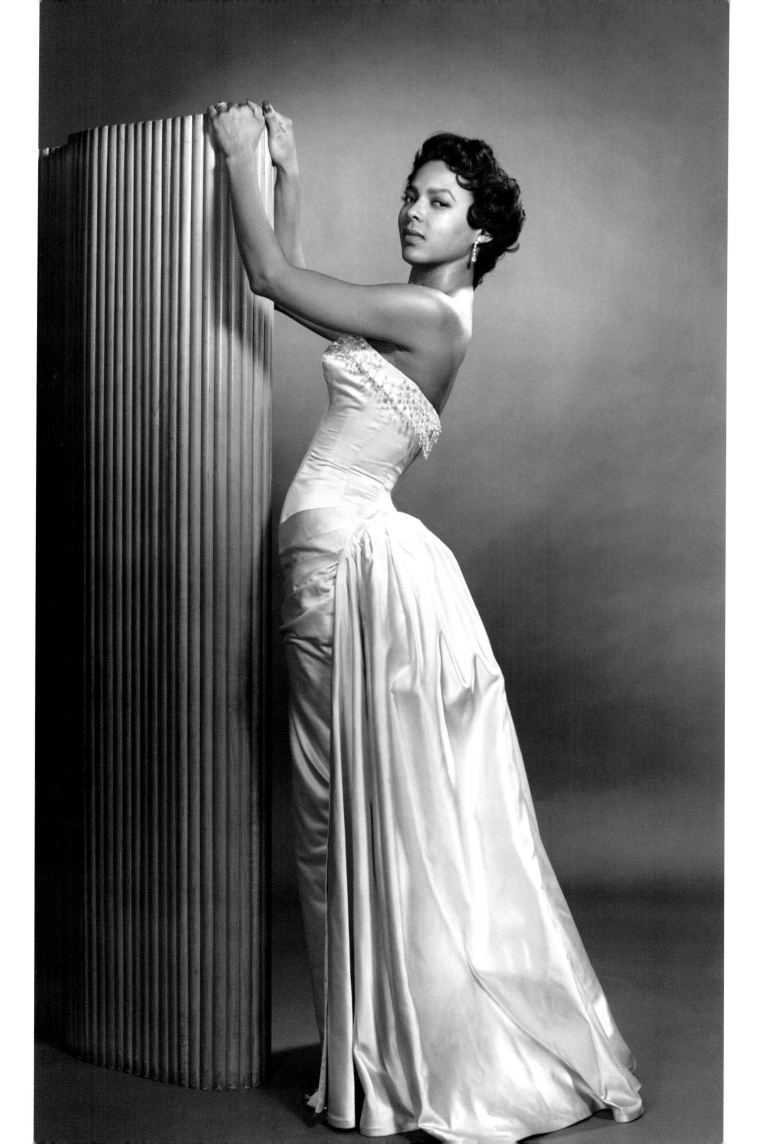

movie, but, as with Belafonte, the more imtimate scenes were cut. American movie distributors refused to handle *Tamango* (1959) even after two separate versions of the love scenes were shot – one for the more liberated French audience, and the other for the conservative Stateside cinema audience.

Like Lena Horne, a drought of follow-up roles suppressed Dandridge's potential to be anything but a sex symbol, and eventually she felt degraded by her iconic status. "My sex symbolism was as a wanton, a prostitute," she said, "not as a woman seeking love and a husband, the same as other women."

But wasn't cinema's archetypal "tragic mulatto" in the same boat as "the tragic white girl"? Weren't the Caucasian beauties of the 1950s – Marilyn Monroe, Brigitte Bardot, and Ava Gardner – also sex objects? Of course, generally they enjoyed a broader spectrum of roles than the average black beauty, but "sex object" is how a male dominated Hollywood regarded all beautiful women. More importantly, the black community needed a mainstream Hollywood sex symbol to affirm its right to be desired as a race, despite the fact that it wasn't always politically correct and the fact that Dandridge was promoted, aside from her talent, was precisely because her features were "un-African."

BLACK IN FASHION
Model Helen Williams's black skin-tone broke with the conventions of the past, which had always marked "dark" as ugly.

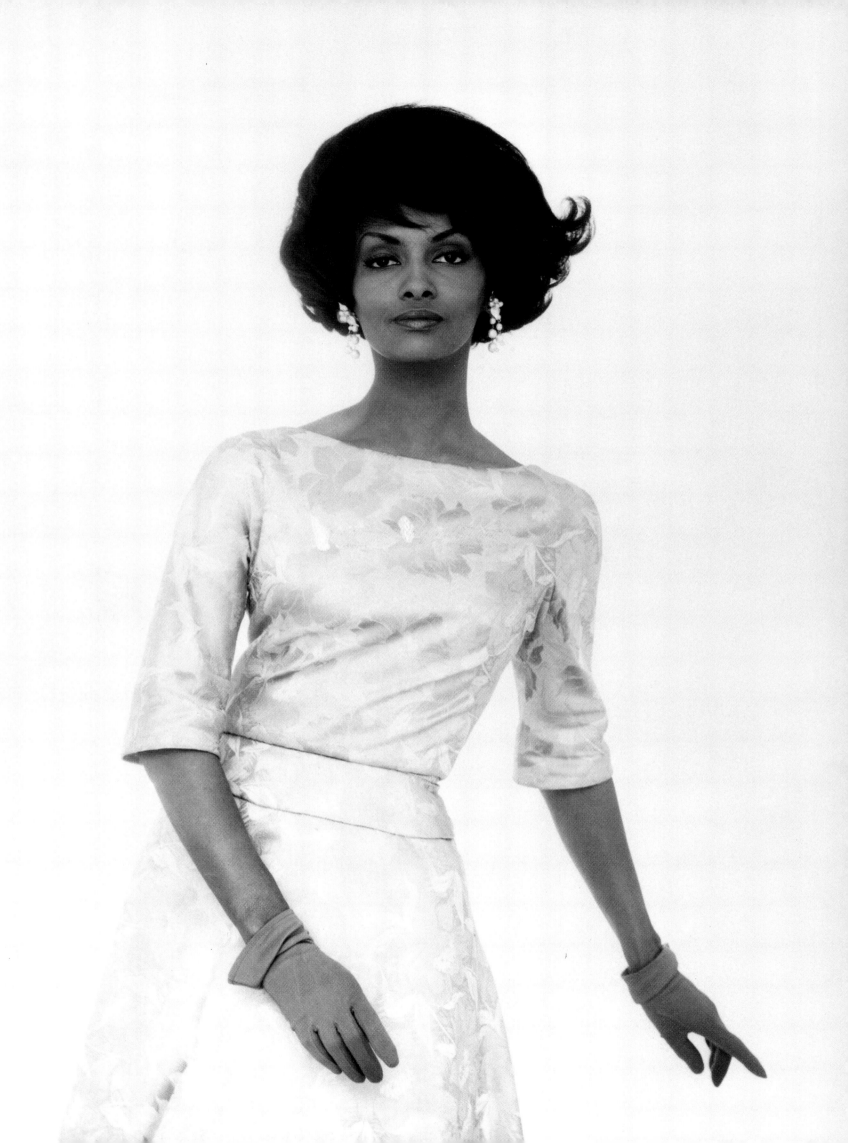

5

black
is
beautiful

1960s

WHEN IT WAS RELEASED IN 1967, the movie *Guess Who's Coming to Dinner?* – an interracial love story starring Sidney Poitier as a doctor who falls in love with a middle-class white woman, played by Katherine Houghton – was criticized for the fact that there were no scenes of intimacy between the young lovers. They appeared to be the most unromantic pairing in the history of love, and the movie shows only one brief moment of contact in which the pair quickly kiss in the back of a taxicab. But Poitier's biographer William Hoffman alleged that there were many more scenes of physical intimacy between Poitier and Houghton that had been edited out of the final cut and kept at Columbia Pictures, New York, daubed with large red Xs – plus the word "HOLD." Newspaper columnist Irv Kupcinet rumored that the movie was originally intended to open with a full-blown scene of Poitier making love to a white woman. Regardless of the revolutionary times and the fact that Poitier was "Black is beautiful" personified, the prospect of his profoundly black skin on a lily-white body sent a deep tremor through Hollywood.

The 1960s was the pivotal decade for black beauty, as it was for people of color across the whole range of social, political, and economic spheres. The Civil Rights Movement spearheaded a new drive for aesthetic self-determination, channelled through the rallying cry of "Black is beautiful." Against a backdrop of R&B and soul, the era ushered in a new series of firsts for black beauty. Sidney Poitier became Hollywood's first black male movie star and sex symbol, Diahann Carroll became the first woman of color to star in her own television sit-com, Naomi Sims became the first black supermodel, and Donyale Luna made the cover of *Vogue*. While Jimi Hendrix took centerstage, the sounds of Motown, led by Marvin Gaye and The Supremes, promoted black beauty en masse. Muhammad Ali brought aesthetics into the sporting arena with his boast of "I'm so pretty," and in an atmosphere of aesthetic revisionism the Afro hairstyle became a marker of racial pride.

The era saw the social tremors of the 1950s finally erupt. A volcano of pent-up rage and frustration overflowed in a black molasses of rousing speeches, riots, Black Power demonstrations, and shows of defiance, as Martin Luther King, Malcolm X, and the Black Panthers challenged the establishment. Black agitation led the way for other marginalized groups who also wanted a better deal. Everybody was protesting about something – Native-Americans, Latinos, even American-Italians who felt themselves too easily associated with the Mafia, stood up to fight their corner. The era witnessed the women's liberation movement, gay rights, the introduction of the contraceptive pill, the legalization of abortion, anti-Vietnam, and "Ban-the-Bomb" protests, as well as the assassinations of JFK, Martin Luther King, and Malcolm X. Everybody everywhere stood up like Peter Finch in the movie *Network* and shouted that they weren't gonna take it anymore.

Against this backdrop, hair and beauty trends were evolving fast. In the early 1960s black models began experimenting with the darkest shades available for white skins, which they mixed like amateur alchemists. Garment model Mozalla Roberts recalled going to Woolworth's: "I picked out the darkest make-up base that they had at the time, a peach color and a bright red rouge, and a nut-brown powder. I took all this stuff home and played with that make-up. By night

LOVE IN A COLD CLIMATE Sidney Poitier and Katherine Houghton in *Guess Who's Coming To Dinner*, 1967, were newly-weds who had to keep away from each other.

THE HEAVYWEIGHTS 1960s superheroes of racial pride, Malcolm X and Muhammad Ali meet at a New York screening of his fight with Sonny Liston in 1964.

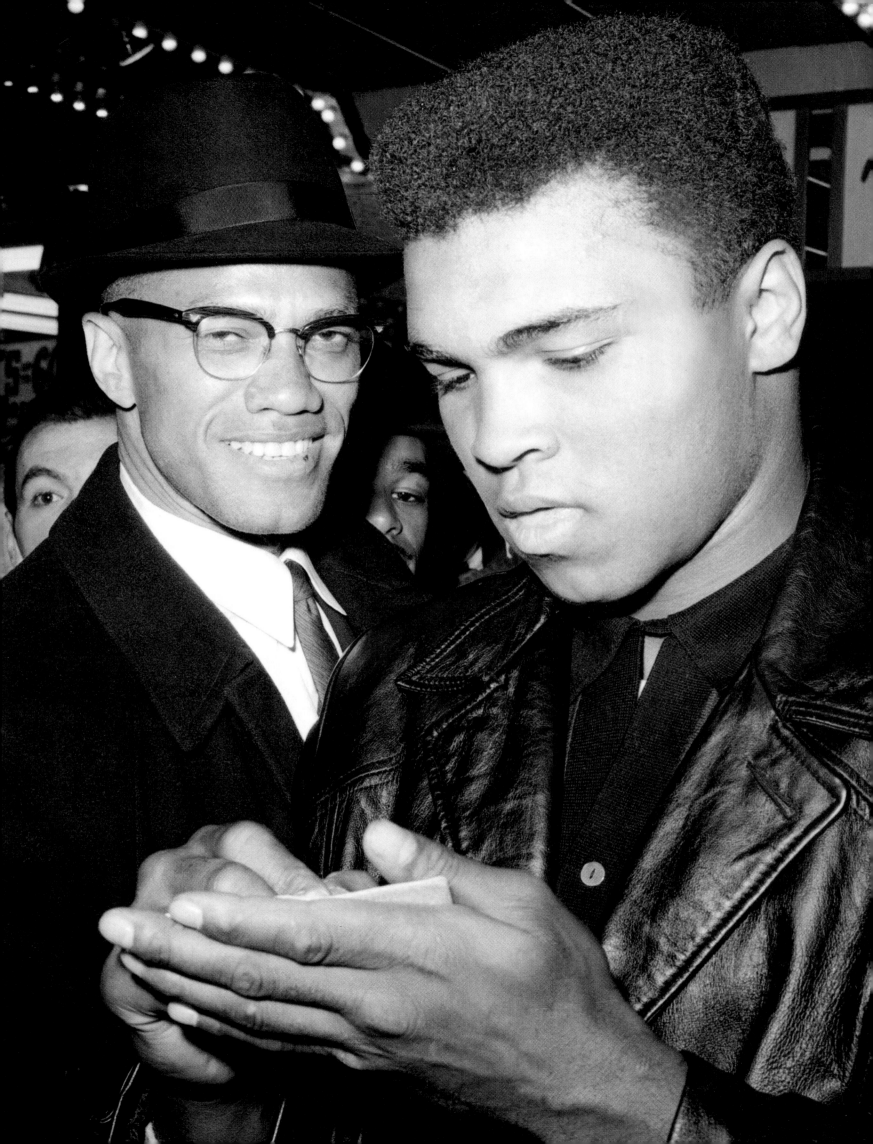

I had perfected a look…I never had color in my life, and here I was brown and gorgeous." In 1965 Flori Roberts launched the first major make-up line for black skins. It appeared two-thirds of a century later than the first skin-lightening and hair-straightening products.

At $44 million, *Cleopatra* (1963) – starring Elizabeth Taylor as the African queen in whiteface – was the most expensive movie of its time. It also turned out to be one of the century's quintessential moments in beauty, resuscitating the vogue for black eyeliner with winged corners garnered from the tomb illustrations of Ancient Africans. The look was favoured by the model Donyale Luna, who was also the first black beauty to wear colored contact lenses for her role as a goddess in the 1969 movie *Fellini Satyricon*.

A backlash against skin-lighteners led to their being reinvented as "fade-creams." Their racially derogatory names faded away and the label inscriptions became more subtle. In 1966, Nadinola – a skin-bleach dating back to 1899 – began to refer to itself as a cosmetic that "brightens away skin discolorations."

As Aretha Franklin sang "(You Make Me Feel Like) A Natural Woman," black grooming choices suggested anything but that, as the beginning of the decade was business as usual for the wig-wearing and chemically straightened fraternity. Diahann Carroll, Shirley Bassey, Ike and Tina Turner, James Brown, Marvin Gaye, Jimi Hendrix, and model Naomi Sims stayed with the "process." "I had some conks in those days that looked like ice-sculpture," said Marvin Gaye in 1961. Ike Turner's conk had a side parting carved into it as neat as Dean Martin's, but when he saw the Beatles's "mop-top" he switched. In the meantime Tina's tresses cascaded the length of her back, and she shook them like the exotic wild woman that was part of her act. Aretha Franklin, a big woman with hair to match, changed styles like luggage, from beehives to bouffants to hairpieces to headwraps. Some of her wigs were actually bigger than her head, giving new meaning to the term "larger than life."

Straight-haired wigs continued to emulate popular white stylizations of the day such as Sassoon's classic cuts "the Shape," "the Acute Angle," and "the One-eyed Ongaro." In October 1964 Ella Fitzgerald followed in the footsteps of the pioneering black-blondes of the late 1950s when she wore a blond wig for her debut at the Las Vegas Flamingo Room. Elsewhere, Cynthia Rose of Sly & The Family Stone wore a striking curly bouffant version throughout the late 1960s and early 1970s. Black wig-wearers were also departing from white stylizations by adopting more unusual, outlandish colors, though the innovations failed to impress Malcolm X. "And you'll see black women wearing these green and pink and purple and red and platinum-blonde wigs," he observed. "They're all more ridiculous than a slapstick comedy."

BUILDING BLOCKS OF BEAUTY
The Supremes look was a kit of "stick-on" parts – fake hair, fake eyelashes, fake nails. They even wore padded bras and "falsies" under their dresses in order to boost their curves.

Right from the start, models were responsible for their own hair and make-up, but black mannequins had to work within the confines of the white beauty values that modeling demanded. Naomi Sims supplemented her straight hair with wigs and hairpieces that she designed herself, as nothing available on the market was realistic enough for high-end fashion photography. She would arrive at shoots, tooled-up with an array of different pieces in her work bag, ready to rustle up any number of looks in just a few minutes flat.

The aesthetic oppression of blacks within modeling still ran deep. In her 1979 book *How to be a Top Model* Sims's best advice for the young black aspirant advocated that she straighten her hair. She also offered tips on how to use eyeshadow and eyebrow pencil as a "concealer" to make a broad nose seem smaller, as well as tips on how to diminish the size of the fuller lip.

THE DUO
Ike & Tina Turner
were connoisseurs of
"international hair."

When Berry Gordy founded his Motown label, his aim was to produce crossover acts that appealed to both blacks and whites, and to do this they needed "international hair." He opened a choreography and grooming division in his father's flat that, as well as giving lessons in how to smoke, how to walk, and how to climb up and down stairs elegantly, taught make-up and hair to Motown's artistes. For many of the girls this was a crucial service. "I didn't know what to do with a wig when I first got it," said Martha Reeves. "But it was part of the costume. Under those lights those wigs could poach your brains."

Motown institutionalized the conk for Gordy's male performers, and the bouffant wig for his roster of girl-bands. Marvin Gaye, Smokey Robinson & the Miracles, The Four Tops, The Temptations, The Supremes, Martha Reeves & The Vandellas, The Marvelettes, and Mary Wells were all identically cloned with slick-heads and big hair. Mary Wells was well-known for her wig-wardrobe. One minute she would be sporting a short blond bob, the next she would be swinging a long ponytail. "Wigging" formed an integral part of the image of The Supremes, and the girls collected them like stamps. "It was easier to change wigs than to change hairstyles," said Mary Wilson in her autobiography, *Dreamgirl*. "We had dozens of them," she continued, "all expensive, handmade human-hair pieces in a variety of styles…the bulk of our luggage was made up of huge wig boxes."

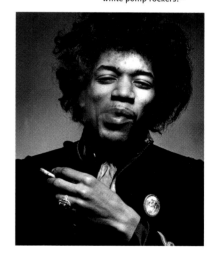

HARD ROCK
"Jimi Hendrix's
medicine-ball-sized
Afro cast shadows
over the heads of
Swinging London's
white pomp rockers.'"

Many of the wigs of the late 1950s and early 1960s – particularly those of Motown's A-list girls – were different from their predecessors, and went beyond mere copies of white female styles. These wigs were more voluminous and outrageously supernatural than before. They were versatile cross-stylized hybrids that defied categorization. They were multi-layered, like the levels of a skyscraper, and they kept their shape under pressure. These were industrial hairstyles – high-performance glamor tools built to withstand grueling sweat-soaked live performances and hurricane winds. No white woman alive had hair like this unless they also happened to be wig-wearers.

The beauty look established by The Supremes was pure fantasy-glamour. Nothing was real. Their big hair was fake, their nails were fake, their eyelashes and eyebrows were fake – even their bodies weren't theirs. They wore padded bras and "falsies" underneath their shimmering gowns in order to boost their curves. Diana Ross, skinny as a pencil, wore hip-pads, while Mary Wilson

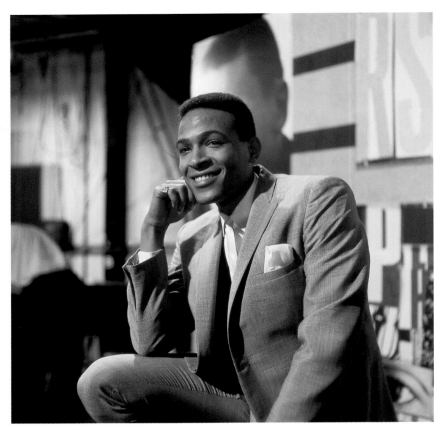

WHAT'S GOING ON?
Marvin Gaye's
hypnotic allure was
matched only by that
of Harry Belafonte's.
He later shed his
sexy image after he
felt it detracted from
his music.

padded out her backside, thereby slaying the Hottentot stereotype of the black woman with a supernaturally curvaceous body that required no artificial assistance. The trio constituted the biggest beauty construct of all time. Their entire look was a kit of parts that came out of a box.

Marvin Gaye, a Washington-born minister's son, was the prettiest and most magnetic male performer in Berry Gordy's stable, his hypnotic allure matched only by Harry Belafonte. Gaye's fine-cut, chiseled beauty and yearnful singing style sent women into a frenzy. "I fell into the habit of taking a handkerchief, mopping my brow, and throwing it into the audience," admitted Gaye in *Divided Soul*. "I loved watching the women fight over my sweat...I saw how much they wanted me. Sometimes one of those women would actually run up on stage and throw herself at me. People laugh, but being sexually assaulted by a half-crazed woman is no laughing matter." But by the end of the 1960s the singer – energized by the Civil Rights era – had become disillusioned with his sexy image, as he felt it was detracting from the music. In an effort to debeautify himself and emphasize his music, Gaye shed the look of the sophisticated crooner, adopting instead the low glamor of casual clothes and a full beard.

Like Little Richard before him, James Brown was also known for his special-effects hair. "The Godfather of Soul" was as innovative with his locks as he was with his music, and he experimented with different variations of the conk, which had names such as "high-English" and "the cement wave." While he was on the road, Brown had a personal hairdresser who would attend to his bouffant up to three times a day. The Godfather was more serious about his hair and general grooming than any other star of the decade, male or female, black or white. "Hair and teeth," he wrote in his 1987 autobiography. "a man got those two things, he's got it all."

Despite having these two things, to some James was still ugly. Albert Goldman in *The New York Times* cruelly likened his visage to "a cat with a pushed-in face," while Leon Austin, Brown's childhood friend, remarked, "James is dark, he's ugly. He made the ugly man pretty...He made himself pretty in spite of bein' dark."

Seattle-born Jimi Hendrix and his outlandish stage performances "made the girls practically come out of their dresses," said promoter Curtis Knight. Critics, armed full of Euro-clichés of savagery and wildness, dubbed him "Mau Mau" and "The Wild Man of Pop," but by the late 1960s he was Europe's number one male sex symbol, his medicine-ball-sized, fluffed-out Afro casting shadows over the heads of Swinging London's white pomp-rockers.

**THE GODFATHER
PREPARES**
A young James
Brown, his head
compressed into an
open-top turban,
waits for his
hairstyle to ripen.

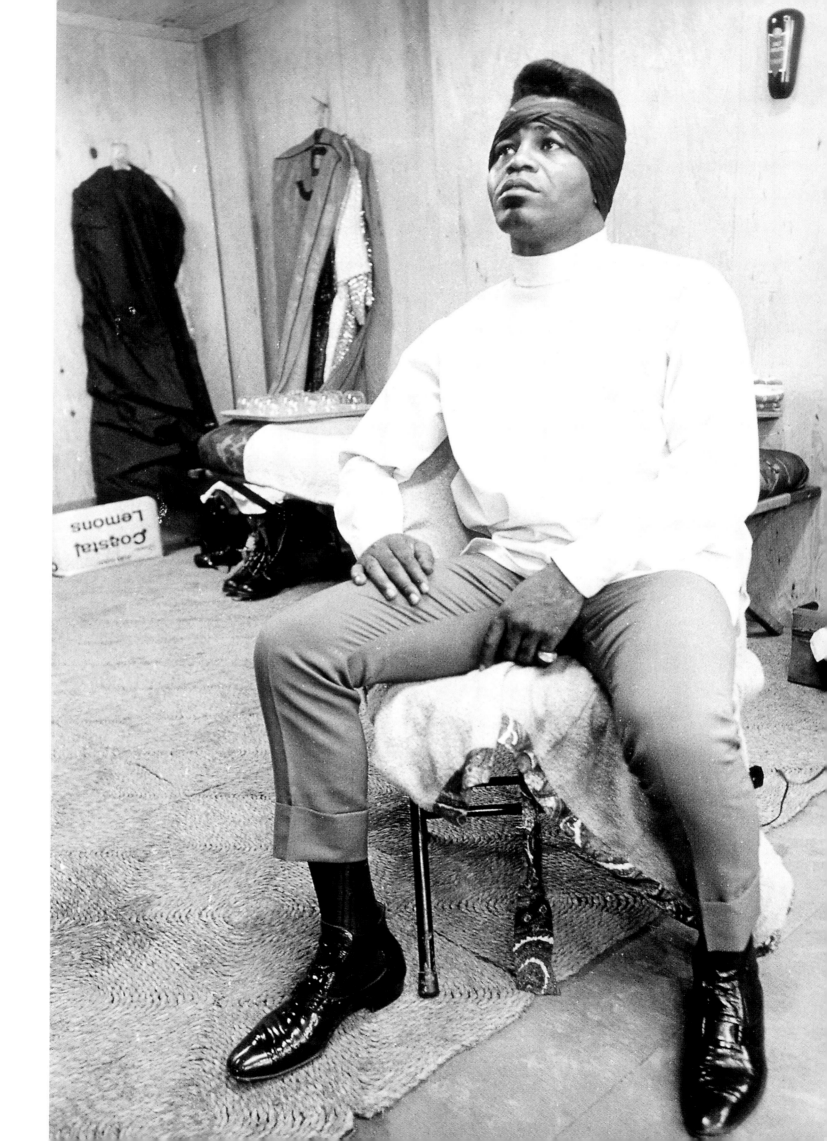

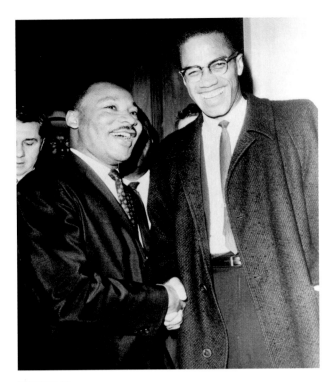

A MEETING OF LEGENDS
Martin Luther King Jr. and Malcolm X share a smile at a rare meeting. They were accidental beauty icons of contrasting physical personality.

Hendrix did nothing to dispel old-fashioned Caucasian fears about the size of the black phallus when he agreed to pose for a plastercast of his penis. The rock star was well-hung, and soon the documentary evidence was circulating in the media. *Rolling Stone* ran a 14-page article on the groupie scene in which Hendrix was described as "Best Score." The myth of the black Satyr had come to life.

Like Marvin Gaye, Hendrix later became disillusioned by the sexual image he had created. He rebelled against his own aesthetic, cutting his hair and toning down his loud dress sense. "I don't want to be a clown anymore," he lamented in *Rolling Stone*.

Aesthetic transfer took a new turn in the 1960s. While insecure black women applied lipstick inside the rims of their lips to make them appear smaller, Mick Jagger's "black lips" were eulogized for their gorgeous fullness. The Lord had surely given Mick a set from the wrong box, and the rock star flaunted them like there was no tomorrow, as if he knew the Lord would one day recognize his mistake and come to claim them back. Journalists had little to say about Hendrix's lips, or those of any other black musician of the 1960s, but the media celebrated the curling thickness of the Jagger pout in a flurry of column inches that put the heat into his sex appeal.

With his facial features Jagger could almost have passed for mulatto. In fact, when Tina Turner first laid eyes on the rubber-lipped rock star in the mid-1960s, she was struck by his apparent racial ambiguity. "I saw this very white-faced boy...with big lips," she told Vanity Fair, "and I had never seen a white person with lips that big...I didn't know...what race he was."

Simultaneously, in Gloria Steinem's *Beach Book* (1963) she confessed to sucking against the heel of her hand because she thought this would make her thin lips full. Parallel to this, in 1967, *The New York Times* carried a report on the University of California's black campus revolts, quoting a member of the Afro-American Students Union, who talked of the aesthetic shame of his past. "In high school I used to hold my big lip in," he said. While blacks were holding it in, Jagger was letting it all hang out.

The onset of Civil Rights had a radical effect on black beauty. The militants encompassed the issue of black aesthetics within their overall human-rights manifesto. The right to be black and beautiful was demanded alongside the right to live free of persecution and racism, and as far as the black radicals were concerned, the most obvious sign that blacks themselves were aligned with the program lay in their choice of hair. The movement stipulated unequivocally that processed hair denoted a processed mind, and thus the revolution started at the most obvious place – with the metamorphosis of the physical self.

The Civil Rights activists formed an unlikely group of sex symbols for the era. The force of their oratory and the conviction of their sentiments turned them into accidental beauty icons

who drew deep sighs of secret longing from the hearts of women everywhere. Martin Luther King and Malcom X possessed contrasting physical personalities. King was portly and chubby-cheeked, with a Little-Richard-style pencil mustache. He resembled a Fats-Domino-style, R&B piano man, and effused the cuddlesome sexuality of a warm-bellied papa. Malcolm X, on the other hand, was tall and wiry, and with his chiselled face, goatee beard, and trademark spectacles, he would not have looked out of place in the darkened, smoky atmospheres of a jazz room, with a horn by his side. He was virile, with the sexual mien of the panther that adorned the logo of Bobby Seale, and Huey Newton's Nationalist organization.

Malcolm X and Stokely Carmichael inherited Marcus Garvey's soapbox in becoming two of the century's most outspoken black knights to champion the cause of aesthetic revisionism. "Can you begin to get the guts to develop criteria of beauty for black people?" stormed Carmichael. "Your nose is boss, your lips are thick, you are black and you are beautiful. Can you begin to do it so that you are not ashamed of your hair?" Malcolm X put it in stronger language when he accused blacks of self-hate. "We have been a people who hated our African characteristics," he said. "We hated our heads, we hated the shape of our noses...we hated the color of our skin, hated the blood of Africa that was in our veins...And we hated ourselves."

From the mid-1960s onward the call for a back-to-roots, low-tech beauty began to gather pace. In 1967, a member of the Afro-American Students Union told *The New York Times*: "We decided to stop hating ourselves, trying to look like you [by] bleaching our skin, straightening

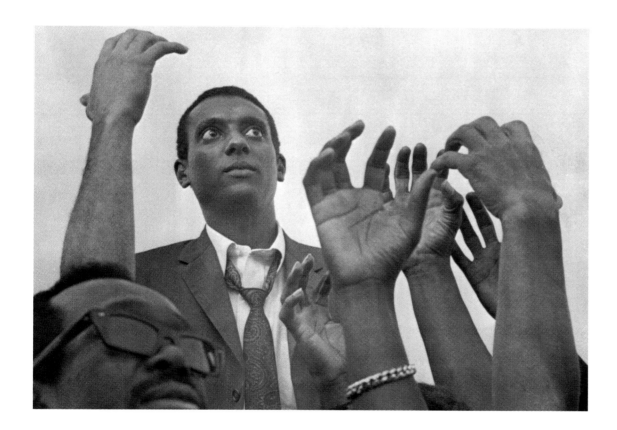

RAISING HOPE
Militant Stokely Carmichael was one of the most outspoken critics of black beauty values, rallying Afro-Americans to have greater aesthetic pride in themselves.

our hair." "Black is beautiful" banners began to appear, held aloft at public demos, and in 1968 Nancy Wilson charted with the song of the same name. The term was subsumed into the zeitgeist and tripled with the era's other touchstone phrases "Black Pride" and "Black Power."

"Black is beautiful" carried a powerful and redemptive message. Up to that point in Western history, clearly white was beautiful – more specifically, blond and white. The new phrase uplifted and united blacks, and at the same time caused confusion. What did they mean "Black is beautiful?" This nose, this kinky hair, these lips, this skin color, and this body that had been so demonized and caricatured for over four centuries? Because blacks had accepted their fate as the uglier race, this new proclamation came as both a bolt of lightning and a declaration of independence. For the first time in history, ethnic beauty was something to be proud of. Being black had value.

Like any successful marketing slogan, it was appropriated by others. Fashion designer Bill Blass rode the mood of the times with his adapted "Blass is Beautiful" and Guinness used the slogan on Irish billboards in the late 1970s.

The new consciousness embraced everything African, from blue-black skin to dashikis and Pan-African studies. The assassinations of Malcolm X (1965) and Martin Luther King (1968) and also the formation of the Black Panthers (1966) were the touchstones of the decade, and the effects on black beauty were far-reaching, as across the country citizens of color and celebrities alike cut off the "process-jobs" that had been standard issue for over half a century, and replaced them with the Afro.

This style did not originate in Africa, as many believe, but was a twentieth-century American innovation – a hybrid that fused African hair with the post-modern black stylizations of the West. Though it appeared well before the 1960s, the style became a symbol of race pride and political consciousness when it was adopted by young Afro-American militants and student radicals on university campuses in 1967.

Never had a hairstyle struck so much fear into white America as the Afro did during the late 1960s. News bulletins of angry-faced Afro-Americans, violent demonstrations and race riots threw the media into a tailspin of hysteria that succeeded in associating the style with hardcore militant behavior. To many whites the Afro was less a style statement and more a signifier of black rage. "I feel that the way that I wore my hair was an expression of the rebellion of the time," said Jesse Jackson. "It was our statement, which was not easy to imitate. The tragedy was that most of the Afro picks [combs] were made by white manufacturers."

The Black Panthers, led by Bobby Seale and Huey Newton, adopted Afros and short naturals within their panoply of leather, turtlenecks, and tight slacks. Beret-wearing Panthers had to keep their 'fro's low in order for their hats to fit. The Afro was a high-maintenance style that required careful grooming and regular trimming to maintain its perfect sphere, but the Panthers' cuts were less concerned with sculpting the perfect "O," as their styles were rougher, angular, and more asymmetrical, as if to suggest that all that fancy grooming was for sissies. They had better things to do than spend their time sitting in a beauty parlor getting "rounded up." The more rugged and "buckwild" the look, it seemed, the more militant you were.

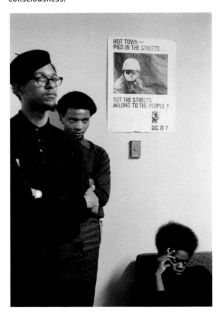

THE POLITICS OF HAIR
The Chicago headquarters of the Black Panthers. The movement adopted the Afro as a symbol of race pride and political consciousness.

Events up to and including the assassination of Martin Luther King made 1968 the watershed year for black beauty, and the most tumultuous for blacks in general. During this time the Afro expanded into a full-blown fashion statement, superceding the straight-haired wig and the conk. James Brown, Marvin Gaye, Jimi Hendrix, the model and actress Marsha Hunt, and a bevy of Motown acts cultivated bushy high-tops or short naturals in place of the process. "I stopped conking my hair," said Marvin Gaye. "I told myself I'd never put that crap in my hair again. I wanted another look. A more natural look." There was a sharp intake of breath as James Brown – the most narcissistic musician-beautician since Little Richard, who had been conking like a champion for over a decade – made the ultimate symbolic statement of shearing off his supernatural quiff. "I cut off my hair on Linden Boulevard," he said. "I showed 'em that this didn't hold me back. That it weren't the hair that make the mind. They said, 'How's he gonna be black if he don't cut his hair?' So I cut my hair." To accompany the gesture he recorded "Say It Loud, I'm Black And I'm Proud," which became the era's soundtrack. It went straight to number one in the R&B chart, selling 750,000 copies in two weeks. Then, as the barber at the Harlem YMCA started advertising haircuts "African-style," Hank Ballard penned his very own anti-hair-straightening anthem, "How You Gonna Get Respect (When You Haven't Cut Your Process Yet?)"

Ebony magazine changed editorial direction in 1968, and suddenly superblack, Afro-headed sisters were seen adorning the pages, and a new banner headline roared out: "The Natural Look – New Mode For Negro Women."

Elsewhere, model Charlene Dash with her balloon Afro was accorded six-pages in *Vogue*, and at the London opening of the musical *Hair*, Marsha Hunt's bouffant, light and fluffy as a marshmallow, became the subject of an ad campaign. "I was only a member of the chorus, but I got a lot of publicity because of my hair," she said. In 1969 she bared all for British *Vogue*, wearing nothing but her outsized puff. Meanwhile Sly & The Family Stone toured America and Britain, their scalps covered with an array of basketball-sized 'fro's and wigs that shuddered with every beat of the kick-drum.

Initially the US military refused to let its young black recruits adopt the style, but in 1969 the Commander of the Marine Corps relented and sanctioned a shorter, modified version of the Afro as standard issue. But this failed to satisfy the black Marines, and in 1971 49 military barbers and beauticians underwent a hairstyling course under the direction of a well-known black hairstylist.

At the same time the Afro sparked off copycat "Whi-fro" curly perms as the look was aesthetically transferred to whites. Jimi Hendrix and Marsha Hunt popularized the trend in London. Hendrix joked that band member Noel Redding only got the job because of his Afro-style hair.

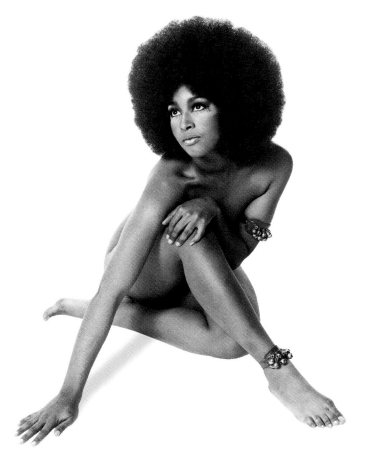

AFRO-CHIC
Actress, model, and singer Marsha Hunt's balloon Afro was captured for British *Vogue* by Lord Lichfield in 1969.

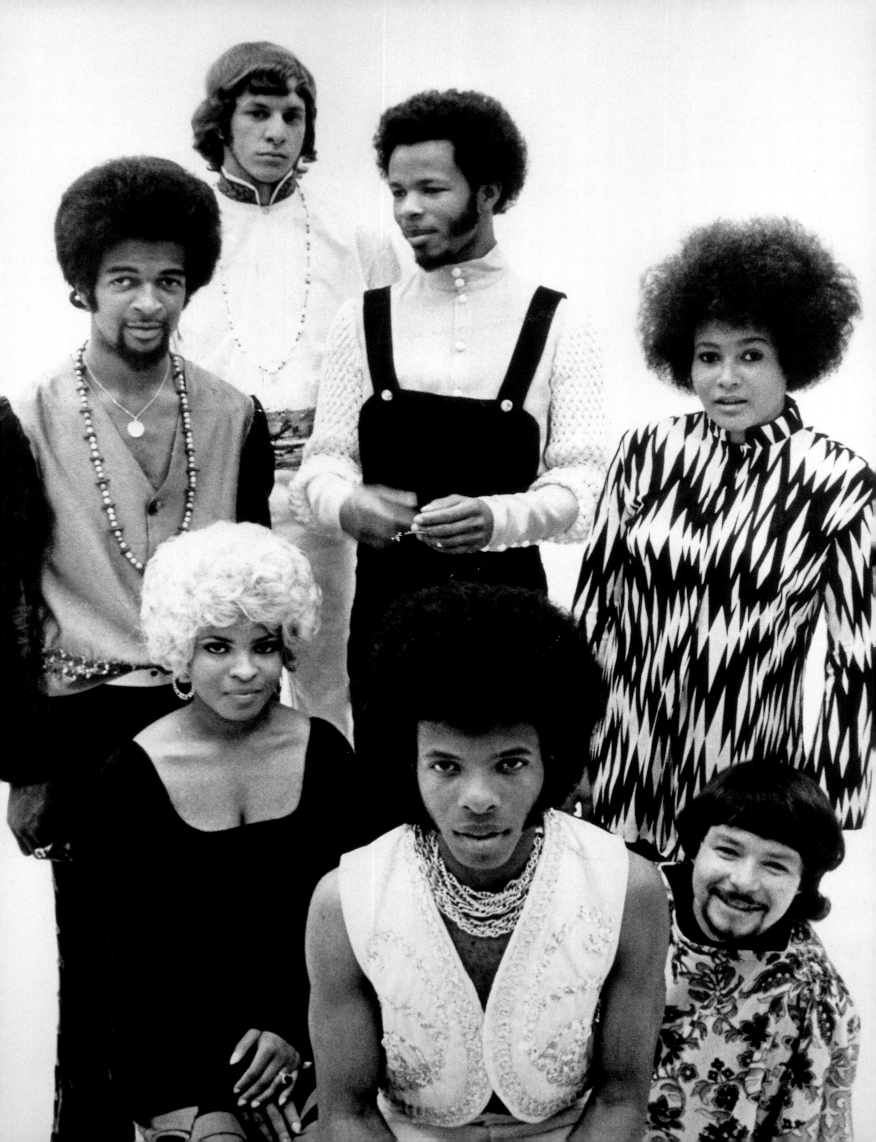

Whites with naturally curling bouffants, such as Art Garfunkel and photographer Lord Lichfield, suddenly became hip, while in the Far East the ever fashion-conscious young Japanese also copied the look. The London mannequin manufacturer Adel Rootstein produced a line of Afro-headed shop-window dummies, and the mannequins in hip stores across Manhattan suddenly appeared with darker hues and an Afro-look, though their features remained resolutely white. Meanwhile Mattel launched a miniature mannequin called Christie, Barbie's black friend.

Dreadlocks came of age at the same moment as the Afro. In 1967 Bob Marley converted from Christianity to Rastafarianism and grew the dreadlocks for which he became known. He had previously sported a mini-Afro in his ska/Motown-inspired group The Wailers. Peter Tosh was also growing dreads, while Bunny had been a Rasta follower for some time. In that year, the group became the first to bring dreadlocks into the realm of popular music.

The straight-haired, multi-colored wigs that black women and entertainers had been wearing for the better part of a hundred years were suddenly rendered politically incorrect in the new climate of 1968, to be replaced by Afro wigs. A newly empowered Diana Ross wore one at London's Royal Variety Show, quoting Martin Luther King onstage and endorsing the views of Stokely Carmichael. The new wigs offered "instant-'fro-without-the-grow" for those too lazy or impatient to cultivate a bouffant of their own. They allowed blacks to live aesthetic double lives. Women could show that they were "down with the cause" while simultaneously retaining the option of keeping their straightened hair, out of sight underneath. Black models were told by their agencies that their own hair had to be straight, and that if they wanted to be "black" they had to carry an Afro wig in their bags and wear it when they were off-duty. This incensed the model Pat Evans when she tried to join an agency in 1966. "I got really mad about that, because all of my life it's been good hair, bad hair, you know."

Yet the double-hair option gave black models the versatility to appear as either "African" or "European" style beauties in advertising and fashion work. Models were often shot wearing the same outfit but with two different hairstyles – the Afro wig for America's East and West coast markets, and straight hair for the Midwest.

Sales of Afro wigs and indeed Afro toupees peaked in the late 1960s and early 1970s, and a variety of styles were just as popular with white women. In London wigs were even available on the National Health Service. Elizabeth Arden sold bows with hairpieces attached, and style-setter Lilly Dache advocated a wardrobe of wigs instead of hats as the ultimate in chic.

By the end of the decade the sculptural impact of the Afro's orblike form was as recognisable across the architecture of the urban landscape as the curve of St. Paul's Cathedral or the geodesic domes of Buckminster Fuller. The swell of race pride also resuscitated traditional Old World African hairstyles such as braiding, cornrowing, plaiting, and headwrappping, and mothers were being tapped for traditional techniques. Nina Simone alternated between Afro and cornrow, and black men swapped cropped styles with London skinheads, proving that if black was beautiful, then bald was bold. R&B singers Geno Washington and Isaac Hayes adopted the shaved "cleanhead" look. Hayes's chocolate orb adorned the cover of his 1969 album, *Hot Buttered Soul*. He called it "as black as you can get." The model Pat Evans became a sensation in

AFRO-BEAUTY
Nina Simone in concert, complete with nest of wraparound braids and Cleopatra-style eye make-up.

YOUNG LEGEND
A baby-faced Bob Marley *(centre)* sporting a mini-Afro in his early group The Wailers, together with band members Bunny *(left)* and Peter Tosh *(right)*.

Left:
AFRO-FUNK-FAMILY
Sly & The Family Stone took the Afro-aesthetic on the road during their late-1960s tour of Britain and America.

Hot Heads
Isaac Hayes called
his shaved dome "as
black as you can
get," while model
Pat Evans's Nubian
look *(right)* was a
protest against the
model industry's
vain attempts to get
her to straighten
her hair.

the late 1960s after she shaved her head in protest at the model agencies' attempts to oppress her into straightening. Instead of conforming, Evans opted to become "blacker," wearing hooped earrings to complete her Nubian look. Things took off from there. "I did all the TV shows, all the magazines," she said. "People were coming from Japan and Germany to photograph me...It was different. It was the right time."

The time may have been right, but the revisionist mood did not permeate the scalps of all concerned. The government of Tanzania banned the Afro after it became popular among urban middle-class African women. The state-owned *Tanzania Sunday News* stated that the style was an unwelcome import from "the land of drug-takers and draft-dodgers." Meanwhile, the actress Diahann Carroll kept her straight-haired bouffant, as did supermodel Naomi Sims. "The Afro had come and gone with no more than a slight nod from me," Sims said. "I had worn the style in a couple of ads but never as a preference." And in 1968 the proprietors of a black-owned New York salon reported that nine out of ten of its regular hair-straightening clientele had ignored the Afro look and continued to have their hair chemically processed.

In Jamaica, the dreadlocked hairstyle adopted by Bob Marley was also proving unpopular. "For conservative Jamaicans like Cedella, [Marley's mother] hair length and style clearly indicated social differences; straight silken hair was the ideal, while naturally kinky hair denoted the lower orders," noted Marley's biographer Stephen Davis. "So the Rastafarians...were looked upon with revulsion and real dread by the mass of Jamaicans. The idea of her boy wearing dreadlocks was almost too much for Cedella to bear."

Within the modeling industry new physiognomical types began vying for representation. A composite of faces brought a new eclecticism to fashion that matched the adventurousness of Paco Rabanne's metal and plastic dresses. At the same time, the multi-ethnic cast of *Star Trek* (1966–71) also reflected the rainbow-colored times. The black cast members may have been subordinate button pushers, but at least they were on board.

The new models could easily have qualified as extras for this show. "Non-standard" Caucasians such as Penelope Tree were juxtaposed with diverse beauties like Pierre Cardin's Japanese model Hiroko Matsumoto and Afro-American beauties such as Donyale Luna, as well as the first model men of color – Tony King, Bill Overton, Renauld White, and Richard Rowntree, later of *Shaft* fame. For New York-born Rowntree, a one-time department-store salesman and cab driver, modeling presented slim pickings – he worked an average three-hour week for $40 an hour. Nevertheless, he was one of the first black male beauties to break the color barrier, doing runway and also print for Sears and J.C. Penney, as well as a photo-shoot with actress Cybill Shepherd.

The exotically named Donyale Luna, a bitpart actress from Detroit, landed in New York in the early 1960s and set the industry alight. "She never wore shoes," said fellow model Pat

Luna Landing
In March 1966, Donyale Luna *(above and right)* became *Vogue*'s first black covergirl. With pale make-up and a well-positioned hand obscuring her face on the cover of this British edition, readers didn't realize she was black.

The first Black Supermodel
Naomi Sims on the cover of *Life* magazine, 1969. Her dark skin recalibrated the industry's aesthetic preferences, as suddenly light-skinned models couldn't get work.

Cleveland. "Wherever she went she would arrive in bare feet. She was so beautiful that people would stop eating if they were in a restaurant and saw her walking by."

Luna was a heady amalgam of Afro-American, Mexican, French, and Irish, with a hard-edged, owl-like beauty. She wore her hair pulled back to accentuate her startled expression and her large green eyes. She was likened to a Masai warrior, a panther, an exotic bird, and a swan.

In April 1965 she became the first black model to feature in a mainstream American fashion magazine when Richard Avedon photographed her for *Harper's Bazaar*. Earlier that year, an artist's interpretation of her as an "exotic-Eurasian" was used for the cover of the January edition instead of a bona fide photograph. It wasn't quite the groundbreaking first cover blacks were waiting for. Luna defected to Europe, where she became an instant hit. "Back in Detroit I wasn't considered beautiful," she said in Paris in 1966. "But here I'm different."

Blacks were finally awarded their first cover in March of that year, as when she became the first black model to feature on the front of *Vogue*. The British edition's image, shot by David Bailey, featured a pale-faced Luna with a hand obscuring her face and heavy Cleopatra-style eye make-up. Readers did not know she was black, and the obscuring hand made doubly sure.

"Excuse me, are you with an agency?" was how it all started for 18-year-old Naomi Sims, a college student fresh in from Pittsburgh, as she was scouted by a keen-eyed photographer's agent on a Manhattan street in May 1967. Sims was a fashion fanatic, obsessed with clothes since the age of four and with subscriptions to *Vogue* and *Harper's Bazaar* at 14.

After testing with two photographers, she made the front cover of *The New York Times* biannual supplement, *Fashions of the Times*, the first time an Afro-American model had appeared on the cover of a mainstream American magazine. With her chocolate skin and a face straight from a sculptor's chisel, Sims made an instant impression. Her beauty "breaks through the printed page or television screen," wrote Bernadine Morris in *The Times*, "and makes people shout, Hurrah! when she steps in a room." From there Sims went onto become the first black model on the covers of *Ladies Home Journal* (1968) and *Life* magazine (1969).

In 1968 she was summoned to see the eccentric *Vogue* editor Diana Vreeland. The white-gloved fashion empress was the first to open the white sheets of the mainstream fashion bibles to black beauties. She had already admitted Donyale Luna, and when Sims walked in the room, she took one look at her and shot out her arm, exclaiming, "She is fantastic!", booking her instantly to shoot the next collections with Irving Penn.

Less than a year later Sims had ascended into the modelling superleague, voted Model of the Year, and was earning a reported $1,000 a week. Her profoundly dark skin had a major effect on the black modelling scene. She cast a long, dark shadow over the industry, which led to a "mulatto backlash," as light-skinned models were suddenly told they were "not black enough," and were denied work. "I had tried to work in New York, but I couldn't make it," said model Carol LeBrie. "I was too light. That was the Naomi Sims period when they wanted dark models." In the supercharged atmosphere of Civil Rights and the new vogue for all things black and African, the industry used Sims to justify that it was doing its bit, and discriminating in favor of darker-skinned models was its way of making its concessions obvious.

Sims's ascendancy, in 1968, coincided with events leading up to and including the death of Martin Luther King when white liberal guilt was at its height. "The death of King shook everybody a bit and woke them up to the fact that something had to be done," said Jerry Ford of Ford Models – an agency once nicknamed "The White House" because of its lack of black models. "Negroes aren't temporary. We're all people," said Wilhemina Cooper of Wilhemina Models. "We live in the same country. Black is beautiful." The fact that these flighty fashionistas – traditionally short on moral crusades and long on discussions about skirt length – were speaking up on behalf of black beauty was nothing short of a revolution.

The effect was immediate, galvanizing the skin-trade into granting Afro-American models a whole raft of concessions that were long overdue. The media now sought out black faces, and both Ford and Wilhemina welcomed a fresh cluster of black beauties into the fold. Another startup agency, Black Beauties, appeared, run by a white director, Betty Foray. "What black people want now is a passageway to economic opportunity," an agency spokesperson told *The New York Times*, "and they know very well that the only way is through white conduits."

Suddenly smiling black faces began appearing across the covers of mainstream magazines. Katiti Kironde II made the cover of *Glamour* in August 1968, followed by Daphne Maxwell in 1969. Quincy Jones's daughter Jolie was first on the front of *Mademoiselle* in the same year, followed by Jany Tomba in 1970. Jane Hoffman appeared on the cover of *Cosmopolitan* in 1969, and in November that year African law student Elizabeth, Princess of Toro, was "reluctantly" allowed to became the first black woman on the cover of *Harper's Bazaar*, although she was paired with a white model and had her face deliberately obscured by the typography of the logo.

Forward-thinking fashion designers had already begun using black beauties as runway models. Structurally, black model bodies were as ergonomically perfect as you could get for clothes, and these girls (many of them ex-dancers) really knew how to move. Their sheer physicality was one racial stereotype they didn't mind having. Donyale Luna, and a bevy of "all-blacks" were booked by designers such as Courrèges, Paco Rabanne, Pierre Cardin, and Halston, and they blitzed the couture shows like elegant stormtroopers.

But not everybody was enthusiastic about fashion's latest arrivals. Despite Civil Rights, the death of King and the international status of supermodel Naomi Sims, American *Vogue* failed to produce a single black cover during the era – the only major fashion magazine to so abstain. This was despite the fact that Naomi Sims was regularly featured on the fashion pages inside. The model Norma Jean Darden remembers challenging the model editor on its policy of racial exclusion. "Oh, I'm sorry, but we're interested in white women here," came the curt reply. Runway superstar Pat Cleveland was so disgusted by events that she left America for Paris, vowing never to return until *Vogue* printed its first black cover.

In July 1964 an alleged incident involving Paco Rabanne rocked the model community to its foundations. The innovative Spanish-born designer had used black beauties in his Paris show to model his futuristic plastic dresses – a move that enraged the American fashion press. According to Rabanne in Barbara Summers's book *Skin Deep*, things got out of hand backstage after the show. "I watched them coming," he said, "the girls from American *Vogue* and *Harper's*

BLACKNESS OBSCURED
Elizabeth of Toro was the first black model on the cover of *Harper's Bazaar*. Her face was deliberately hidden by the title typography.

Left:
FIRST TELEVISION SUPERSTAR
Ex-model Diahann Carroll was the first Afro-American to star in her own TV series, *Julia*, in 1968. She later went on to star as Dominique Devereux in the 1980s blockbuster, *Dynasty*.

Pages 82–3:
THE GREATEST
"If the phrase 'Black is beautiful' were to be found in an illustrated dictionary, it would be Ali's visage that would accompany the definition."

If you find
this man attractive
you have been
exposed to
what psychiatrists
call role confusion.
But be not afraid.
It simply means that
you're all woman.
See The Age of the
Hard Man, page 62.

Writing in
this issue:
Mary McCarthy
A S Byatt
Brian Moore

HELLO LADIES
Football-star-turned-
actor Jim Brown
brought sexual heat
to the cover of
British women's
magazine, *Nova*, in
1969.

Bazaar. 'Why did you do that?' they said. 'You don't have the right to do that, to take those kind of girls. Fashion is for us, white people.' They spat in my face. I had to wipe it off." Rabanne was subsequently blacklisted by the fashion cartels until black runway models finally became chic in the 1970s.

"I'm so pretty," was as famous a catchphrase as "Coke Is It," but Muhammad Ali was no adman's creation. He wrote his own lyrics – like the first rapper – and never in history has any icon been so direct a beauty braggart as the Louisville Lip. His legendary declaration was not merely a cold statement of fact, but also a rallying cry for people of color to take pride in their ethnicity. Run through a translator, he was megaphoning the message "Black is beautiful," using himself as the prime example, while simultaneously daring anybody within range to challenge his audacious narcissism. Nobody could. If the phrase were to be found in an illustrated dictionary, it would be Ali's face that would accompany the definition. "He was extraordinarily handsome," wrote Thomas Hauser unequivocally in *Muhammad Ali: His Life and Times*. "Better looking than most movie idols."

The Ali-aesthetic was low-tech and functional – medium-length Afro hair and hard-scribed features within a round, fleshy face. No additives, no preservatives, no artificial colors. He was as wholesome as a black man could get. It was a jolting irony that such a capacity for human destruction could derive from such an angelic visage. Ali was a grandmaster of the hurting business, and yet he had the looks of a model or a singer. A lover, not a fighter.

And it was a close call as to which was prettier – his face or his body. "Ali looked like a piece of sculpture," said the artist Leroy Neiman, "with no flaw or imperfection. His features and limbs were perfectly proportioned." The racial stereotype of the performing black gladiator – dull of mind and powerful of body – did not apply to Ali. To the women of America, he was just plain sexy.

But Ali's beauty had a professional purpose, as he was the first athlete to introduce the psychology of aesthetics into the sporting arena. He invented the concept of beauty as a weapon, lobbing verbal hand-grenades at his opponents in an effort to wind them up, undermine their confidence and degrade their ability both in the pre-fight build-up and during the bout itself. He called Sonny Liston "The Big Ugly Bear" and Joe Frazier was nicknamed "The Gorilla." A black man calling another a primate was racially risky ground, but Ali went there anyway. "Joe Frazier is too ugly to be champ," he ranted during the prelim to the 1971 bout. "...The heavyweight champ should be smart and pretty like me." To Ali, being ugly was the same as being a bad boxer.

His pot-pourri of schoolyard name-calling and barbershop-boasting formed a crucial component of his winning formula. During the Civil Rights era it inverted the whole idea of "Black is beautiful." It was almost as if he were saying that in spite of the revolutions of the era, Civil Rights could do little to emancipate the ugly faces of his opponents. For the sake of the preservation of beauty, they had to lose.

The social tremors of the era were nowhere more keenly felt than in Hollywood. In 1968, Jim Brown, a rough-house ex-football pro with the Cleveland Browns, made history when he featured in the era's first interracial sex scene with Raquel Welch in the movie *100 Rifles*. Brown was well-suited to his new vocation as Hollywood's first black action-hero. He stood six-foot-two in his socks, with a 45-inch barrel chest and the tough, hatchet-faced beauty of a natural-born movie star. He was a walking, talking slab of raw sex appeal, cut from the bone. A macho man to match the era's militant machismo, he was the forerunner to the Afro-headed, ass-kickin' badasses of the Blaxploitation era. In 1969 he became the first black male pin-up to front a mainstream magazine when he featured on the cover of the British fashion title *Nova*.

Ex-model Diahann Carroll made her name in the 1950s movies *Carmen Jones* and *Porgy & Bess*. She was the heir to the throne of the "café-au-lait" diva previously occupied by Dorothy Dandridge. "I'm acceptable," she said. "I'm a black woman with a white image. I'm as close as they can get to having the best of both worlds." Carroll's straight "bobbed" hair, high forehead, "surprised" eyebrows, and chiselled jawline imbued her with the refined, sophisticated look of a Motown girl-groover. She could have been the fourth member of The Supremes.

Instead, in 1968 she became the first Afro-American to star in her own TV series, *Julia*. Though the show was much criticized for its unrealistic portrayal of black life, it nevertheless

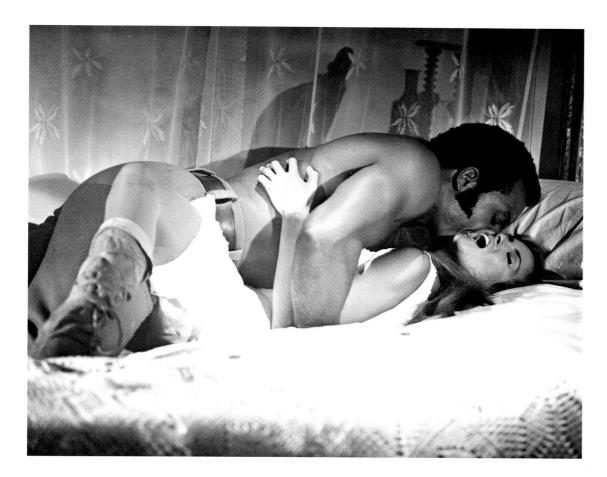

INTERRACIAL BEHAVIOR
Jim Brown beds Raquel Welch in *100 Rifles*, 1968. He was the first Afro-American male to feature in an interracial sex scene.

surmounted some serious aesthetic hurdles. A network show featuring a black cast and attracting advertising was a groundbreaking achievement for the times as evidenced by the hate mail from angry whites not yet ready to accept a black face on television – even one as easy on the eye as Carroll's.

Together, Muhammad Ali and Sidney Poitier epitomized the race pride of the era. They could have passed for chic Civil Rights leaders – but we already had two of those. Poitier, a poor farmer's son from the Bahamas, was Hollywood's first major black male sex symbol, although not by design. With his dark skin and overtly African features, he fitted Hollywood's traditional image of the black male "non-beauty." His promotion was not intended to have a sexual or beauty-related purpose, but to preserve the aesthetic order. This was borne out by the roles Hollywood designed for him, which, right until the late 1960s, were almost exclusively void of any sexual personality. *The Long Ships* (1964), *Patch of Blue* (1965), *Guess Who's Coming to Dinner?* (1967), and *Lilies of the Field* (1963) compensated for this by featuring characters who were resolutely pure and noble of purpose. Exasperated critics cruelly dubbed him "the ebony-saint." Sidney was the sex symbol without sex.

But Hollywood hadn't counted on the feelings of red-blooded women who, regardless of his asexual roles, his superblack skin, and his African features, found him irresistible. Also, the Civil Rights Movement and the banner of "Black is beautiful" acted as timely endorsements of his aesthetic because the vogue for all things African was at its height.

Poitier eventually established his sex symbolism in 1968 in the black love story *For Love of Ivy*. When the movie opened it was "attended by lots of ladies of both colors and all ages," reported critic Stanley Kauffmann. "When Poitier stepped out of his car to make his entrance, a sigh went around the theater..." The movie was the first Hollywood production ever to feature two Afro-Americans in a nude love scene, low on action though it was. It was a surprise hit that proved the studios wrong in their initial assumption that images of black beauty and sexuality would not cross over to white audiences.

THE ACCIDENTAL SEX SYMBOL Sidney Poitier became Hollywood's first male Afro-American sex symbol, although not by design. His early parts were designed as sexless, non-beauty roles, but women fell for him anyway.

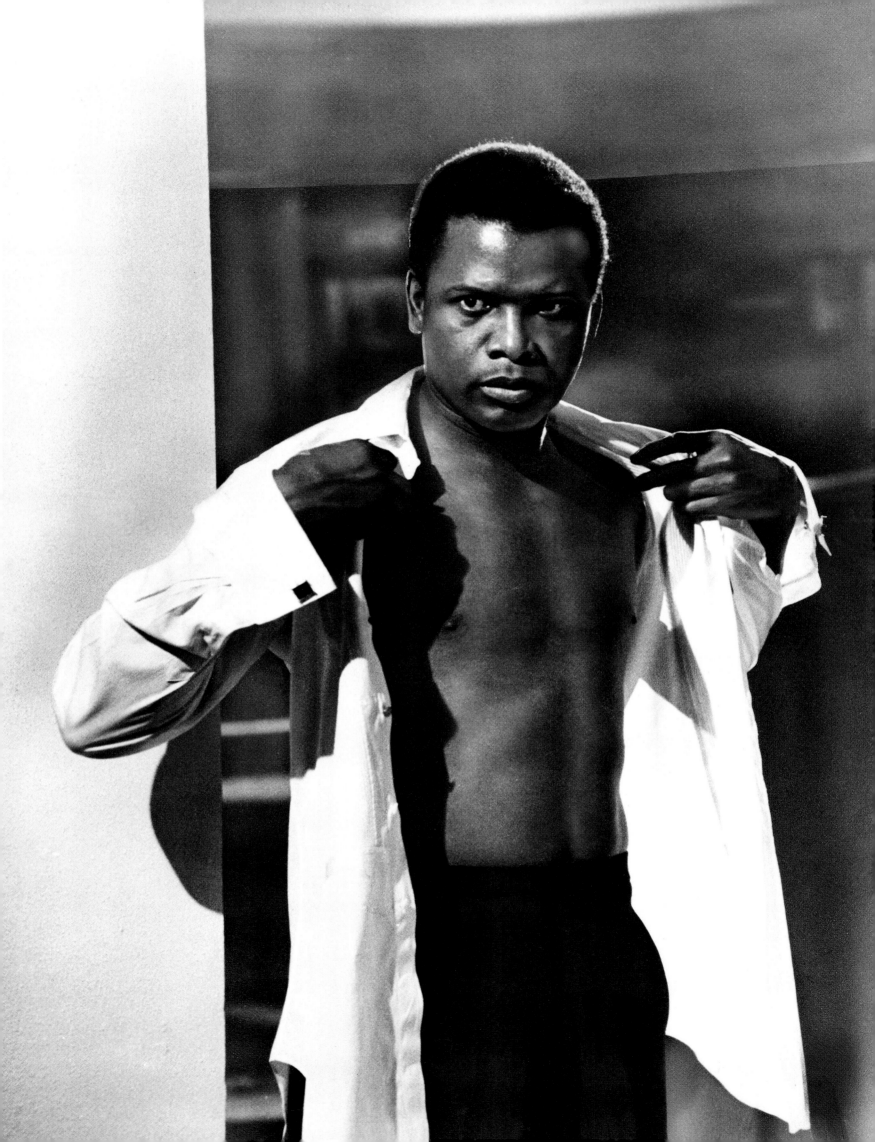

6

black
is
black

1970S

IN AUGUST 1974, AS NIXON RESIGNED over Watergate, another historic event was taking place down on the newsstands. Beverly Johnson – a former swimming champion from Buffalo who missed qualification for the 1968 Games by one-tenth of a second – was splashed across the cover of American *Vogue* – the last bastion of white beauty values. Swimming's loss was black beauty's gain as the new supermodel darkened the lily-white sheets of the fashion mafia's most cherished bible. Never before in the history of fashion photography had a single face carried so much significance for so many. And as Nixon was packing his personal effects into a cardboard box, the champagne corks were popping for Johnson as blacks, Mexicans, Puerto-Ricans, Native-Americans, and Asian-Americans all scrambled for copies. To people of color, this single event had more relevance than the first moon landing.

The 1970s ushered in a musical and aesthetic eclecticism not seen in previous decades. Disco produced Donna Summer and Sylvester, reggae promoted Bob Marley, and funk furnished a trailer-load of performers, led by Parliament and Funkadelic. Cinema spawned Blaxploitation, Bruce Lee, Cicely Tyson, and Billy Dee Williams. Modeling presented Beverly Johnson and Iman, while the tail-end of the Civil Rights Movement featured Angela Davis.

The fallout from the 1960s darkened the landscape of black beauty. Suddenly, after 400 years of "café-au-lait" favoritism, the color black had arrived in the beauty zone to balance the scales. But the celebrations were muted, for already the banner of "Black is beautiful" was fading to a faint blip on the Western radar, along with other ex-zeitgeist catchphrases such as "Ban the Bomb." It was born out of protest and it needed to survive – but who would help it do that? Malcolm X was dead and the Nationalists had been brutally crushed by the FBI's counter-intelligence program. The cause of aesthetic revisionism had lost its champions.

Nevertheless, the changes were marked. The era swept away much of the aesthetically derogatory imagery enshrined within American media and society and established new policies of aesthetic representation and accountability.

Within the cosmetics industry the range of make-up shades for the woman of color were still basic. "Make-up artists had to mix three or four or even five foundations to make one that was the right color for me," said Iman. "People would stop me in the street, asking where I got my make-up from, assuming that I had some wonderful secret supplier. But I mixed the foundations at home, too."

A new set of innovators were experimenting with new styles. Blaxploitation star Tamara Dobson as Cleopatra Jones wore a vampish-style make-up with thick eyelashes and plucked eyebrows drawn back on, Dr. Spock-style. During her disco phase Grace Jones combined heavy black eyeliner with plucked eyebrows and gloss lips. When she modeled in Paris she shared a flat with fellow model Jerry Hall and the pair would invent different looks and then hit the clubs. "Designers used to love to watch us walk in, to give them ideas for their next collection," remembered Jones. In 1970, Jean-Paul Goude devised a set of African-inspired stick-on facial scars for the model, Radiah. They were removable, like false eyelashes. "They emphasize the

FASHION OPENS ITS DOOR
Ex-swimmer Beverly Johnson as American *Vogue*'s first black covergirl, August 1974. The publication was the last major fashion magazine to use a black covermodel, after having abstained throughout the Civil Rights decade.

WHAT ARE YOU LOOKING AT?
Richard Rowntree as renegade detective Shaft, complete with trademark lightbulb Afro, mutton-chop sideburns, thick mustache, and "up yours" attitude.

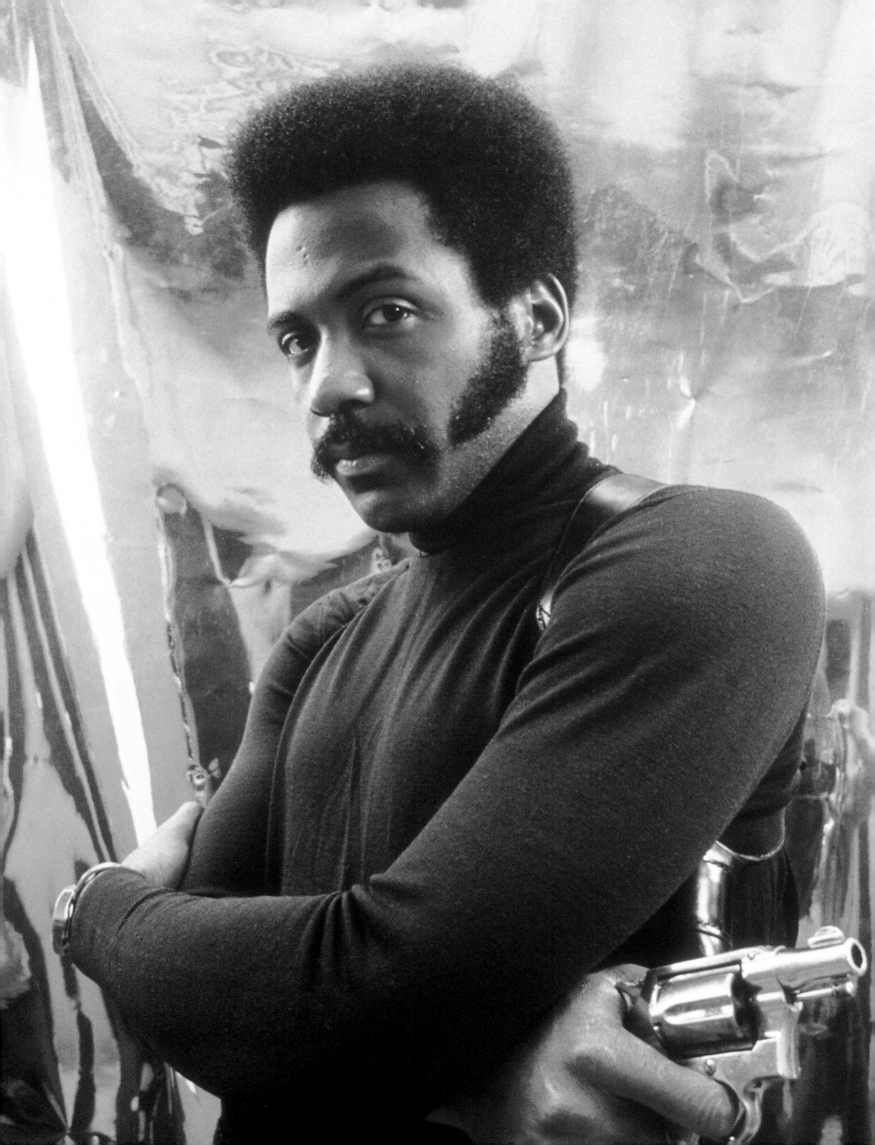

**A DIFFERENT
AESTHETIC**
The cornrowed
Cicely Tyson broke
the mould of the
mulatto-style diva
that had dominated
Hollywood since its
earliest days.

FUNK IN YOUR FACE
George Clinton's
outlandish hair and
make-up took black
male beauty to new
extremes.

savage aesthetics of the face," he explained nonchalantly in an edition of *Esquire* magazine.

Men also became serious about make-up. Everybody from David Bowie to Kiss were busy painting their faces, including a new generation of black performers such as Sylvester, Prince, and George Clinton and his P-Funk-Allstars.

Skin-lightening creams took a lower profile in the West during the resurgent Afro-consciousness, but in South Africa, sales were booming among those "chasing the dream." These products used mercury as the primary bleaching ingredient, despite the fact that it was known as a potential cause of brain damage. Excessive usage resulted in an epidemic of a skin disorder called ochronosis. In 1975 the active ingredient was changed to hydroquinone, but this, too, was potentially damaging. A report in the *British Journal of Dermatology* described how the chemical first bleaches the skin, then coarsens it, resulting in black lumps that can lead to abscesses and ulcers.

The Afro maintained its 1960s dominance as the most popular look for both men and women. Black males combined the style with "mutton-chop" sideburns, scraggly beards, and bushy downturned "Desperado-style" mustaches. Ironically, this was a beauty fixture they shared with the gay biker/construction worker look popularized by The Village People.

The Blaxploitation star Pam Grier's Afro was as round and as black as an LP record, but never flat, while Jim Kelly's in *Enter The Dragon* (1973) was shaped like a lightbulb. The funk-bassist Stanley Clarke customized his with a huge valley-like parting that looked as if it was made by an axe. The ensemble resembled a cheese with a segment missing. The Earth Wind & Fire singer Maurice White had a receding Afro that grew back and up at the same time, while Richard Pryor and Bill Cosby wore straggly, "nappy-headed" Black-Panther-style versions. The freckle-faced songstress Chaka Khan was a big woman with even bigger hair – her superbouffant was the size of three or four Afros re-worked into orbit around her head. Meanwhile, in 1971, The Jackson Five's Afros were immortalized in a popular cartoon series on ABC television. In 1975 Arthur Ashe became the first black winner of a Wimbledon singles title when he beat Jimmy Connors. His quiet dignity and trademark Afro turned him into black beauty's most significant sporting ambassador since Muhammad Ali.

The models Bethann Hardison and Toukie Smith wore short, boyish "naturals," disco diva Grace Jones cropped hers low, and Cameroon's Manu Dibango and Britain's Errol Brown of Hot Chocolate shaved their heads.

Ron O'Neal as *Superfly* (1972) was the first black actor to wear long hair that was not vertically coiffed. His hung straight down, back-combed and shoulder-length like the funkiest hippie in town, it was girl's hair on a macho man. His mustache was so thick that it constituted a hairstyle all of its own.

Blaxploitation extended the symbolism of the Afro to the black criminal. The genre created a new stereotype of the Afro-headed pimp, hooker, snitch, junkie, jive-talking gangster, or dope-dealing hustler.

Old World African hairstyles staged another comeback. Ex-model Tamara Dobson wore skullcaps and headwraps in the Blaxploitation film *Cleopatra Jones* (1973) and, braiding became popular among musicians including Randy Crawford, Stevie Wonder, and Patrice Rushen.

Traditionally, for blacks in the West the cornrow style was a children's hair-do. Wig-wearers also used it to keep their own hair as neat and flat as possible in order to accommodate a better fit. The look was always concealed and never worn externally – until the new Afro-awareness brought it out of the closet. Nina Simone, Cicely Tyson, and others adopted the style. Tyson appeared on the *Mike Douglas Show* wearing a Nigerian style called an Eko Bridge – an intricate crownlike plaited style named after a famous bridge in Lagos.

Historically, the appropriation of black beauty styles by whites through aesthetic transfer has effectively enhanced its status for the white recipient. This was no better illustrated than in 1979 when Bo Derek became an international sex symbol after wearing her hair in African braids in the movie *10*. Hers was a case, not of blond ambition, but of ethnic ambition.

In 1973 supermodel Naomi Sims retired from modeling and started her own wig business. The Naomi Sims Collection consisted of 15 different styles, using special synthetic fibers she invented herself. Gloria Gaynor, Iman, Donna Summer, the Three Degrees, and the actress Pam Grier formed a new generation of wig-wearers. Male grooming took another feminine spin when black men also began "wigging." Little Richard's band twinned Afro wigs with slashed-to-the-navel jumpsuits, while George Clinton and his P-Funk posse wore every kind of hairstyle and wig ever invented. Clinton's headgear remains as legendary as his music. He was the original punk rocker. He sported styles and colors that broke the rules before Johnny Rotten had even bought his first bottle of hairdye. He wore wigs curly, straight and in every conceivable length and color, from dirty-blonde to red. Mixed in with his multi-colored braids were beads, feathers, pieces of string, and all manner of random cargo, plus make-up, straggly beards, and crazy sunglasses. His whole head was a party. He was the brother-from-another-planet with a weekend visa pass from the hair asylum.

Incarcerated members of the Black Panthers began wearing Afro wigs as prison regulations prohibiting long hair meant that they couldn't "grow their own." The virile masculinity of the Panther members contrasted sharply with these curly-falsies. Here were these macho black heroes, wearing the same kind of fake hair as Diana Ross or Aretha Franklin.

In 1971 the Afro-wig proved deadlier than cyanide in its role in the assassination of Black Panther George Jackson in San Quentin Penitentiary. Jackson, originally incarcerated for robbing a petrol station, was one of the

HEAD TURNER
Stevie Wonder popularized elaborate African-style beaded braids amongst black performers.

THE FAMOUS FIVE
The Jackson Five doing it live. Their Afros were immortalized in a popular cartoon series on ABC television.

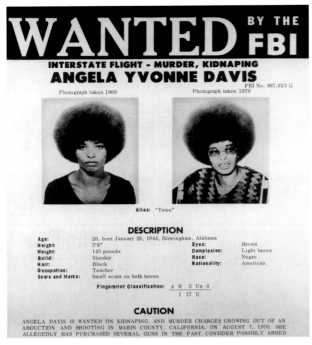

WANTED BY THE **FBI**

INTERSTATE FLIGHT - MURDER, KIDNAPING
ANGELA YVONNE DAVIS

FBI No. 867,615 G

Photograph taken 1969 Photograph taken 1970

Alias: "Tamu"

DESCRIPTION

Age:	26, born January 26, 1944, Birmingham, Alabama		
Height:	5'8"	Eyes:	Brown
Weight:	145 pounds	Complexion:	Light brown
Build:	Slender	Race:	Negro
Hair:	Black	Nationality:	American
Occupation:	Teacher		
Scars and Marks:	Small scars on both knees		

Fingerprint Classification: 4 M 5 Ua 6
 I 17 U

CAUTION

ANGELA DAVIS IS WANTED ON KIDNAPING AND MURDER CHARGES GROWING OUT OF AN ABDUCTION AND SHOOTING IN MARIN COUNTY, CALIFORNIA, ON AUGUST 7, 1970. SHE ALLEGEDLY HAS PURCHASED SEVERAL GUNS IN THE PAST. CONSIDER POSSIBLY ARMED

THE FUGITIVE WITH THE 'FRO
Communist intellectual and Black Panther sympathizer, Angela Davis was hunted by the FBI after some guns used in a hold-up were traced to her. "More than any other figure of the times, she equated the Afro with radical politics and revolution."

Soledad Brothers, three prisoners charged with the killing of a white prison guard in Soledad jail. On 21 August Jackson was shot dead by guards at San Quentin. Early radio reports crackled across the wire claiming that he had smuggled a bulky 9mm automatic pistol into the Adjustment Centre – a high-security wing of the prison – under an Afro wig. It was the lamest explanation for cold-blooded murder since Kennedy's "magic bullet." As Angela Davis listened to the radio talk shows, she said: "Over and over again, people commented on the contempt the administration had shown by not even constructing a sensible story."

A communist intellectual and Black Panther sympathizer, the super-Afro'd Davis was a sophisticated radical who had travelled Europe, studied at the Sorbonne and taught at UCLA. One of the few female stars of the Civil Rights era, she became an icon in August 1970, when she was placed on the FBI's Ten Most Wanted list after some guns used in a courthouse hijack were traced to her. The whole event, and the subsequent campaign to free her, turned her into a media celebrity, anti-establishment heroine, and beauty icon.

And yet there was something delicate about Davis's Afro that belied her reputation as a granite revolutionary and fugitive on the run. Her 'fro was a perfect orb – light and wispy as candy-floss, and sensitive as a dandelion in a breeze. When the sun shone through it, it radiated like light through a stained-glass window. More than any other figure of the times, she equated the style with radical politics and revolution. To the media she was "the fugitive with the 'fro," and in some ways the sheer presence of her supersized silhouette meant that she was bound to be caught eventually. Where could she hide, after all, with a 'fro that big?

In 1972 black Hollywood produced a new kind of sex symbol when Billy Dee Williams starred with Diana Ross in *Lady Sings the Blues* (1972). With his slicked-back hair and sculpted mustache he had the refined, sophisticated look of a 1920s jazz musician. He could have been one of Duke Ellington's side-men. While all his contemporaries were busy cultivating Afros, he ignored convention in becoming the first major black actor to have chemically straightened hair. "I never like natural hair on me," he said in *Men Of Color*. "It just didn't look right, and it was hard to comb. It's interesting how people think that straightening your hair is somehow the equivalent of rejecting your racial origin. I disagree. African culture is filled with examples of Africans using natural elements to straighten hair. It's not unusual in any culture for people to use various methods of adornment to make themselves attractive. It's not a question of trying to assimilate, but of finding things that work for you."

Dreadlocks came of age in the mid-1970s, as a raft of Jamaican reggae artists such as Black Uhuru, Eddy Grant, Bunny Wailer, and Peter Tosh sported vinelike tresses. Bob Marley became the first dreadlocked superstar, sparking the decade's growth in Rastafarianism and

NATTY DREAD
Seminal dreadlocked superstar Bob Marley. "Each chunky vine had a different character, and when he shook them onstage they swirled into orbit around his head like a fairground carousel."

popularizing the look internationally. "Bob Marley is the person who taught me to trust the universe enough to respect my hair," said Alice Walker.

Audiences worldwide were mesmerized by Marley's look: the lean frame, the low-glamour clothes, the chiselled face, and goatee beard, the Marvin-Gaye-style yearnful expression. And then there was the hair. "Bob was a great story," commented his biographer Stephen Davis, "a new kind of rock star...who wore his hair like a Gorgonian snake nest..." People had never seen a black man with hair like this. Each chunky vine had a different character, a different thickness, length, curve, or subtle coloring – and when he shook them onstage they would swirl into orbit around his head like a fairground carousel.

The Afro and dreadlocked styles led parallel lives. Both were innovations of the twentieth century that eschewed chemical straightening and were originally conceived not for any beauty purpose, but as symbolic representations of rebellion, identity, and Pan-Africanism. The styles were then appropriated as fashion statements. Both looks were imbued with a certain mystical, beguiling quality that made people want to reach out and touch them.

The Queen of Disco
Donna Summer "had the surprised, permanently pouty expression of a doll just off the production line, shocked to discover itself in the real world."

The revolutions of the 1960s paved the way for the new sexual and aesthetic freedoms of disco. For the first time, black artists were eulogized by the gay and lesbian community. Donna Summer, Sylvester, Gloria Gaynor, Evelyn "Champagne" King, Linda Clifford, Amii Stewart, Sister Sledge, and the ex-model Grace Jones all possessed an individuality of sound and style that pushed at the barriers of categorization and influenced a whole generation.

Boston-born LaDonna Gaines – otherwise known as Donna Summer – was the queen of the disco boom. Her image combined girl-next-door innocence with high-octane sexuality. The drop-out from high school had the surprised, permanently pouty expression of a doll just off the production line, shocked to discover itself in the real world. Her sensuous mouth – permanently ajar throughout ten years of photographs – was lipstick-painted a color that can only be described as "cherry-red-ripe," and her hair, a jet-black mass of curls, graduated down and across her shoulders like the perfect A-shaped mountain. She was a picture.

Her 17-minute epic single, "Love To Love You Baby" (1975) – complete with its deeply orgasmic moans and groans – earned her the title "First Lady Of Lust." *Time* magazine counted 22 "orgasms" on the million-seller, which was condemned by moralists and feminist groups, and banned from playlists.

The former LA child gospel star Sylvester James flouted sexual stereotypes and gender categories. *Vibe* magazine called him "the lip-lacquered Pied Piper of queerdom." He was disco's answer to Little Richard – a high-camp, flamboyant male diva who wore women's clothes and make-up, and didn't give a damn. In a famous incident on *The Joan Rivers Show* in 1987, he proudly flashed the wedding ring his lover Rick had given him. At a moment when the air was musty with the testosterone and overt machismo of Blaxploitation, Sylvester, with his Naomi-Sims-style statuesque physiognomy, high falsetto vocals, and man-to-man eroticism, provided a gutsy counterpoint.

The world of black modeling quietly continued its forward drive. In 1970 a new outlet for black models appeared in the form of *Essence*, an Afro-American lifestyle magazine with a bold mission statement. "You, the black woman in America are wrestling with your own identity and undergoing a process of change," the publisher Edward Lewis told its readers. "Above all, *Essence* is launched to delight and to celebrate the beauty of all Black women." Like its counterpart, *Ebony*, it would have to reconcile its editorial stance with its promotion of ads for "ethnicity-altering" cosmetics.

In 1971, three years before Beverly Johnson made the cover of American *Vogue*, Carol LaBrie became the first black woman on the cover of the August Italian edition. Renauld White followed suit in November 1979 as the first black male model to appear on the front of the national men's magazine *GQ*, and in 1976, Darnella Thomas featured in the long-running campaign for the fragrance Charlie.

But things were not all rosy, as the aesthetic oppression of black models was still very much alive. Three-times *Vogue* covergirl Peggy Dillard was a rarity in wearing her hair long and unprocessed. "Some people feel that in order to be a sophisticated, educated, intelligent Black woman, you must have straight hair," she said. "Some of the models are into that look, yet there are a lot who would prefer not to straighten their hair, but because of the money they do...I like myself as I am."

The volume of mainstream editorial and ad campaigns available to black beauties was as thin as the girls themselves, so they made the runway their own. The 1970s saw a huge demand for black runway models across Europe, as fashion finally woke up to the fabulous-factor of beauties such as Toukie Smith, Pat Cleveland, Peggy Dillard, and Grace Jones. "There was one season in Italy where I did 41 shows in one week," said Dillard. "I mean, people were pulling us off the street because black girls were really, really hot then," confirmed Sandi Bass.

In November 1973 a special runway event at the Palace Of Versailles became the defining moment for the black runway model. In celebration of the restoration of Louis XIV's 300-year-old palace, five American designers showed alongside five of France's best. The show featured a tour de force of two-dozen black beauties covering the whole aesthetic spectrum. When Bethann Hardison appeared in a tight-fitting yellow silk halter, "the audience exploded in a frenzy of approval," wrote Bill Cunningham in the *New York Daily News*. "They stomped, screamed and threw their programs into the air."

COOL GLAMOUR
Actor Billy Dee
Williams "had the
refined, sophisti-
cated look of a 1920s
jazz musician."

As a result, aesthetic transfer infiltrated the industry, as a new generation of "copy-cat" white models were drafted into the mix. "When the black girls would come down with their walk and the music, then the white girls started doing the same thing," said model Rene Hunter. "When did you see white girls get behinds? And lips? All of a sudden now all of the white girls have got big full lips and they've got nice little behinds and everybody's jiggling and wiggling."

"Models, what do they do?" Beverly Johnson had asked when friends first suggested that she take up the vocation. To Johnson's father they were no better than hookers, so he was less than keen on his daughter's prospective career. Nonetheless, the fresh-faced 17 year old with big hair and an attitude to match went ahead, marching straight into the offices of *Glamour* magazine and marching out just minutes later booked on a ten-day shoot on Fire Island. The pay for this first assignment was $300.

By 1975 Johnson had amassed a recordbreaking six *Glamour* covers and two *Vogue* covers, and had featured in Revlon's "Most Unforgettable Women in the World" campaign. The groundbreaking American *Vogue* cover of 1974 was significant not only politically, but also in terms of the nature of the photograph. Past covers had shown black faces obscured or diffused in side profile, or the models were chosen for their "exotic" lightness. Johnson's cover was a direct, unobscured full-face shot of a smiling, brown-skinned visage. Predictably, *Vogue* had opted for an All-American look with which to represent black beauty, but nevertheless it was a landmark.

And it sold. "When they took the first chance of putting me on the cover...they didn't know it was going to double in circulation," said Johnson. "It was because they had Chinese women buying it and Puerto-Rican women buying it and Mexican women buying it. They can't deny it, but they don't publicize it."

At a New York press conference in 1975, a group of 64 journalists gathered to listen to a Cinderella story about an illiterate 16-year-old chocolate-skinned tribeswoman, discovered while tending her family's herd on the plains of Kenya's northern frontier. The woman allegedly spoke no English, and all questions were answered on her behalf by the photographer Peter Beard, the man who "discovered" her. "Beard snagged the tribeswoman...away from her chores tending the family's 500 cattle and sheep," reported *Time* magazine. For three months Iman Abdulmajid played along with this elaborate hoax, listening to models on shoots bitch about her in front of her face because they thought she could not understand English.

The story was a potent fiction. Iman was in fact a well-to-do, multilingual diplomat's daughter and university major in political science, who was actually discovered on a Nairobi street. The hoax reheated the European cliché of the noble savage that had worked perfectly for Josephine Baker in the 1920s. In the ensuing role play Iman was cast as "trophy," and Beard as the "safari-suited big-game hunter" who had captured his prey and transported it to civilization for all to behold. It was a bad-taste joke that worked brilliantly – a fantasy straight out of a

Hollywood jungle movie or an Edgar Rice Boroughs novel. "I was totally pissed off at the representation," Iman later told British *Vogue*. "But that's the only way they would accept me."

And accept her they did, as the Somalian-born beauty, with her aquiline features and Nefertitian hauteur introduced a new strain of blackness to the model scene. But some whites could not believe that such beauty could be all black. "White people would ask, 'Are you mixed race?' As if I couldn't look good unless I was," she said.

In 1979 her African heritage attracted the attention of Revlon, one of the first major cosmetics houses to cash in on the developing market for black hair and beauty products, and she became the first model of color to sign an exclusive cosmetics contract for Polished Ambers, a new make-up line for dark skins. The deal was worth a reported $150,000.

Although a black model with an exclusive make-up contract was a major step in the right direction, the value of black beauty was still nowhere near as high as that of its white counterpart. In 1973 Lauren Hutton had signed for Revlon's Ultima brand for a reported $400,000, and in 1976 Fabergé paid Margaux Hemingway a cool $1 million to star in a series of fragrance ads for Babe.

The French graphic-artist and photographer Jean-Paul Goude internalized black aesthetic values in his beauty preferences. In his honest and brutally racist book, *Jungle Fever*, the Svengali behind Grace Jones's image of the 1980s describes his fascination with the black female form and physiognomy. "When I was at school I painted a nun and she was white, but she had a flat nose and thick sensuous lips. I realize now that I was painting a Negro nun." Goude eulogizes blackness; the first time he met Zou Zou, one of his many black lovers, he was drawn by her "flat nose, high round forehead, big lips, a cross between Marlon Brando and Ginette Leclerq. I was so overcome by her beauty that I couldn't find the courage to speak to her."

But then, like a modern-day Dr. Frankenstein, he embarked upon a series of bizarre graphic experiments, re-working the aesthetics of his black lovers to create his image of the ideal black woman. He made photographs, drawings and a 12-inch-high replica doll of model Toukie Smith, which he then set about "dissecting." "The real Toukie was a step in the right direction, but she was not quite like my drawings," he said. "I had to see my dreamgirl for myself and also show others my concept of beauty. So I started chopping the replica...elongating limbs and widening shoulders. Toukie's tits looked unnatural...So I chopped them off and made them more natural with big prune-like nipples." Goude's "cutting-up" of black women was a direct throwback to George Cuvier, the nineteenth-century Swiss anatomist who dissected the body of Saartje Baartman, the so-called Hottentot Venus, placing her parts on public display. Both men shared the same view of the black female as a sub-human object that could be ogled at and manipulated at will.

Goude remolded Toukie's whole body. "I always admired black women's backsides, the ones who look like racehorses," he said. "Toukie's backside was voluptuous enough, but nowhere near a racehorse's ass, so I gave her one. There she was, my dream come true, in living color." The result was a distorted, grotesque, X-certificate Barbie doll, sexualized beyond recognition.

Unsurprisingly, Toukie did not take kindly to the Svengali's work. "To my disappointment, Toukie hated what I did," said Goude. "I think it was the main reason for our separation...I saw her as this voluptuous girl-horse."

Goude's love of blackness was purely of the flesh. His girlfriends were raw material to him, not people, and he was not interested in their concerns. "Black Power didn't interest me much," he admitted. "...My enthusiasm was aesthetic." In fact, it was more than that. Goude's mission was to control black femininity – to colonize it, and for people to recognize the "creative genius" of his manipulative deconstructions.

The decade propelled a raft of black faces into mainstream television with a cluster of new shows that cast people of color in beauty roles. *Sanford and Son*, *Good Times*, *The Jeffersons*, and Alex Haley's *Roots* contrasted with British shows *Love Thy Neighbour*, *The Fosters*, and *Empire Road*.

A diverse range of black aesthetic styles began to emerge in Hollywood. Dark-skinned African faces such as Yaphet Kotto and Lou Gossett Jr. contrasted with the tough femininity of Vonetta McGee, Irene Cara, and Rosalind Cash. Diana Ross graduated from the sugarpop sexuality of The Supremes, reinventing herself as a sophisticated movie actress. Pauline Kael in *The New Yorker* described her performance in *Lady Sings The Blues* (1972) as "like a beautiful bonfire."

The James Bond movies are important indicators of the beauty standard, as it is estimated that half the population of the world has seen at least one of these epics. The first non-white Bond girls – Eurasians Akiko Wakabayashi and Mie Hama – did not feature until the late-1960s, in *You Only Live Twice* (1967). Blacks finally infiltrated the genre in 1971, when Trina Parks became the first black Bond girl, in *Diamonds Are Forever*, followed by the former *Playboy* bunny Gloria Hendry as an ass-kicking, Pam-Grier-type who beds Roger Moore's Bond in *Live And Let Die* (1973).

The Harlem-born actress Cicely Tyson began her working life as a typist for the Red Cross. Although this was a step up from a childhood selling shopping bags on the street at the age of nine, it still wasn't what she wanted to do. So one day she screamed across the office: "God didn't intend for me to sit at a typewriter all my life!"

Tyson bounced into modelling and thence to acting, eventually ascending into the Hollywood stratosphere with her Oscar-nominated role in the movie *Sounder* (1972). Pauline Kael called her "visually extraordinary," and she wasn't wrong, as Tyson's physiognomy broke the chain of

LIVING DOLL
Model Toukie Smith. Jean-Paul Goude made a 12-inch replica of her body, complete with distorted sexual organs.

Left:
AFRICAN QUEEN
Somalian super-model Iman's Nefertitian beauty introduced a new strain of blackness to the model scene. She was the first black beauty to secure an exclusive cosmetics contract.

HARD ACTION
Bruce Lee in fight
mode. He "gave
birth to a new kind
of colored hero."

Hollywood's 50-year line of "mulatto-only" divas that had begun with Nina Mae McKinney in the 1920s and went right through to Diahann Carroll in the 1960s. The new blackness that had revolutionized modelling in the 1950s and 1960s had finally reached Hollywood. Tyson, the female equivalent of Sidney Poitier, was often cast in stoical, rather than beauty, roles – playing women strong of spirit – but nevertheless she pioneered a new kind of low-tech, earthy beauty symbol for the times.

Bruce Lee, meanwhile, single-handedly transformed Hollywood's perceptions of Eurasians from victimized, uglified Charlie-Chan types into heroes and beauties. Initially, in similar fashion to the experiences of Lena Horne and Dorothy Dandridge, he was passed over in favor of the Caucasian David Carradine for the lead in *Kung Fu*, the 1972 TV series he devised. Hollywood producers told Lee that audiences "didn't want to see yellow faces." Nevertheless, when *Enter The Dragon* was released, three weeks after his death in 1973, "it gave birth to a new kind of colored hero," according to *Vibe*, idolized across the globe. "Everybody wanted to be Bruce," said Wesley Snipes. Japanese teenagers cut their hair like his, and hundreds of fan magazines, comic books, and martial-arts schools sprouted up. A theater in Iran played the movie for six years straight, and Elvis Presley bought a 35mm copy that he watched over and over again. *Esquire* reported that there were Malaysian tribes who worshipped him as a god. Today Jackie Chan carries Lee's legacy into the twenty-first century.

The Blaxploitation series of movies were popular because they depicted a black universe in which people of color triumphed. These pistol-packing, urban renegades were assertive, independent, and unapologetically violent, and they kicked white-ass – something movie-goers had never seen before. It was like cinematic revenge for 400 years of white oppression.

The genre represented the first time in history at which black characters possessed sexual personalities and were acknowledged as beauties – something that had been only hinted at in

BLAXPLOITATION
GODDESS
Pam Grier as *Foxy
Brown*, 1974. "The
movie featured a
scene in which she
pulled a gun straight
out of her Afro, like a
rabbit out of a hat."

the 1950s and 1960s. Now, in place of the sexless clowns, servants, and noble martyrs of old, the heroes of Blaxploitation were supervirile, drop-dead-gorgeous, and most of all, they had sex.

The movie that established the aesthetic of the genre was *Sweet Sweetback's Baadasss Song* (1971) written, produced, directed by, and starring, Melvin Van Peebles. "Of all the ways we've been exploited by the Man," he told *Time*, "the most damaging is the way he destroyed our self-image." The movie's success kicked the door back into the faces of the Hollywood powerbrokers who had denied blacks proper aesthetic representation. When the moguls smelled the money to be made, their fears of black sexuality suddenly evaporated, and they went into overdrive with a raft of releases between 1971 and 1974.

MGM released a little-known movie called *Shaft* (1971) which was only expected to do moderately well. Instead, it grossed $12 million, turning the former male model Richard Rowntree into an instant superstar, in only his second movie. As the Afro-headed renegade detective he became the quintessential sex symbol of the Blaxploitation era. "Hotter than Bond, Cooler than Bullitt," promised the promo.

"She's brown sugar and spice, but if you don't treat her nice, she'll put you on ice," proclaimed the poster introducing the former switchboard operator Pam Grier as *Foxy Brown* (1974). In a throwback to the assassination of Black Panther George Jackson, the movie featured a scene in which the queen of Blaxploitation pulled a gun straight out of her Afro, like a rabbit out of a hat.

Grier was Richard Rowntree's opposite number – a superchested, super-Afro'd, superbad macho goddess, who epitomized the tough black mama out for revenge. Both Grier and *Cleopatra Jones* star Tamara Dobson were unapologetically sexual with it. "Each was a high-flung male fantasy," said Donald Bogle, "beautiful, alluring, glamorous...ready and anxious for sex."

Maybe it was men who were more anxious, as the sexually combustible superstar, with her double-D front and cutaway curves, posed nude for *Playboy* and *Players*. In 1975 Grier became a feminist icon after she fronted the cover of *Ms.*, billed as "The Mocha Mogul of Hollywood."

Though Blaxploitation movies broke free from black Hollywood's past in depicting people of color in sex scenes, they also reheated one of slavery's oldest stereotypes – that of blacks as hyper-libidinous sex machines. But Blaxploitation offered a new context in which sex was an expression of independence and assertiveness. This gave the black hero the same sexual freedoms enjoyed by white heroes. After all, wasn't James Bond also hyper-sexual?

But hyper-sexual toward whom? Like Bond, Blaxploitation was criticized for its portrayal of women as disposable sex objects, and Grier's and Dobson's characters were accused of being mere male-fantasy fodder. But the very fact that there were now black sex objects for people of color to complain about was a marker of just how far they had come in the beauty stakes.

7

blacklash

"THE BLACK GIRL WON! THE BLACK GIRL WON!" screamed the mother of Ed Eckstine, president of Mercury Records and Vanessa Williams's future executive producer. It was 17 September 1983 and the reason for the euphoria was that Williams – a 20-year-old college student from Millwood, New York, had just made history by becoming the first Afro-American to win the coveted Miss America pageant. But celebration later turned to scandal, as just ten months into her reign of official duties – kissing babies, smiling tightly, signing autographs, and answering random questions on politics – she received an anonymous telephone call. The voice informed her that *Penthouse* was going to run a nude photo-spread she had posed for some time ago during a summer job in her freshman year. Instantly the beauty queen's professional smile tightened to a grimace. *The New York Times* described the offending shots as simulating "sexual relations with another woman." The pageant's executive director balked, demanding Williams's immediate resignation in the name of "traditional American values." But six years later, under the same system of values, a young white model called Cindy Crawford appeared in *Playboy*, and this time America fell in love with her.

The sonic forces of rap, electro, and house augmented punk, English-ska, and "New Wave" in defining the kinetic energy of the 1980s. Michael Jackson, Prince, and Grace Jones redefined gender boundaries, while Naomi Campbell and Vanessa Williams led the beauty stakes. *The Cosby Show* defined aesthetics for the modern woman of color, while cinema introduced the movies of Spike Lee and spawned a new crop of divas led by Whoopi Goldberg.

The early 1980s witnessed a beauty backlash against many of the changes and revisions of the 1960s and 1970s. The Afro was dead, Blaxploitation was over, and "Black Pride" and "Black is beautiful" were zeitgeist memories. Though positive and permanent gains were made, no sooner had the energy of black agitation cooled than many people withdrew their concessions toward black beauty, and individuals reverted to their old aesthetic choices. A re-evaluation of black aesthetic codes brought with it new hairstyles, new icons, and new attitude.

There were more developments in the world of hair and beauty. In 1985 Naomi Sims introduced her own skincare and cosmetics line, providing black women with a wider range of colors and shades, while a fresh generation of black male performers led by Prince and Michael Jackson augmented processed hairstyles with make-up. As whites took to sunless bronzing through sun beds and tanning tablets, Grace Jones went blue-black for the cover of her album *Nightclubbing*. Triple Olympic gold-medalist Florence Griffiths Joyner (Flo Jo) popularized the fashion for extended, talonlike nails, painted in rainbow colors; and in the late 1980s hip-hoppers such as Slick Rick and Public Enemy's Flavor Flav adopted gold teeth in the style of the early blues songstress Ma Rainey.

Aesthetic transfer evolved a stage further when collagen came into popular use as an age-management product and a beauty enhancer. Cosmetic surgeons began to swell thin lips to fashionable fullness as white women sought the voluptuous pouts that blacks had possessed since the dawn of time and Western culture had derided and ridiculed over four centuries.

SHE'S A WINNER
Vanessa Williams
cries tears of joy as
she is crowned
Miss America in
September 1983.

strange innovation – a post-Afro-Afro – an imitation of itself. Little Richard and Nick Ashford of Ashford and Simpson wore hanging versions, which fell like tresses about their shoulders. The look swept the American nation, coiffing the heads of Michael Jackson, Prince, Sugar Ray Leonard, and Philip Michael Thomas of *Miami Vice*, establishing itself as the era's hottest hairstyle for men.

It proved its flammability in 1984 when Michael Jackson's curls famously combusted during the filming of an ad for Pepsi-Cola. While the media gloated, Afro traditionalists looked upon it as a sign, a warning to those who dared tamper with the laws of nature.

The Nigerian-born ex-fashion designer and model Sade came from the Billy Dee Williams school of smoothness that eschewed the curly perm. Her perfect straight hair, pulled back off her face, obeyed the aesthetic formalism of jazz greats such as Duke Ellington and Billie Holiday, and accentuated the elegant mystique of her features.

The era witnessed a revival of the 1950s trend for big hair. The re-emerging Diahann Carroll opted for a superbouffant for her role as the shoulder-padded Dominique Devereux in the TV series *Dynasty* (1984–87). Tina Turner also made a comeback in 1985 with the multi-platinum *Private Dancer* and a thick wig to match. James Brown and his legendary hair-narcissism returned with a bouffant that was part Liberace, part Shirley Bassey, and part Joan Collins. He epitomized the new seriousness of male grooming. His hair relied on the two "C"s – care and cash, and he was more than forthcoming with both. In 1982 *Parade* magazine estimated his hairdressing bills at a massive $700 per week. On tour his non-performing entourage and equipment included several cases of rollers, hair-relaxers, and all manner of grooming products, plus his own personal hairdresser. His was the hardest-working hair in showbusiness.

In the late 1980s the trend for wig-wearing mutated into the "weave" hairstyle – a stay-on wig, in which real or artificial hairpieces are applied in strands to the top of the head and interwoven with the person's natural hair, which is plaited flat underneath to form a base. Unlike a conventional wig, once fixed in place, the weave remains in situ for the duration of wear, and behaves like real hair. The style provides straight hair without the damage caused by the heated comb or chemical relaxer. The earliest adopters were female performers – the same group that first wore wigs in the late nineteenth century – followed closely by fashion models.

Human hair used for weaves and also extensions is imported to the USA from countries including Russia, Italy, Spain, China, and India, where it is processed before being shipped to salons throughout the world. For many years there has been industry speculation that some of the human hair used for weaves comes from the heads of corpses. In *Bulletproof Diva* Lisa Jones cites the case of the New York veteran hair-processor Bill Tucciarones of BT Hair Goods. "As a teenager working at his grandfather's factory, he regularly saw pieces of scalp mixed in with the hair."

Dolls as beauty symbols became big business, and in 1980 Mattel launched the physiognomically Euro-centric, straight-haired black Barbie – "brown plastic poured into blond Barbie's mold," according to Lisa Jones. She was more Naomi Campbell than Whoopi Goldberg,

SMOOTH OPERATOR Nigerian-born chanteuse Sade, inherited the sophisticated aesthetic and elegant mystique of jazz greats such as Billie Holiday and Duke Ellington.

and unlike Jean-Paul Goude's sexualized, animalistic Toukie-doll of 1974, there were no extraneous bodily features.

Throughout the twentieth century, dolls have acted as crucial signifiers of the black self-image. In 1987 the clinical psychologist Darlene Powell-Hopson replicated a 1940s study in which children were shown black and white dolls and asked to choose which was good or pretty. A large percentage of children, black and white, chose the white doll as representing the positive values. Then the children were told stories that portrayed the black doll as a heroine and beauty figure, and the percentages reversed.

The Minneapolis-born Prince Rogers Nelson redefined what it was to be a beautiful black man. "For sheer girlish vulnerability there's no one around to touch him," wrote Bill Adler for *Rolling Stone*. Like Little Richard in the 1950s, Sylvester in the 1970s, and Michael Jackson in the 1980s, he blurred gender definitions and shocked and confused audiences. "Everybody thinks I'm gay or a freak and all kinds of things like that, but it doesn't bother me," he told the *Minneapolis Star* in 1980. "That's the way I am." Like Grace Jones, aesthetically Prince represented a new kind of popstar, not male, not female, but category three. With his long cascading hair reminiscent of *Superfly*'s Ron O'Neal, his sassy-ass cuteness, and his doe-eyed, come hither coyness, together with the wispy blouses and girly-girl clothes, make-up, high heels, and falsetto vocals about being someone else's girlfriend, he was effeminate to the bone – the last American dandy.

When Vanessa Williams was crowned Miss America in 1983, with her blue-green eyes and golden-brown hair, sections of the Afro-American community attacked her for the way she looked. "A lot of people thought I wasn't representative of a true African-American since I didn't have dark eyes and dark hair, and wasn't brown-skinned," she said. "So there was a division. It was hurtful to me initially, because this is the way I was born. These are the eyes I was given and this is the hair color I was given. I don't enhance it."

White extremists were also unhappy with the black beauty queen, and she received death threats from the Ku Klux Klan. "I had a whole FBI file of people who said they were going to kill me and my parents," she revealed. Williams was caught between a rock and a hard place – hated by the Klan and disliked by sections of her own people merely on the grounds of her biological inheritance.

Aesthetic intolerance within the Afro-American community was also causing problems for the black lifestyle press. In 1985 *Essence* ran a cover featuring the light-skinned, blue-eyed model Marguerite Erasme. The issue caused an uproar among readers who felt that she wasn't "black enough" but the beauty and cover editor Mikki Taylor defended the magazine's position. "We don't have the right to judge one another," she argued. "How Black is Black? She's black with blue eyes and she's still one of us...if you love *Essence*, then you have to love it when it gets down to the light end of the spectrum, too."

In the same year, another light-skinned black covergirl was rejected, this time by whites. Kenyan model and *Cosmopolitan* coverstar Khadija, a cinnamon-skinned beauty with cat's eyes

FEMALE SENSITIVITY "For sheer girlish vulnerability, there's no one to touch him," wrote Bill Adler for *Rolling Stone*. Prince's cross-sexuality redefined gender lines. He was not male, not female, but category three.

and big hair, became the first black model to front a crossracial make-up campaign, but her triumph was shortlived. "Sales went down because I was a black girl," she said. "People wrote nasty letters." The make-up sold well in France, but not America.

There was also a backlash against the 1970s boom for black catwalk models. An article in the influential *Women's Wear Daily* stated that the Paris runways were beginning to resemble Harlem's 125th Street. "That one sentence had a greater effect on the black models' income than any other phrase," said model Peggy Dillard. "The next season you saw less than half of the black girls that you had seen before. The season that followed that, you saw even less." Another model Bethann Hardison, saw it coming. "I kept thinking that the upsurge of black models was going to die at any minute, because I don't trust this industry," she remembered. "I know how it is: here today, gone tomorrow.'

In 1984 Hardison took action, setting up her own agency. Four years later she formed the Black Girls Coalition, a contingent of top black models dedicated to raising awareness about issues of race and representation within fashion. "Racism is practiced every day in the industry, but they just don't realize it," she said. "Minority money is being spent, and minority images are not being made."

A new generation of models such as Roshumba, Beverly Peele, Lana Ogilvy and Eurasian Arianne Koizumi began breaking into mainstream editorial pages and advertising, but it was a slow trickle. The dark-skinned beauty Aria featured in Ralph Lauren's first black ad in 1989, and Karen Alexander did covers for *Vogue, Elle, Harper's Bazaar,* and *Glamour.*

The 1980s saw the globalization of fashion, as brands switched from localized campaigns to pan-European initiatives. In 1984 Benetton launched its groundbreaking "All the Colors of the World" campaign, across 14 countries and featuring the entire spectrum of ethnic beauty. The concept of the "international rainbow" had begun with the Coke and Pepsi ads of the 1970s, and it would become the hot marketing ticket for the progressive fashion brands of the 1990s.

In 1985 the most notorious black model of the twentieth century was just a 15-year-old schoolgirl, walking home through London's Covent Garden when the hand of destiny struck in the form of a tap on her shoulder. "Do you want to model?" inquired the voice of the scout Beth Boldt, as her critical eye scanned the youngster's form. Thus did Naomi Campbell, born in South London, begin her ascent into the supermodel stratosphere.

Her timing was perfect for what modeling had become. A glamor-vacuum left by flashbulb-shy Hollywood superstars promoted models as surrogate celebrities. Raw beauty brought the power, status, and fame of an A-list movie star, and Campbell was the first black member of this new breed.

Naomi Campbell and the other supermodels were more than mannequins. They were the first models who dared. They acted like movie stars. They had famous boyfriends, made outrageous demands, and knew how to work the media. "There was a strategy that had to do with getting noticed," said photographer Steven Meisel. "It was simply a question of publicity."

BUDDING BEAUTY
(left) A young Naomi Campbell. "During her early photo-sessions, she perfected the startled expression of a deer that has just heard a twig snap."
(above) Her first American *Vogue* cover, September 1989.

But the real oddball among the group that included Jennifer Beals, Rae Dawn Chong, Irene Cara, and Debbie Allen was the dreadlocked Whoopi Goldberg. "When I started out, I knew I didn't fit any visual," she said. As far as Hollywood was concerned, her dreadlocks, dark skin, and African features constituted a triple-whammy which put her out of contention for sexual and beauty roles. "Out in Hollywood...you go for a role...and they look at you and say, 'Oh no, no, no, we need a really attractive woman,'...because of the way people perceive what you should be, you find yourself not included...you just have to remind yourself that what they're saying is not true. This has been a lifelong process."

Far left:
THE AESTHETIC ATHLETE
Carl Lewis's model looks turned sprinters into sex symbols.
Left:
FAMILY VALUES
The Cosby Show's Huxtable family defined the archetypal television image of black female beauty.

8

painted
black

"BEAUTY IS JOLTING," said Olga Viso, art curator at Washington DC's Hirshhorn Museum. Never was this observation more correct than in the winter of 1997, when the November edition of American *Elle* hit the newsstands with a picture of a teenage model from Sudan's Dinka tribe on its cover. The needle on fashion's seismograph went wild as the image of Alek Wek overshadowed Beverly Johnson's groundbreaking *Vogue* triumph of 1974. After a century of All-American beauty this was the single most significant cover in the history of magazines, and Wek was the most potent female visage of the twentieth century, breaking every rule of Western beauty values. Her hair was unfashionably natural, boyish, and as clipped as her surname. Her face, as black as midnight, was as round and sheenful as a freshly dipped championship bowling ball. Her features were unobscured and unashamedly African – low-tech and free of the cosmetic pot-pourri of processes, colorants, and other fancy jazz. She was so beautiful, she was ugly. Joltingly so. Ugly according to prescribed Western aesthetics, that is, whereby a woman like this was more likely to be cast as a victim of famine, flood, or military coup, the reluctant star of the latest African tragedy on CNN or a Live Aid clip.

As the new millennium rapidly approached, propelled by a pulsing cocktail of rap, R&B, and rock, the 1990s swept in a new generation of black superstars. Alek Wek was joined by the supermodels Tyra Banks, Veronica Webb, and Tyson Beckford, and music released an avalanche of new beauties, from Lil' Kim to Lauryn Hill. Hollywood produced its own cargo, from Denzel Washington and Wesley Snipes to Halle Berry and Jennifer Lopez, while sport offered up Michael Jordan and Dennis Rodman, and Oprah became a TV legend.

The 1990s saw the promise of all the previous decades come to fruition.

Telecommunications and a "one-world" culture ran parallel to new terms such as "global beauty," which inspired new exponents of diverse beauty to challenge the status quo. Women became inspirational, strategic power-players – independent, outspoken, and in control – and to accompany this, new high-tech cosmetics turned beauty into a purchasable commodity – pro-choice and apolitical. The full spectra of Afrocentric and New World hairstyles co-existed in contrasting juxtapositions of color, construction, and attitude. Elsewhere, black faces proved their commercial appeal in selling mainstream products to young urban consumers. Anything painted black was white hot.

More than ever, the 1990s was a cosmetics decade. When the supermodel Veronica Webb was asked how long it took to make her beauty natural, she replied "Two hours and $200." "Fake" was no longer as dirty a word as Alexander O'Neal made out in his barnstorming hit of the same name. Artifice was the most popular form of reality, as processed hair, wigs, and weaves were bundled into the same user-category as colored contacts, nose jobs, boob jobs, collagen lips, liposuction, and facelifts.

For the better part of the twentieth century black females had spent millions on cosmetic products designed for white women. The 1990s witnessed an explosion in the volume and diversity of new lines aimed at the woman of color, as independent and mainstream

REDEFINING THE
RULES OF BEAUTY
Sudanese
supermodel Alek
Wek makes the cover
of American *Elle*,
November 1997.

ELLE

E 25 L
E

**TAKES ON
THE SEXY SUIT
THE ULTIMATE
GETAWAY CLOTHES**

FASHION
HEATS
UP

GLOWING
SKIN HOW TO
GET IT
HOW TO
KEEP IT

**EXCLUSIVE:
LOVE IN
THE '90S**
RICHARD GERE,
PAUL REISER
PLUS A LITTLE
ADULTERY
AND A WHOLE
LOT OF LUST

0 274921 9

02492

11

NOVEMBER 1997
USA $3.00
CANADA $3.50

manufacturers alike finally woke up to the consumer demands and financial muscle of the ballooning black economy. "Mainstream companies have always left the black market alone, but now they can no longer ignore it," said make-up artist Ellie Wakamatsu. "The market for skincare and beauty products must move to appeal to individual needs," the Estée Lauder president Robin Burns told *Harper's Bazaar* in 1995. The industry went through its own Civil Rights revolution, and for the companies eager to cash in on the black market, the figures were juicy. In 1992, Afro-Americans made up 12 per cent of the American population, and yet they purchased 34 per cent of all haircare goods.

Iman responded by launching her own company, IMAN Cosmetics, in 1994, and by end of the century all the leading cosmetics names, including Clinique, Chanel, MAC, and Bobbi Brown would all be producing lines for the woman of color. For the new generation of black-blondes, L'Oréal introduced its Féria range, while Clairol, the company that had revolutionized the industry back in the late 1950s by inventing the first bottle-blonde home dyeing kits for whites, produced a specially formulated hue for black heads.

Significantly, the new ranges were not marketed as "separates," but as integrated components within the broad tonal spectrum – from translucent-white right through to blue-black. The industry adopted more of a "world" view, and much of the emphasis shifted to the creation of multi-racial products that could be used by anybody and everybody. Iman's range I-Iman catered for all skin-shades. "Global beauty" became the new slogan, expanding the remit of "Black is beautiful." Aesthetics was no longer a simple case of black or white, but a multi-brew of ethnic denominations. The melting-pot theory as applied to face powders and lipsticks had finally arrived.

An eager generation of black beauties rushed to re-kit their make-up bags with the new products. When the model Tyra Banks started doing runway, to avoid the ever-long make-up line she would arrive with her own arsenal of 30 lipsticks and eyeshadows ready to take charge of her own artifice. Supermodel Veronica Webb carved out her own niche by making herself over. "I sort of invented this look for myself," she said. "I cut my hair really short, in a bowl cut, and drew on these really big, long, thick eyebrows."

No one was more fond of make-up's new possibilities than pint-sized rapper Kimberly Jones, a.k.a. Lil' Kim, who wore gold and pink shades with bleached eyebrows. Nzingha, her make-up artist, said: "Kim loves fashion and will try anything in terms of make-up. She's the black Barbie." The self-titled "Queen Bee" was the most high-maintenance diva of them all – the most cosmetically constructed black star since The Supremes. She had false hair, false lashes, false eye color, false breasts, and a false name. Rival cosmetics brands jostled hard for the privilege of having her use their products. "Sorry, Chanel," Kim said on one occasion. "It used to be their lipliner until Iman sent me boxes of her make-up when I was on tour."

The logical step to ensure brand loyalty and influence consumers was to sign these stars as spokesmodels. Iman was make-up's first black contract girl back in 1979, and by the 1990s the remit had expanded to include entertainers as well, and an army of new endorsers were drafted into the breach. MAC signed the drag queen Ru Paul in 1995, followed by Mary J. Blige and Lil'

BLONDE AMBITION
High-maintenance rap diva Lil' Kim, "the most cosmetically constructed black star since The Supremes."

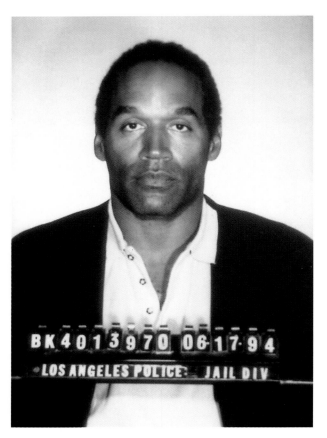

**How O.J. Got
Blacker**
Time magazine
darkened the face of
O.J. Simpson for its
June 27 1994 cover,
a move which was
interpreted as a
deliberate revisita-
tion of the historical
legacy of dark skin's
association with evil.

Kim in 1999, while Cover Girl signed supermodels Veronica Webb, Tyra Banks, Lana Ogilvy, and songstress Brandy. L'Oréal secured ex-Miss America Vanessa Williams, Jennifer Lopez, and models Kiara and Janine Green, while Revlon signed actresses Halle Berry and Salma Hayek. Maybelline contracted model Tomiko to partner Christy Turlington, while Wella won Naomi Campbell, and Alek Wek became the face of Nars.

These promotions keenly illustrated the extent to which the marketability of black beauty had evolved. But, once again, the question of the style of beauty being pushed was still an issue. With the exception of Alek Wek, these campaigns exclusively promoted a world of Europeanized aesthetic values in an unbalanced ratio that left ethnic beauty at the gate.

The desire for pale skin continued to preoccupy ethnic groups. "I'm asked to do make-up at Asian weddings, and the bride always wants to be lighter," said make-up artist Ruby Hammer in British *Vogue*. "They don't like it if I match the make-up to their real skin tone." On the Indian sub-continent the skin-lightening cream Fair & Lovely held firm as its best-selling cosmetics product, while in Japan sales of skin-whiteners rivalled those of lipsticks and cleansers. Tokyo women clung to the belief that good skin is clear, white, uniform, and free of blemishes or freckles.

In 1992 the sale of across-the-counter skin-bleaching creams containing hydroquinone was banned in South Africa. An active black-market trade in creams with illegally high levels of hydroquinone – many of which were imported from English manufacturers – flourished. "It is another example of the exploitation of the Third World," said South African dermatologist Dr. Hilary Carman. "Like women the world over, Africans are buying a dream and are being sold a lie." More recently, the Internet also became a conduit for sales of high-strength products with names such as Fair Skin Fading Solution, White Night Restore, and Triple Action Skin Lightener.

In April 1997 Britain's *Independent on Sunday* newspaper reported on the continuing use of skin-lightening creams with hydroquinone levels of up to eight per cent. For some users the results were disastrous. "It became difficult to apply make-up, because it would slide off my face after a few hours," said Sarah, an unemployed graduate who had been mixing different creams together. "My dermatologist told me my skin is permanently damaged. It won't absorb anything, not even moisturizer."

There was no clearer indication that dark skin was bad news than the events of 27th June 1994, when *Time* magazine published its notorious O.J. Simpson cover in which the photograph of the ex-football star's face was darkened – a move which was interpreted by some as a deliberate attempt to demonize him. The association of dark skin with innate evil dates back to the early Christian Fathers of the third century. Now, many centuries later, this association was still as strong and as resonant as ever, preserved through the technological innovation of computerized image manipulation.

Benetton made use of the same technology a year earlier, causing controversy when the June edition of its in-house magazine, *Colors,* featured a series of aesthetic transfer vignettes in which popular icons were "race-reversed." Spike Lee and Michael Jackson were depicted as white, while Arnold Schwarzenegger and Queen Elizabeth II were rendered in blackface. The British tabloid press were outraged by the Queen's retouched visage. One newspaper referred to the image as "a racial slur," despite the fact that the Queen actually has a distant black ancestor – German-born Queen Charlotte Sophia (1744–1818) the mixed-race wife of George III.

The decade saw a boom in body accessories, as gold became a popular oral addendum among an array of performers, from Mary J. Blige to the Wu Tang Clan's Method Man and RZA. The Brooklyn rapper Just Ice sported a mouthful of 30 glimmering gold ones. "Women love it," he said. "They lick my teeth." Meanwhile the rapper Slick Rick and the English soul songstress Gabrielle wore Jolly-Roger-style eyepatches, and rappers Eve and Missy Elliott adopted Flo Jo-style nails in metallic and day-glo colors. Ex-SWV songstress Coko's talons were so long that she had to use her knuckles to dial telephone numbers. Body piercing also became popular, and Charli Baltimore, Jodeci, and Tyson Beckford, among others, adorned their bodies with elaborate tattoos.

In 1970 Pecola, the character in Toni Morrison's debut novel *The Bluest Eye*, prayed for God to grant her blue eyes, like the white girls in her neighborhood had. This genetic fantasy became a reality in the 1990s, as the gods of cosmetics came through with a proliferation of colored contact-lenses. Post-modern Pecolas could now have not just blue eyes, but any color they wanted. Ads began appearing in the black lifestyle press alongside those for hair-straighteners and skin-lighteners, and they fast became a standard accessory for black supermodels and R&B divas such as Naomi Campbell, Foxy Brown, Eternal, and Lil" Kim. "My eyes are cosmetic," said Campbell. "It's like make-up. I change them all the time." Lil' Kim's baby-blues were not so much lenses as "eye-couture" – custom-made, handfinished high-fashion items, with a laminated surface to create a special 3-D effect – all at a cool couture price of $1,250 a pair.

There was also an explosion of ethnic and New World hairstyles. The Nubian-style shaved head was enjoying its most popular decade among a host of rappers, sportsmen, movie stars, and male models. Onyx, Guru, Ice Cube, R. Kelly, Tupac Shakur, Samuel L. Jackson, Ving Rhames, Tyson Beckford, Charles Barkley, and Shaquille O'Neal all adopted the low-maintenance look. "Shaving has become an equal-opportunity fashion statement," noted *Vibe* in 1993. "Not just for skinheads, Muslims, frat boys, and prisoners anymore. Almost anyone can do the dome." The actress Rosie Perez expressed a special weakness for a chocolate-headed curve. "Black men make my nostrils inflate," she said, "especially if they're bald-headed."

Hairlessness focused attention on the shape of the head as a beauty symbol. "By taking away the hair, we now radically adjust to the head as a whole," wrote Nancy Etcoff in *Survival of the Prettiest*. "Does anyone remember how Michael Jordan looked with hair?" "Or Yul Brynner?"

GOLDEN BROWN Cosmetics house MAC signed quintessential black-blondes Mary J. Blige and Lil' Kim as spokesmodels for their Viva Glam III lipstick range.

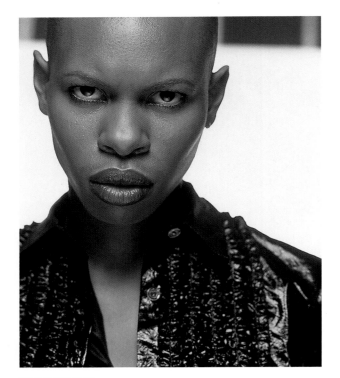

CHOCOLATE CURVES
"Skin, from British
rock band Skunk
Anansie combined a
shaved head with
gloss lips remiscent
of Grace Jones
during her 1970s
disco phase."

Jordan's was the most significant dome since the boxer Jack Johnson's, and he did more to popularize the look than any other star of the decade. Hair was excess baggage to his lean, mean exo-skeleton – no help to a man with such an utter disrespect for gravity. Everything had to be wafer-light to make the hoop, like a rocketship striking out for Mars. Shaving down was a ritualized way of shedding payload.

For women, the cropped or shaved head symbolized a new, sexually androgynous beauty first pioneered by models such as Pat Evans and Bethann Hardison in the 1960s. It blurred the gender boundary between male and female. For the bald-headed bisexual bassist and singer Me'Shell NdegéOcello it represented a battle against perceptions. "In this culture, if you don't have hair, you're not considered attractive," she said. "Like, when I go in the bathroom...women go, 'Oh, you have the wrong bathroom." She shared the look with Skin, of the British rock band Skunk Anansie, who combined a shaved head with gloss lips reminiscent of a late-1970s Grace Jones during her disco phase. "I wanted to look different," she said. Elsewhere, Alek Wek and the Eurasian model Jenny Shimizu sported short crops, as did Jada Pinkett-Smith, Halle Berry, and British singer Gabrielle.

Black men were adopting a broader, bolder attitude to hair creativity. "I've had every kind of hairstyle you want to imagine," boasted Coolio, whose speciality was a splay of Nigerian-style pipe-cleaner plaits that resembled the silhouette of a tree in winter. Snoop Doggy Dogg also sported a variety of styles, including a center-parted, straight-haired bob, an Afro, and his trademark cornrows, customized with an array of hanging schoolgirl-style pigtails. The look offset the gaunt-cheeked narrow architecture of his face, with its thin lips, lurching profile, and sharpened nose.

Cornrows were also adopted by black stars such as the Wu Tang Clan, D'Angelo, Maxwell, basketball's Allen Iverson, and the female rapper Da Brat. Braiding became popular with everyone from kiddie hip-hoppers Kris Kross to Janet Jackson, Brandy, Jade, and Dutch soccer ace Edgar Davids. Jamaican dancehall songstress Patra's ropelike braids were as thick as fingers, and snaked half the length of her bodacious form, halted only by the curve of her behind. Hip-hopper Krazie Bone had a variation tipped with dangling mini-skulls, while the rapper Yo Yo and Beyoncé Knowles from Destiny's Child cross-pollinated their vinelike tresses with blond-colored plaits.

Braids, beads, and biceps provided a winning combination for the fierce tennis of Wimbledon champions Venus and Serena Williams, who followed in the footsteps of Patrice Rushen and Stevie Wonder in reviving the trend. Theirs was an innovative color contrast of grapelike-clusters or hanging strands of white beads, laid through furrows of black braids and finished upon shiny brown skin.

The Afro made a series of cameo appearances throughout the 1990s, coating the heads of Snoop Doggy Dogg, Ice Cube, Maxwell, Macy Gray, and Lenny Kravitz. In a throwback to the

CHOCOLATE CURVES
"Michael Jordan's
was the most
significant dome
since boxer Jack
Johnson's."

1970s, the Nigerian supermodel Oluchi bore an Afro-wig on the cover of the August 1999 edition of the London style-zine, *i-D*.

Black jew Lenny Kravitz reminisced about the bouffant he had as a youngster. "I remember once I went to Hebrew school...and I had this big-ass Michael Jackson Afro," he said. "Anytime I went to temple, it was like, Okay, how am I going to get my yarmulke to stay on? I had to pin it."

The Harlem-born songstress Kelis had similar childhood "tales from the 'fro." "Everyone else had straight hair and I had this big hideous knotted ball on my head," she recalled in *The Sunday Times*. "I didn't know what to do with it. My mum tried to slap it back in a ponytail, but it always looked awful."

Dreadlocks were embraced by a whole new generation of performers, as both a style statement and symbol of ideological significance. Wyclef, Lisa Bonet, Toni Morrison, actors Gary Dourdan and Glenn Plumber, and the children of the late Bob Marley all sported the style. Its rebellious connotations and popularity with young opinion-formers was not lost on the mainstream fashion brands, and the decade saw dreadlocked models appear in ads for Gap, Benetton, Tommy Hilfiger, and ckOne.

Lauryn Hill broke new barriers in becoming the biggest dreadlocked superstar since Bob Marley. She scored a double coup in 1999, becoming the first dreadlocked coverstar in history to appear on the covers of the mainstream fashion titles, *Vogue* and *Harper's Bazaar*.

But the social stigma attached to some ethnic hairstyles still loomed large. In New York in June 1998 Afro-American United Parcels Service (UPS) driver, Charles Eatman, was suspended for refusing to wear a hat to cover his dreadlocks while on the road. In the same year Detroit car mechanic, Robert Frett, was sacked after he began growing locks. "My manager...told me I couldn't wear my hair like this; it was against policy," he said. In Zimbabwe, a dreadlocked lawyer, Munyaradzi Gwisai, was barred from court for two years after the judge described his hair as "unkempt", while immigration officials in the British Virgin Islands placed a blanket ban on all visitors wearing the style. When the dreadlocked *Newsweek* and *Harper's Bazaar* freelancer, Veronica Chambers tried to get into a local nightclub during a trip to the Bahamas, she was directed to a sign that read: "NO JEANS. NO SNEAKERS. NO DREADLOCKS."

This was not the only ethnic hairstyle to be ostracized. In 1993, after wearing braids to work for nine months, American Airlines employee Barbara Cooper was ordered to have them removed, as they were considered "too ethnic." The case ended up in court. Similar disputes were ongoing with the Marriott and Hyatt hotel chains. "Companies like Disney called me when the...suits were raging and asked me what they should do to change their policy," attorney Eric Steele told *The Source*. "They didn't want to wait until an employee sued them."

Cases of discrimination became so serious that in 1997 Congresswoman McKinney, along with the Congressional Black Caucus, initiated a forum to discuss the topic. "We found that discrimination against African-Americans who wear their hair natural is very serious," she said. "We're going against a global trend that has existed since the earliest days of colonialism."

Meanwhile hair discrimination within fashion had reached its 50-year anniversary. In 1999 19-year-old Kenyan model Agola Kataka became the latest victim of the West's hair oppression.

WE ARE THE CHAMPIONS
Wimbledon winners Venus & Serena Williams brought traditional braided hairstyles into the sporting arena.

Left:
LENNY CHECKS HIS HEAD
R&B sex bomb Lenny Kravitz traded in his dreadlocks for the wild, crunchy Afro he originally had as a youngster.

"Upon the advice of her agency, she had her Afro straightened," reported *Harper's Bazaar.* "It's different," sighed Kataka. "Even if I miss my own hair, I'm liking it."

The weave became the standard hairstyle for black girl-groups, hip-hop-soul singers, and supermodels. SWV, En Vogue, TLC, Whitney Houston, Robin Givens, and Naomi Campbell led a bevvy of black brunettes. Naomi was famous for many things – habitual lateness and famous boyfriends among them – but within the black community, it was her "Pocahontas-hair" – straight as an ebony waterfall – that was her trademark. She was the decade's quintessential example of the look. She did for the weave what Michael Jordan did for the bald head.

Campbell also epitomized the high-maintenance obsession that black women have with their hair. She even planned her work schedule around it. In the March 1999 edition of American *Vogue,* Jonathan Van Meter detailed a fascinating "hair moment" he overheard Campbell having with someone on her cellphone. "Hello?...Will you please bring some relaxer," she stressed. "I don't know how we're going to do this because they're telling me now they want me to do pictures all day Friday morning...In Milan...I told her my hair needs to be done...You're gonna take all my hair with you, right?...You're saying we shouldn't redo, we have to just fix up? But we have to redo for couture, and that's next weekend...So do we do it in Paris...Or do I have to stay an extra day in New York to do it?...You have to let me know so I can plan my schedule."

The history of black hair is also a tale of the struggle of black women to keep their hair away from water, which causes it to shrink and go superfrizzy. Water is to a black woman's hair what Kryptonite is to Superman. "When I was first training for the marathon and it was raining, I said to Bob, my trainer, 'Can't go out today,'" recalled Oprah Winfrey. "And he said, 'Why?' and I said, 'I cannot get my hair wet. What's wrong wit' you, white boy?...I will turn to stone!'"

The hair ads of the 1990s continued to exploit the apprehension that African hair was innately defective. "Get Straight," commanded the headline of a 1999 ad for a hair-straightener by Dark & Lovely. "...if my hair's straight, I'm straight," it said matter-of-factly. "If you want to get control of your lover, you have to get control of your hair," read the copy for an ad for Optimum Care, in the September 1998 edition of *Essence.*

Musicians continued the tradition of self-invention through hair. The R&B songstress Kelis colored her corkscrew psychedelic Afro bright fuchsia, and bleached her eyebrows, while Queen Pen wore straight red locks reminiscent of the early vaudeville performer Clara Smith. Yet this was nothing compared to Janet Jackson, who continually reinvented herself, utilizing every hairstyle in the book, from curly perms to straightened locks to bouffant ringlets to chunky rope braids and back again. Meanwhile TLC's Lisa "Left Eye" Lopes had "Star Wars" hair – an outlandish, futuristic set of dangling, tentaclelike pigtails.

The mystic chanteuse Erykah Badu recoded and reclaimed the headwrap that had been a marker of ugliness and derision throughout Hollywood portrayals of mammies and Aunt Jemimas. The Dallas-born earth-mother did for the style what Little Richard did for the conk back in the 1950s. She innovated by extending it. Hers was not just a wrap but a towering cocoon – a supercharged turban that came in a range of interchangeable fabrics. "I've always

wanted to go against the grain, to go for what was different, to be an individual," she said. For adding instant height, it was more effective than a platform shoe, and the mystique of its form left one yearning to explore the secret content of its interior.

The period also saw an upsurge of blond ambition within black beauty. Blonde streaks, white flashes, platinum weaves, wigs, and extensions draped the heads of a bold new era of make-over queens. Lil' Kim, Mary J. Blige, Faith Evans, Whitney Houston, The Braxtons, Pepa, TLC's T-Boz and the drag queen Ru Paul all adopted the twentieth century's most eulogized hair-tone. The notorious black-blonde Lil' Kim had been wearing platinum and colored wigs since the age of 14, while Mary J. Blige was an "every-blonde" who changed styles like underwear, from a bouffant of ringlets to a bob to long, flyaway tresses. Her look contrasted with the skull-tight platinum do and Grace Jones-like androgyny adopted by the female rapper Eve, while L'Oréal model Janine Green wore a blond mini-Afro in the ad campaign for the Féria range of dyes.

In his 1994 book *The Art of Make-Up* Kevin Aucoin gave Grace Jones a blond makeover, lightening her skin with a pale foundation, and fitting her with a blond wig. "I realized that the most shocking thing I could do with Grace would be to transform her to look the polar opposite of the way she usually does – a black Marilyn Monroe," he explained.

At the same time platinum cropped hair became fashionable among black men such as the R&B singer Sisqo and the English soccer player and former Armani model David James. Goldie's golden crop was razor-indented with a herringbone pattern. Dennis Rodman's multi-toned hair constituted the decade's most radical look. His whole head was a celebration of day-glo punk-rock colors, like a 1980s b-boy's best graffiti transferred from the side of a New York subway train.

But what was the nature of the black ambition for blond? Clearly, these stars dyed their hair not to be "unblack" but to be different. To have standout appeal. It was a high-definition ploy – an attention-seeking breakaway move. "When I put on a blond wig, I am not selling out my blackness," stated Atlanta-born dragster Ru Paul. "Wearing a blond wig is not going to make me white...I want to create an outrageous sensation, and blond hair against brown skin is a gorgeous outrageous combination."

TWO-FACE
Top: Ru Paul, the hip-hop generation's answer to Dame Edna, in full tilt. *Below:* The drag queen as himself.

The culture of aesthetic transfer exploded into a swapshop of beauty styles. While blacks appropriated Euro-style blondness and long, straight, flyaway hair, fly white girls and fashionistas swapped blond ambition for black ambition by braiding and cornrowing, as Madonna did in the 1995 video for her hit 'Human Nature'. The fashion designers Gaultier, Versace, and Givenchy featured the styles in their runway shows. "Trustafarians" from London's Notting Hill to the ski-towns of Colorado joined Rasta-Buddhists and New Age hippies in adopting dreadlocks in a range of crosscolors, and people were "locksing" from New Zealand to India, (where the style is called "jatta.") Meanwhile braiding centers sprang up in Jamaica around Montego Bay and other areas, catering for the tourist trade, and white holidaymakers suddenly turned "black," returning home deep-tanned and fully braided.

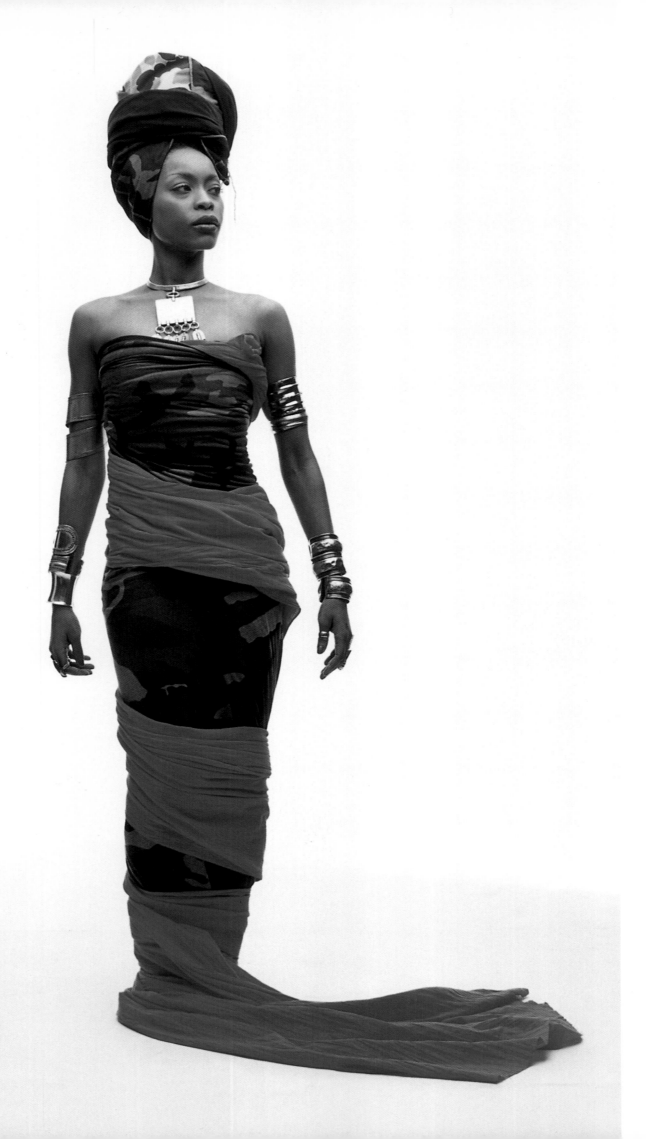

SHIFTING
AESTHETICS
Mystic chanteuse
Erykah Badu
"reclaimed the
headwrap that had
been a marker of
ugliness and
derision."
Right: Dennis
Rodman's multi-
toned hair and full
make-up made him
the twentieth
century's most
radical black beauty.

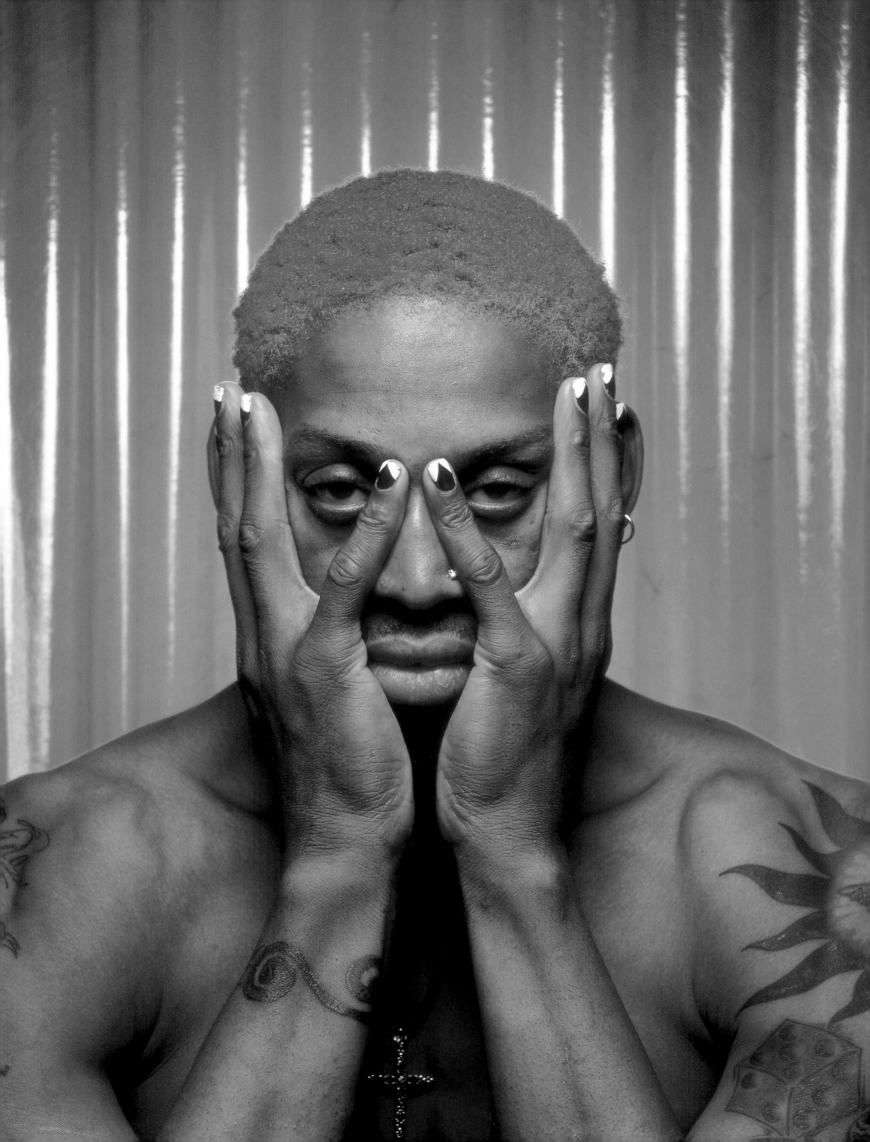

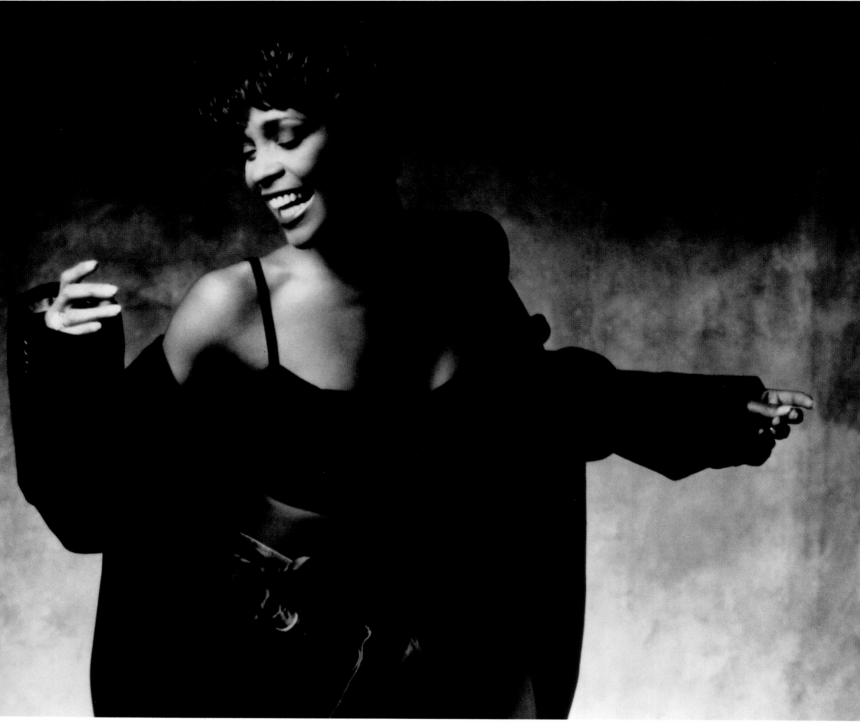

STRAIGHT AHEAD
Whitney Houston led
a bevvy of straight-
haired Afro-
American vocalists –
a performance
tradition stretching
back to the late
nineteenth century.

Indian aesthetic motifs also became fashionable. Demi Moore and Madonna had themselves painted in the intricate patterns of *mendhi*, a reddish, henna dye that traditionally covered the hands and feet of Indian brides-to-be and temple courtesans. The material girl was subsequently rewarded with the VH-1 fashion award, which she collected dressed in a sari. Fashionistas and popstars such as No Doubt's Gwen Stefani also began adorning their foreheads with *bindis*, traditional Hindu symbols of marital devotion that for many years had been worn by unmarried Asians as a beauty accessory and symbol of pride.

Some sections of the ethnic community were less than happy about the manner in which their beauty signatures were suddenly eulogized as a result of their association with whiteness. "Madonna got the fashion award for wearing these clothes that people have been wearing for hundreds of years and, because she is white, it's suddenly innovative," lamented the Asian composer Nitin Sawhney. "A lot of people think they can go over and absorb this culture instantly," he said. "It's almost psychological residue from the Empire, thinking, 'They are not as good as us really, so we can take in their culture in ten minutes and use it in our culture.' It is never truly learning about it."

But are not ethnic groups themselves also guilty of random aesthetic appropriation, not only from whites, but from each other? Erykah Badu and Prince also wore *mendhi*-like patterns, and Janet Jackson sported a bindi combined with an Indian-style nosering and chain. Mary J. Blige wore a bindi in her video for her hit song "Everything." Did they all understand the true meanings behind these gestures? "I just sat down with the director and the stylist to come up with something to express the spirituality that I was feeling," said Blige vaguely.

Thick lips on white faces were still a potent beauty signature. Aside from Mick Jagger there was Aerosmith's Steven Tyler and his daughter Liv, Jon Voight's daughter Angelina Jolie, Sandra Bernhard, and the Spanish supermodel Esther, who were all lip-lauded via the "whites-only" set of journalist-inspired phrases such as "bee-stung," "pouty," "swollen" or "pillow-lipped."

But within the system of values that had derided the black physiognomy, somebody forgot to remind blacks that their lips were sexy, too, and many of them tried to muffle the impact of their full pouts with make-up. "When I make up a black woman I often get the complaint, 'My lips look so full!'"said the make-up artist Bobbi Brown. "I feel like saying, 'Well those are your lips, and they are beautiful!' I think that most black women have incredible lips, and my instinct as a make-up artist is to highlight them. It's ironic that white women run to get silicone injections to plump up their lips, and black women seek to minimize the size of theirs."

The black backside, however, – derided during the time of the Hottentot Venus – was reclaimed and recontextualized by blacks within contemporary urban dance – from Jamaican dancehall girls, with their tight "batty-rider" shorts, to MTV's rap videos. Meanwhile whites were suffering "ass ambition" for what they viewed as the stereotypically fuller, more curvaceous black behind. Eurasians were also afflicted, so padded-panties became the rage in Japan, where the manufacturer Wacoal sold "instant-ass" for $24 each.

OUT OF SIGHT
Global beauty has acknowledged other ethnic groups such as Latina Jennifer Lopez, although it was her rear end that initially fascinated the media.

In America in the late 1990s, the press took another look at the ethnic behind, courtesy of a famous Latina. "Lopez, whose spectacular ass juts out as expressively as her swollen mouth, is terrific," gushed LA Weekly in its 1998 review of the Jennifer Lopez movie *Out of Sight*. The fetishistic allure that the behind held for Anglo-Saxons reached boiling point, as the Bronx-born star was subjected to a barrage of cod-anthropology about her rear end.

But the bodies of Lopez, hip-hop's rap mammas, and Jamaica's batty-riders were not those of the bondaged, passive slaves of old. While the form of the nineteenth-century Hottentots was used to deride blackness, the Lopez posterior was viewed admiringly. It now possessed a sexual currency for its owners and was the envy of flat-butted girls everywhere. Lopez's form became a fleshy icon for the fuller-figured female. "To me, the positive spin on it is that people don't feel like they have to be one size to be attractive," she said.

However, in focusing on her rear end, the danger is always that the media reduces her from a personality to a sexual commodity. "It gets out of control, because it's all they want to talk about, it's all they want to write about, and it's all they want to photograph," she despaired.

Hip-hop's rappers came pre-packaged with the coiled facial demeanor of renegade prisoners, still smarting after being slapped by the warden – the pursed lips, the mean-jawed, eyeballing side-profile – and the body – tattooed, cut like an athlete's and puffed and buffed full of attitude – became a mandatory ideal of which Ice Cube, Public Enemy's Chuck D, and Onyx were the exemplars. Contrast these hard-bodied renegades with the unmuffled sexual heat of Maxwell, Ginuwine, Baby Face, Eric Benet, Teddy Riley, or Q-Tip.

THE CHANGELING
"Janet Jackson continually reinvented herself, utilizing every hairstyle in the book, from curly perms to straightened locks, to bouffant ringlets to chunky rope braids."

Janet Jackson, En Vogue, and Whitney Houston introduced their own blend of wholesome beauty, girl-next-door sexuality and approachable glamor. She "looks like the dream girl so many little black girls wanted to be," declared *Vibe* of Michael's sister. They contrasted with the tomboyish sexuality of TLC and the Pam Grier-like machismo of the rappers Yo-Yo and Eve – the self-proclaimed "pit-bull in a skirt." Just as tough were the hip-hop divas Mary J. Blige and Foxy Brown, with their distinctive brand of edgy, feminine sophistication and dangerously bodacious curves.

"I just don't have the look to be an artist," lamented the five-foot-two Virginia-born rapper Missy Elliott in her earliest days as a struggling artist. She was built large, like Billie Holiday, and in similar fashion to the experience of Whoopi Goldberg, her look was initially deemed uncommercial. "I'm gonna do it anyway," she asserted, becoming a role model for the fuller-sized woman.

"If you look good and you rhyme, you get that much more props," said Lauryn Hill. "If I had one eye lower than the other, I probably wouldn't be as dope as everyone claims I am." But New Jersey's multi-Grammy-winning songstress was as gorgeous as they come. The architecture of her face was like a state-of-the-art piece of Japanimation. It defied the photo-logic law

DREADLOCKED BOMBSHELL
R&B songstress Lauryn Hill. "The architecture of her face was like a state-of-the-art piece of Japanimation."

Pages 138-9:
A LIGHTER SHADE OF
BLACK
Left: The paler end
of black beauty's
tonal spectrum is
not easy to detect.
The racially mixed
Mariah Carey was
originally written up
as "a white girl who
can sing."
Right: The crossover
appeal of cinnamon-
skinned Tyra Banks
launched her onto
the cover of *Sports
Illustrated's*
prestigious swimsuit
edition in February
1997.

that states that gorgeous superstars can't always look great in pictures. Her curvaceous schoolgirl chassis, twisting locks and chocolate tone made grown men coo with appreciation. When her full-plumed lips came together they formed a perfect oval, with a generous surface area that cried out for lipstick and kissing.

Hill was at the vanguard of the Old World-inspired Afro-centricity epitomized by performers such as Arrested Development, The Roots, and Erykah Badu. They were cut from the same spiritual and aesthetic cloth as Bob Marley. Theirs was an earthy, back-to-roots aesthetic – stripped down and free of the cosmetic regalia of bolt-on weaves, hair-straighteners, colored lenses, and "falsies," and imbued with an old-school kind of sex appeal. They were aesthetic Luddites. If they'd been around during the Civil Rights decade they would have been adopted by Malcolm X and Stokely Carmichael alongside Ali and Poitier as paradigms of racial pride.

At the other end of the beauty spectrum was Lil' Kim, self-penned "Queen Bee" and the queen of artifice. She was the culmination of 100 years of the Afro-American performance tradition that has seen black females adopt the veneer of hyper-sexuality and crossover Euro-style beauty as a performance play and prerequisite for success. "Kim Jones is basically me. Lil' Kim is what I use to get my money," she said.

Her alter-ego of the ever-ready, sexually ripe booty-grinder with the unquenchable appetite of a sexual Tyrannosaurus captivated audiences. "I'm obsessed with her hardcore sexuality," said the photographer David LaChapelle. "[She] is like Betty Boop meets Marilyn Monroe." With her X-rated lyrics – labeled "melodic prostitution" by one protest group – voluptuous sexual costuming and bad-girl glamor, the Brooklyn babe was out to out-Madonna Madonna, and anybody else who tried to front better than her.

Once again, skin-tone became an issue within black beauty, this time when the aesthetically ambiguous Mariah Carey and her record company were accused of concealing her racial identity, preferring instead to sell her as a more lucrative white crossover artist. For years the press had written her up as Caucasian, journalist Nelson George even referring to her as "a white girl who can sing" – a mistake her record company allegedly did nothing to correct. In fact, Carey was born to an Irish-American mother and a black Venezuelan father. "I'm mixed, baby!" she proclaimed in *Vibe* in 1999. "I'm not in denial of either of them. But anybody who's mixed knows they're of the black race."

There was a similar hoo-ha in 1997 when the championship golfer Tiger Woods declared himself not white nor black, but "Cablinasian" – a dynamic four-way scoop of Caucasian, black, Indian, and Asian. Was the divider between racial aesthetics becoming increasingly fuzzy?

"Individualism" and "character" became buzzwords for the new generation of models – it was the 1960s all over again as an eclectic mix of multi-ethnic beauties and audacious faces and bodies breached the fashion barriers. The new obsession with global beauty ushered in girls from all over the world. The Afro-Americans Veronica Webb, Karen Alexander, Lana Ogilvy, and Tomiko, were joined by black Europeans such as the French models Chrystalle and Noemi, plus

HIP HOP
DEMEANOUR
Tattoos, baldheads,
and athletic torsos
became the favored
look amongst the
new generation of
rappers such as the
late Tupac Shakur.

a new wave of African-born beauties with names as beautiful as their faces: Waris, Adia, Agola, Alek, Kadra, Kiara, and the Nigerians Oluchi and Cherech all joined the ranks. The ethnic mix became even more complex – Devon Aoki, Jenny Shimizu, and Audrey Quock were Asian-American; Yasmeen Ghauri was Indian; Zoya Todorovic was Yugoslavian; Giselle Bundchen was Brazilian;, and Irina Pantaeva was from a Siberian tribe descended from Genghis Khan. "There's a change in fashion in terms of the different types of people who are being acknowledged," said Aoki. "It's cool, what's happening now as we step into the future." Carol White of London's Elite Premier model agency agreed. "There's a big ethnic revolution taking place now," she said. "The current financial climate is allowing people to be more adventurous with the images they are allowed to use...There's more money now, so things are changing, and it's brilliant."

This new individuality ushered in its own set of new catchphrases. Unlike "Black is beautiful," the zeitgeist slogans of the 1990s were born not out of political agitation but in the marketing departments of the major fashion houses. Calvin Klein urged us to "Just Be," Nike said "Just Do It" and Hugo Boss said "Don't Imitate, Innovate."

Ethnic beauty finally established its commercial potential, particularly in its appeal to young urban consumers. Following on from the groundbreaking cosmetics campaigns secured by black models, major advertisers, and fashion brands adopted a system of proportional representation in which models of color were included within brand-marketing strategies. There was more activity crammed into the 1990s than ever before, as Ugandan-born Kiara secured campaigns for Gap, Tommy Hilfiger, and Allure; Adia did Guess?; Brandi Quinones did Chanel; Karen Alexander did Oil of Olay; male model-turned-singer Tyrese did Coca-Cola, Tommy Hilfiger, and Guess?; Tyson Beckford did Ralph Lauren; Naomi Campbell won Versace, Absolut Vodka, Prada, and Ralph Lauren; Alek Wek modelled for Joop!, Moschino, Issey Miyake, and the Clinique fragrance, Happy; and Tyra Banks secured Pepsi, Nike, Swatch, and Victoria's Secret. Celebrity endorsers were also ushered in, as the R&B singer Usher and rapper Treach from Naughty By Nature modeled for Tommy Hilfiger, while Foxy Brown and Macy Gray endorsed Calvin Klein Jeans. Meanwhile other urban brands such as Carhartt, Kangol, Caterpillar, and Fubu made a deliberate beeline for ethnic models.

But was all this enough? As recently as 1991, New York City's Department of Consumer Affairs published *Invisible People*, a report of a survey of 11,000 ads across 27 national magazines and 157 fashion catalogues. The findings revealed that a staggering 96 per cent of the models were white, in spite of the fact that the readership was 11 per cent Afro-American.

The issue of ethnic models on the covers of mainstream fashion and lifestyle magazines was still a bone of contention. The industry has always argued that black faces don't sell as well as white ones, and consequently most of them have adopted a quota policy of one obligatory cover per year – usually a celebrity beauty such as Naomi Campbell or Lauryn Hill, whose fame is unlikely to affect sales adversely.

But even in countries such as Brazil or Japan, in which the majority demographic is non-white, the images remain resolutely Caucasian. Far Eastern editions of titles such as *Vogue*, *Elle*, and *Marie Claire* feature white covergirls. "Glancing at the rows of magazines lining any

SERIOUS HEAT
Tyson Beckford, the world's first black male mega-model. "He was a double-hunk, with triple-thickness deep-pile lips and Eurasian-style eyes, narrow as blades."

THE SUPERMODELS
The famous January
1990 cover of British
Vogue which
trumpeted the arrival
of the supermodels
and hailed Naomi
Campbell as one of
the world's five most
beautiful women.

newsstand in Brazil, a stranger could mistake this racial rainbow of a country for a Nordic outpost," reported Diana Jean Schemo for *The New York Times*. "Slender blonds smile from the covers of fashion magazines, and white faces dominate all but the sports glossies."

The success of African models such as Iman and Alek Wek focused attention on the continent as a potentially rich vein of new black beauties. Consequently, Africa began holding its own model competitions. In 1998, in association with the Elite model agency, the South African cable network M-Net launched "The Face of Africa," an annual, continent-wide event in which the winners received a $150,000 modeling contract with the New York agency.

"We had over 2,000 girls from Nigeria alone come along to a casting session one afternoon," said event-organizer Herbert Mensa. "And from there, we had to come down to just three." At the 1998 auditions M-Net officials were stunned when United Nations aid workers brought several Somali and Sudanese refugees to one of the Kenya casting sessions.

The search for the next unique face became so intense that it sometimes skirted dangerously close to antiquated ideas of noble savagery. "We also go into the bush in trucks and look for the girls," said Mensa. "We bring a few hundred in and then the show producer will look through them and make a shortlist."

A key bone of contention among the African press concerned the kind of girls being promoted. In order to be groomed for the fashion industry in the West, the finalists were required to conform to European, not African physical and facial standards. "We are looking for girls who will work in the international fashion markets," said Karen Lee, Elite Models director of scouting, and the competition's chief judge. "Maybe some Africans don't think that woman is beautiful. They may have another idea of what is beautiful in Africa."

Certainly, toy manufacturer Mattel did in 1990 when they launched Nigerian Barbie, complete with traditional hairstyle and Afro-centric features. It was a stark contrast to the Euro-inspired straight-haired lookalike doll that Naomi Campbell launched in March 1996.

"I was shocked at first," remarked Alek Wek of the moment when she was stopped by Fiona Ellis, the London scout who discovered her at a college fashion show. "We were raised not to consider our looks. She asked me if I'd ever thought of being a model, and I said my mum would kill me." Wek's story was a fairytale that would make aficionados of noble savagery glow with delight. She arrived in Britain in 1989 with no clothes, a 14-year-old Sudanese refugee who had never seen an underground train or even flushed a toilet. At that point she spoke only Dinka and Arabic, subsequently learning English in London's rough-and-tumble East End.

Her rise into the supermodel stratosphere recalibrated perceptions of beauty. "When I was growing up, if you'd been on the cover [of a magazine] I would have had a different concept of who I was," Oprah Winfrey told her. Arguments raged about whether Wek – voted MTV's 1997 Model of the Year – was beauty or bad taste. Of course fashion sporadically promotes those it considers "freaks" in order to satisfy its insatiable demand for self-renewal and to generate new focal points within the aesthetic homogeneity of looks, and Wek's features, taken out of the

context of Africa, were suddenly jarring to Western sensibilities weaned on Euro-centric beauty values and Nordic blue-eyed blonds. Ultimately, her look represented everything that had been denegrated about black beauty throughout history but this time recontextualized in the positive.

"I work with divas a lot, and she's the best of them," said stylist Patti Wilson of Naomi Campbell. "because you know what? Everything works: the hair, the make-up, the body, the style. She's got it." More than any other face, Campbell's dominated black beauty in the 1990s, trailblazing her All-American look across the world, from South African townships to the Far East. "People aspire to be like Naomi Campbell here," stated Yoshiko Ikoma of *Vogue Nippon*. "You might think that because she's black, Japanese women wouldn't identify with her but that's not the case."

Within fashion circles, it was Campbell's amazing body and runway "badda-boom!" that sustained her legend. "Naomi is the Concorde of the catwalk," said milliner Philip Treacy. "There is no other body, there is no other pair of legs," confirmed *Vogue*'s Andre Leon Talley. The South London beauty raised model physicality to new heights, reworking its currency and sparking naked envy in her clunky, pasty-faced counterparts.

With more magazine covers to her name than any other black star of the twentieth century, Naomi cracked open the market for a new generation of black beauties. Her most significant moment came in 1990, when, along with Tatjana Patitz, Christy Turlington, Linda Evangelista, and Cindy Crawford, the English beauty featured on the cover of the January edition of British *Vogue*. Here was the famous band of five supermodels looking like a pre-Spice Girls supergroup. It was a bold moment in the history of pop culture, which, following on from the Benetton ads of the 1980s, marked the beginning of global beauty culture. The fact that one of the five most beautiful women in the world was black was all that was needed to convey the message that people of color were now an integral part of the mix.

Twice voted one of the 50 Most Beautiful People in the World by *People* magazine, All-American black beauty Tyra Banks exploded on to the scene in 1991 in Paris, where, as a fresh-faced 17 year old with a Donna Summer-style open-mouthed expression of schoolgirlish surprise, she blitzed 25 runway shows. Like Naomi Campbell, she, too, broke editorial and commercial barriers, making her mark in February 1997 when, with her windblown hair, cinnamon skin, and wearing a miniscule red-and-white polka-dot bikini, she became the first black model to feature on the cover of *Sports Illustrated*'s prestigious swimwear edition.

Elsewhere, the black male modeling scene had also come of age, courtesy of Jamaican-born Tyson Beckford. "Recently I was in Miami and a girl jumped out of her truck, leaving it in the middle of traffic, and started chasing me down the street. All I heard were screeching tires and screaming. I ran." This was a standard reaction to the sight of the world's first black male supermodel and the face and body of the famous Ralph Lauren Polo Sport campaign. Beckford shattered past advertising policy in which black models tended to be featured only as part of a group dominated by whites, but seldom as a stand-alone beauty. In becoming the sole focus of of the selling propostion for Polo Sport, he rewrote the rule book on black male beauty.

Pages 146–7
THE BODY
BEAUTIFUL
Naomi Campbell raised model physicality to new heights. "There is no other body, there is no other pair of legs," said *Vogue*'s Andre Leon Talley.

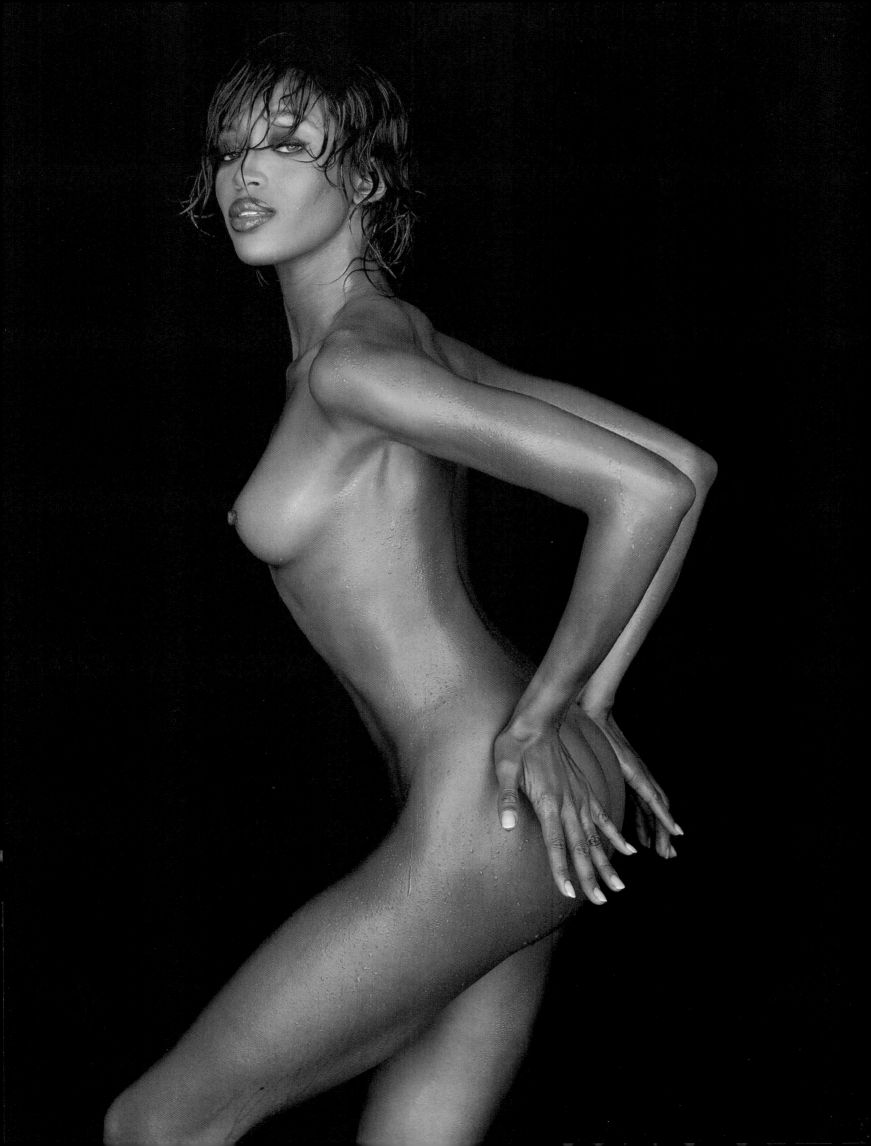

KNOCKOUT
Heavyweight champion Mike Tyson. "He had cropped hair, cuts for eyes, gap teeth like Lauren Hutton and a neck like a bicep."

The very fact that the highest-paid male model of all time was black was nothing short of revolutionary. His ascent was all the more extraordinary when one considers his look. He was big for a model – cut more like a body-builder – and facially he was the opposite of the moustachioed, sophisticated "Billy Dee Williams" models of the past, such as Renauld White. Beckford's tightly cropped hair, tattoos, and chocolicious skin-tone were ruggedly urban products of the hip-hop generation. He looked more like a rapper, bringing a tough edge to male beauty that established a new blueprint for an entire lineage of black male models. Everything about him was chunky. His boxer-like form, beefy and substantial, was all man. He was a double-hunk, with triple-thickness deep-pile lips and Eurasian-style eyes, narrow as blades.

And the Beckford billboards for the Polo Sport range packed more sexual heat than the Diet Coke guy. The images crashed cars, intimidated white men, filled black men with pride, and sent female diaphragms across the world heaving into yearning longing, while mouths gaped hopelessly ajar at the mere sight of him. He wasn't simply advertising a sportswear brand, he was advertising negritude.

"I couldn't live that straight-and-narrow role," said the electric-blonde hoopster Dennis Rodman. "I wanted to be totally different." Basketball's kingpin rebounder was the century's most radical black beauty. There was no category to harness adequately the slippery enigma of what he was. To cast him as a crossdressing sports superstar didn't cover it. Was the freaky enigma man or fish, devil or rockstar, enfant terrible or genius, babe or tranny-fanny? Was he a man-woman, woman-man, or simply a "category three'? He was macho at work, but offcourt he was girly. He is heterosexual, but he nicknamed himself "Denise" and wore women's clothes to the MTV awards. He frequented gay joints and hung out with drag queens. He posed bare-assed for *Playboy*, he is pierced from nose to scrotum, and he has fantasized about playing his last NBA game in the nude. No one in the history of beauty and sexuality has ever gone this far.

But how far did Iron Mike Tyson go? He was beautiful and virile – a post-1960s example of race pride, a symbol of strength and power. His features were compelling. He had cropped hair, cuts for eyes, gap-teeth like Lauren Hutton's, a neck like a bicep, and the body of a seven-footer somehow condensed into a chunky, economical five-eleven-and-a-half. But then the sex symbol became the demon – a renegade buck out of control – and the same aesthetic signatures were suddenly realigned as brutal and menacing.

Life in Hollywood at this time was proving to be bittersweet for the latest generation of actors. With less than a handful of bankable leads, once again there was a paucity of quality roles. A new crop of actors, bursting with enough sex appeal to burn a hole clean through celluloid, cooled their heels in roles that side-stepped their aesthetic allure. "If [mainstream Hollywood] needs to cast a sexy guy, they automatically think sexy white guy. That's just how Hollywood is," sighed Taye Diggs, whom *Vibe* described alongside Mekhi Phifer and Omar Epps as "a holy trinity of female fantasy." Meanwhile Samuel L. Jackson, Blair Underwood, Don Cheadle, Morris Chestnut, and Michael Beach joined them at the forefront of the new acting lexicon.

LEADING LADY
Honey-hued Halle Berry and her come-hither look inherited the legacy of Hollywood legends Nina Mae McKinney and Dorothy Dandridge.

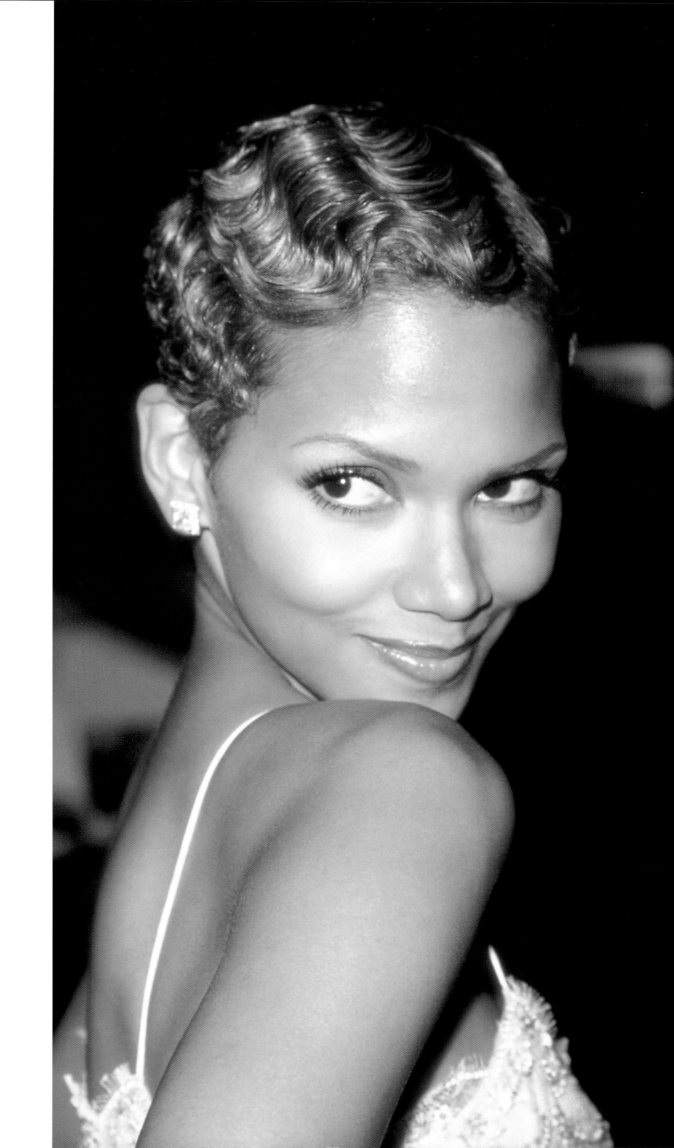

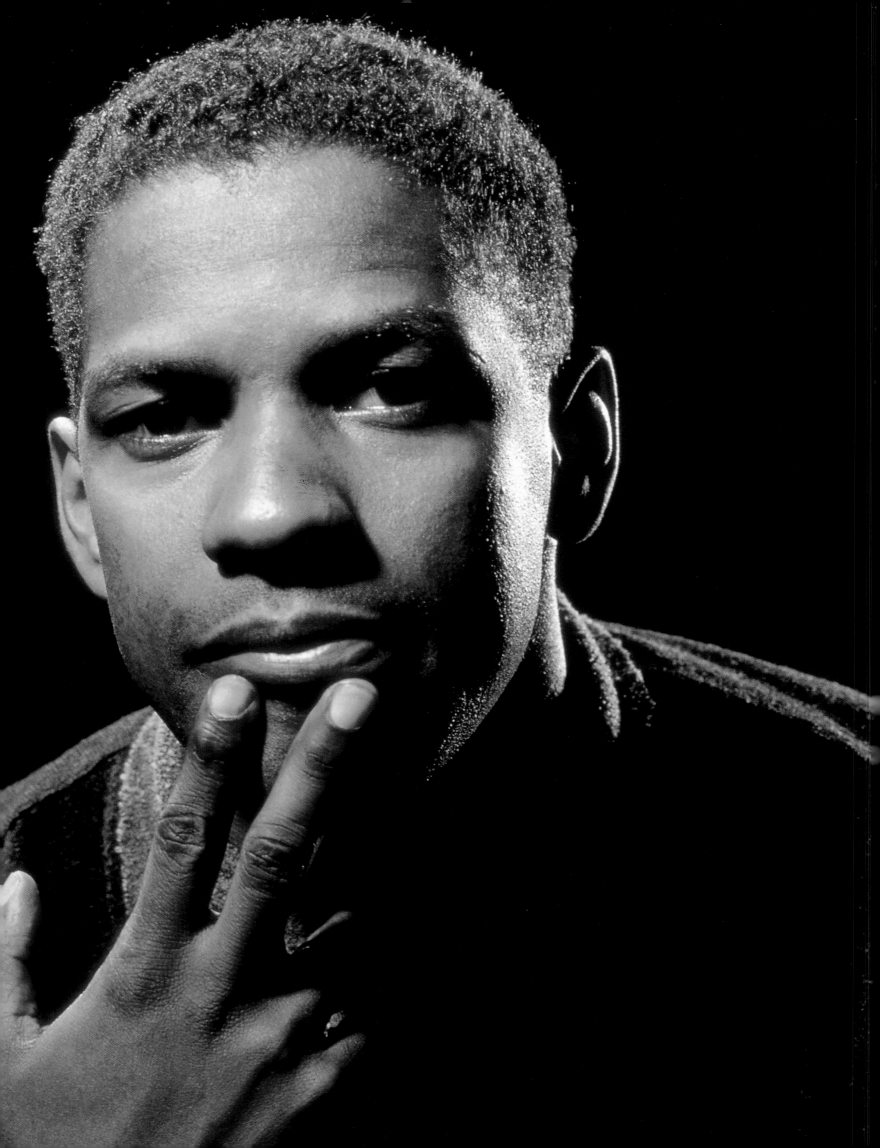

Pages 150–51
THE SUPERSTARS
Left: "The dark
Gable," Denzel
Washington. "He
was canned heat, his
sexuality muffled like
a blanket over a
roaring flame about
to explode."
Right: Will Smith,
actor, rapper. "A
schoolboy's face so
cuddly and scrummy
that girls didn't
know whether to eat
it or take it home to
meet momma."

"I remember going to see Checkmates on Broadway, and the minute Denzel came onstage, all the women started oohing and aahing and that kinda stuff," said Spike Lee. "Women love them some Denzel." The Oscar-winning "dark Gable" was Hollywood's quintessential black sex symbol of the 1990s, and, like early Poitier, he achieved it by being sexy in non-sexual roles. In a career spanning more than 25 years, he featured in less than half a dozen romantic liaisons. He was canned heat, his sexuality muffled like a blanket over a roaring flame about to explode. Was he sex shy, as so many claimed? "I've heard so many times that I don't want to do a love story, and that is just not true," said Washington. "The truth is, a good love story has not come my way in all these years."

"Always bet on black," said Wesley Snipes in *Passenger 57* (1992), and, in terms of being a bankable sexual character, he proved a perfect tipster. The Florida-born maverick stomped all over Hollywood's racial conventions, pioneering roles that others couldn't, or were afraid to, play. Screenwriter Barry Michael Cooper called him "the black Pacino," but he was more a hybrid of Sidney Poitier and Shaft. Facially, he was black like Poitier – superblack – and his features hardcore African, like a male version of Alek Wek. Sexually, his persona came straight out of Blaxploitation. He was tough, macho, virile, and ready to exercise his own sexual perogatives with women of any hue. In *Jungle Fever* (1991) and *One Night Stand* (1997) he dared to cross the color line, just as John Shaft would have done. And his sexuality mined even deeper seams, playing a drag queen in an early stage performance of *Execution of Justice*, and also in the movie *To Wong Foo* (1995) with Patrick Swayze.

"Years ago, a friend likened the rear view of his head to that of a '68 Buick with the doors open," wrote *Vibe* of Will Smith's ears. They were an important part of his cuteness and disarming youthful innocence. But it wasn't just the ears, as set between them was a schoolboy's face so cuddly and scrummy that girls didn't know whether to eat it or take it home to meet momma. Though the Philadelphia native was renowned for his boy-next-door, non-threatening sexuality, *Bad Boys* (1995) – one of the era's few movies to feature black leads in beauty roles – was a turning point. "*Bad Boys* was the first time in my life that I can remember people looking at me as physically attractive," he said. "I've always been kinda goofy-looking. Thin and lanky and goofy ears and all of that." Along with Wesley Snipes and Denzel Washington, he completed a perfect triangle of black aesthetic and sexual diversity, each with his own distinct flavor.

Hollywood's black female leads such as Whitney Houston, Robin Givens, and Jada Pinkett-Smith fought to find good material. "She evokes the Hollywood of Garbo and Dietrich," noted *Vibe* of Angela Bassett. But this wasn't enough to earn the roles for the muscular actress with the quiet, smouldering sexuality, although she did star alongside Whitney Houston in *Waiting to Exhale* (1995), one of the decade's key films in its depiction of black beauty and sexuality.

Meanwhile former Miss Teen America, Halle Berry, inherited the crown of the honey-hued diva pioneered by predecessors such as Nina Mae McKinney and Dorothy Dandridge, successfully blending the look with enough raw talent to propel her right to the top of Hollywood's list of black leading ladies.

THE MAVERICK
Superblack, with a
hardcore African
face, Wesley Snipes
"stomped all over
Hollywood's racial
conventions,
pioneering roles that
others couldn't."

In keeping with global beauty's remit, ethnic groups found their way to the big screen, led by Latins Rosie Perez, Jennifer Lopez, Salma Hayek, and John Leguizamo, while Asian Sarita Choudhoury starred with Denzel Washington in *Mississippi Masala* (1992). But in terms of roles, the situation was worse than it was for blacks "We're not even in the running," said Rosie Perez in 1993. "There are no roles. I'm stealing the roles written for non-minorities." The Mexican Salma Hayek said: "I always have to audition and most of the time they say, 'She's the best, but we're still going to go with the blond girl.'"

From blond girls to Bond girls, the story was the same. In *Tomorrow Never Dies* (1997) the Malaysian beauty Michelle Yeoh became only the third Eurasian to feature in the series, and the first for 30 years.

The same concerns over the unbalanced promotion of Euro-style black beauty also began to surface within the Latino community. "It unfortunately seems that in the world of American pop culture, Latinos are only palatable as long as they appeal to a mainstream Caucasian standard of beauty," wrote Alisa Valdes-Rodriguez in the *Los Angeles Times*. "Jennifer Lopez seems to have figured this one out," she said. "Her naturally wavy, dark brown hair has been lightened and straightened, and her once fuller body has been whittled down by a fitness guru to something indistinguishable from the lean, muscular Madonna."

"I never thought that I was pretty because I thought you had to be light-skinned, have a pointed nose and thin lips in order to be pretty," said Oprah Winfrey. "The thought of being pretty was a foreign idea to me. So I decided to be smart instead." And it worked, as America's queen of talk grew up winning a string of beauty pageants not on looks, but because she was better than the prettier girls at the question-and-answer section.

Her career first took off in the mid-1980s with the success of *The Oprah Winfrey Show* and an Oscar-nominated performance in *The Color Purple* (1985). By the 1990s the Mississippi marvel was a worldwide phenomenon, a household name with a bigger reach than any other black beauty in the history of television. With her newsreader-style bouffant and down-to-earth sexuality, her daytime diet of confessional therapy was a colossal force in assailing aesthetic and racial barriers. At its peak, the show had an audience of more than 33 million, was syndicated to more than 130 countries, and pulled in 15,000 letters per week. People across the world who had never seen a black face recognized Oprah as if she were a corporate logo for the race. Throughout remote homes, taverns and caverns, she was blackness personified.

THE MAESTRO
"People across the world who had never seen a black face recognized Oprah as if she was a corporate logo for the race."

epilogue

fade
to
black

I REMEMBER THAT THE BLACK GIRLS AT SCHOOL used to play a game called "white girl." They'd put a jumper over their heads so that it draped down like flowing hair, and then they would prance around shaking it as if they were real white girls with real white-girl hair. Then there was a period at university when I used to straighten my Afro hair with a sodium hydroxide emulsion that burned right to the cranium like hot sauce, just as black men had done since the 1920s. I took strange comfort in having something in common with the jazzheads of the Roaring Twenties as well as the young Malcolm X, Miles Davis, Little Richard, and a whole bunch of other "straights." I remember, too, being told as a boy to practise pinching my broad nose in the hope that it would become more aquiline and less African-looking. Broad was not beautiful.

After more than a century of tales of aesthetic dissatisfaction, of representation and misrepresentation, of derision and eulogy, of good hair *vs* bad hair, of light skin *vs* dark, where does it all leave us in the new Millennium? Who are we?

Clearly, negritude is a different proposition than it was a century ago. To the new generation of urban Westerners, black blood is now more revered than blue. Even Diana, Princess of Wales, with a rack of stiff-upper-lipped, pasty-faced suitors to choose from, ended up with a "colored boy," as in some post-modern Euro-remake of *Guess Who's Coming to Dinner?* These are the days when whites proudly boast of having bloodlines of color in their families.

Diana Vreeland, detected an early tremor of the racial shift. "I sometimes think there's something wrong with white people," she observed in her 1984 autobiography, *D.V.* "We're in the wrong place at the wrong time. Blacks are almost the only people I can stand to look at nowadays."

Most of all it has been a century that said "Black is beautiful" and urged us to "Just Be," and then told us that "being" just wasn't good enough. So what are you supposed to do when being "yourself" is not enough?

Self-invention was the answer. The culture of ethnicity-altering cosmetology carried within it the notion that people of color had to overcome their blackness in order to be successful. If there was ever one global phrase to sum up twentieth-century black beauty, it would be "adapt yourself." The last hundred years of beauty culture has brought a diverse range of styles within the reach of people of color.

Madame C.J. Walker's cosmetics absorbed the values of slavery's derision of the black physiognomy. Today's ads continue to promote the aesthetic inferiority of Afro hair as the catalyst for these products, depicting a world populated by terrifyingly beautiful, Pocahontas-haired black women who smile contentedly from the product packaging.

The manufacturers of these cosmetics and the media that promote them continue to gain the most from the preservation of slavery's old order. In a business that is worth an estimated $1.5 billion a year, many of its main profiteers are white-owned cosmetics companies such as Revlon and African Pride.

Within a culture in which an estimated 75 per cent of Afro-American females wear straight styles, natural kinky hair remains an ugly, unwanted, knotty burden. Straight hair has now

ANCIENT BEAUTY
Princess Nefertiabt
of Egypt, with
braided hairstyle and
panther-skin dress.
4th Dynasty,
2613–2494BC.

**PRESERVING
TRADITION**
(above and right)
Afrocentric
hairstyles may be
read as forms of
resistance to
European beauty
values.

usurped Afro hair as that which is regarded as typically black. This explains why the supermodel Alek Wek is such an anomaly here in the West. In a bizarre about-face, her Afro-headed visage has now become the "freak" image. The traditional has become the radical.

Within this context, the hairstyles of ethno-beauties such as Pat Evans, Nina Simone, Angela Davis, Cicely Tyson, and Lauryn Hill may be read as forms of resistance to the oppression of Western beauty standards.

Black men on the other hand, for whom looks are less of a factor within success, have not been as affected by beauty's coercive law and have therefore been freer to express their options. They have gone from conks to Afros to curly perms, today settling almost exclusively for ethnic styles such as shaved heads, short naturals, and cornrows.

As the less aesthetically terrorized gender, men have generally been unsympathetic to the struggle of black women to resolve their beauty issues. Throughout history, most of the critical voices about black female choices have belonged to sneering black males. During the 1960s it was the macho militants who cried shame and reprimanded women of color for processing their hair. Over the course of the century, black women have not had the same freedom as whites to experiment without being punished.

Most of the white-influenced hairstyles adopted by New World blacks — such as conks, weaves, and bouffant-wigs — were unadventurous copies. Although the wholesale adoption of these styles said more about conformity than so-called "freedom of choice," there was nevertheless a kind of unity and pride within their replication — a real sense of black people doing something together.

The most innovative stars pioneered new styles and color variations. Clara Smith, Florence Mills, Josephine Baker, Little Richard, George Clinton, Dennis Rodman, and others used Afro hair as a raw material with which to sculpt new hybrids, elevating the craft into an art form. These creative improvisations were not wholly African, yet neither were they simply white copies. They were fusions — just like jazz or funk.

At the same time Grace Jones, Bob Marley, Cicely Tyson, Afrika Bambaataa, Cameo's Larry Blackmon, and the 1980s b-boys worked their innovations by staying low-tech, re-working Old World hair via cutting, shaping, matting, and plaiting.

The definitions "beautiful" and "ugly" have always been central cogs within the ideology of racism. In the 1960s black Nationalist thinking focused on realigning aesthetic pride as part of a counter-measure in the battle against Western hegemony. But the Afro that became its logo and the rejection of straight-haired and chemically processed styles did not last. One of the problems was that people of color were bullied into aesthetic-revision mode by the aggressive verbal broadsides of the Nationalists — and who would dare argue with these gritty brothers? They didn't ask, they told blacks that their hair was wrong. It was a one-way conversation — a

demand, a slap to "get back to black." And of course, reacting to a demand is not the same as belief. As a banner declaration of old-school beauty, "Black is beautiful" relied on a belief system that many simply did not have. It was a battle, not just for heads, but for hearts and minds. If oppressing black women into straightening was bad, was oppressing them into "unstraightening" any better, even if it was well-intended as a corrective action?

After decades of straightening, who could relate to this sudden and purist notion of Afro beauty? For many blacks, straight hair had become a habit of a lifetime. It was all they knew. It was ingrained. This African hair they were supposed to revert to was natural, but alien. The idea presupposed that the frame of reference for black Western beauty was Africa when really it was America. Culturally, black women were more Doris Day than Miriam Makeba. Under the terms of Western beauty hegemony, African beauty was not beautiful, and African hair was out of date. New World, "ethnically altered" black was beautiful. International hair was beautiful. All-American-style black beauty – a sanctioned and affiliated sub-classification of the white beauty standard – ruled the game.

The aesthetically revisionist times also needed white co-operation to sustain itself. As long as power was in white hands, it was the white definition of black beauty that mattered most. Of course, white commitment to Afro-centricity was strongest within medias in which there was money to be made, but ultimately their concessions had no lasting intent.

Most of all, the movement required sustained "marketing" by the radicals who instigated it, but by the 1970s they were gone – dead, imprisoned, retired, or exiled and blacks crept back to their old styles. The failure of "Black is beautiful" to sustain itself provided the first clear evidence that black beauty values had become inextricably bonded to white aesthetic standards.

Looking around at the popularity of today's multi-hued wigs and weaves, I wonder what Malcolm X and the militants, if they were still around, would have to say about these hairstyles? Judging by their previous comments, I doubt they would be too pleased.

But why? After all, the wearing of false hair in varying colors is one of the oldest forms of black adornment, dating back to Ancient Africa, 1000 BC. Wigs were worn by the Egyptians and the Nubians over shaved heads or short "naturals" as sun protectors, as well as for social and ceremonial occasions. They were constructed of real hair, wool, cotton, or plant-leaf fibers, and were produced in both curly and straight varieties. Dyed variations were used for different occasions – black was generally for "daywear" whereas henna and indigo were mixed to create greens, reds, and blues for ceremonial scenarios. Gold was also popular. The wig became the catalyst for the "stay-on-hair", commonly known as the weave, which is currently so popular among women of color.

Thus these falsies are as traditional a part of black beauty as braids or cornrows. This effectively makes today's wig-weave-extension-wearing sisters nothing less than Afro loyalists, who are in fact guilty of nothing more than being old-fashioned in their choice of hairstyle. Their look is in fact more African than the Afro that so symbolized the blackness of the Civil Rights era.

PLATINUM STYLE
Short cropped
blonde hair is now a
hot look for both
black women and
men alike.

But at the same time, how many of today's wig and weave devotees think of their falsies as an African legacy? Is what we see on the heads of countless black divas of rap, R&B, and modeling a statement of traditional Egyptian-style Afro-centricism, or a straightforward appropriation of Caucasian beauty values?

"What does it say about racial purity that all the best blonds [Harlow, Monroe, Bardot] have been brunettes?" remarked Julie Burchill in her book *Girls on Film*. But by the same token, in the 1990s, what did it say when the best blonds – Lil' Kim, Mary J. Blige, Ru Paul – were all black? It said that in the Millennium age, a person can be anything they want to be, as modern beauty is an interchangeable kit of parts, free of the gender and race restrictions of the past. "It's like Herb Ritts always says to me, 'When I look to shoot you I don't think of you as a black girl,'" said Naomi Campbell of the photographer. "You can make people believe you are whatever color you want to be."

Hip-hop culture's yellow-headed divas were the perfect heirs to Hollywood's royal house of blonds. Like Harlow, Monroe, and Bardot, they, too, were fakes – bonafide platinum forgeries – and therefore just as qualified to be admitted to the blond hall of fame as the white girls. Aligning themselves with the twentieth century's most popular hair color suggests that they demanded to be judged not on black, but on blond, terms. Jean Harlow was ugly next to Mary J. Blige, Lil' Kim was dirtier than Sharon Stone or Madonna, and Ru Paul's hair was better than Pamela Anderson's.

In some ways the decision of blacks or brunettes to go blond seems curious given that historical stereotyping has color-coded the blond not just as sexy, but also as submissive, weak, and most of all, stupid. Blonde is a no-brainer, and jokes about yellow-heads are legion. If being a natural blond marks a woman out as a space-case, then what does deliberately choosing to become one say about you?

But in truth these black-blondes reinvented the genre. They were not the Monroe-esque "boop-boop-be-doop" ditzy divas of the past, but tough, sassy, independent, take-no-shit mammas – platinum Pam Griers – and if you didn't give them respect, they'd kick your ass – and win! When cosmetics company MAC signed all three as spokesmodels for the brand – first Ru Paul in 1995, followed by Lil' Kim and Mary J. Blige in 1999 – it was a signifier that these go-girls had something that Hollywood's girly-girl blonds Cameron Diaz, Uma Thurman, and Gwyneth Paltrow didn't. No doubt if Warhol were alive today, it would be Lil' Kim who would be his latest muse and silkscreen replica – Marilyn's blond successor, only this time edgier and more outrageous.

The rationale that blacks go blond in order to be different, or as Ru Paul puts it, to evoke "outrageous sensation," only partially explains why blond is the chosen hue. If shock is indeed the governing rationale, then why not choose silver, gold, electric green, shocking pink, or any such combination? They are arguably more outrageous hues. In the 1980s, for example, when punks wanted to be "different," they chose non-human hair colors, thus freeing themselves from any association with conventional beauty values.

Thanks mainly to Hollywood, whose potent history has eulogized the blond as the ultimate in Western beauty, choosing to be blond is not about being shocking or different, but about internalizing blond values. "This culture has turned blondness into a beacon and wired it to the navigational equipment of every male," noted sociologist Grant McCracken.

The psychology of blond ambition involves a perception that it promotes the wearer into being somebody. As bell hooks has recognized, for dragster Ru Paul there was more currency in dressing up as a blond woman than as a black woman. For Lil' Kim blondness packaged with sexual outrageousness was a way of compensating for being black and four-feet-eleven. Would either of them have attracted as much attention without their platinum heads?

For weave-brunettes and those with chemically straightened hair, the most commonly quoted reasons for adopting such styles are that they are easier to manage than their own coarsely textured Afro hair, and that they also afford them a different range of stylistic options. While this is true, it fails to acknowledge the stylistic influence of white beauty values, from which many of these looks are derivated. In the past blacks have been embarrassed to admit to being influenced by white culture, for fear of being branded sell-outs.

The self-perpetuating culture of straightness is now a century-long tradition in which the wearer no longer feels right without it, as a man does not feel right without trousers. Even Malcolm X, before his political awakening, understood what it was to be hooked on the habit. "I vowed that I would never again be without a conk, and I never was for many years," he admitted in his autobiography.

Ultimately, though, the problem with high-tech, cosmetically constructed beauty is that you never really know whether or not success is down to you, or "the thing." Ultimately, maybe its recipients don't care as long as they win. But what happens to the concept of the role model if winning is more important than how you win? Effectively, the result is that the genre of the beauty role model mutates, veering away from a paradigm of aesthetic political correctness to the beauty equivalent of the flawed hero – the role model who sets a good and bad example at the same time.

Moreover, adopting straight or blond hair does not mean, as is often claimed, that black women want to be white. The juxtaposition of blackness with white styling may be thought of more as an expression of W.E.B. Du Bois's notion of double-consciousness – of a black dual-culture experience, or what Kobena Mercer calls creolizing stylization. We are African and yet we are Western. We come from the Old World, but we live in and are influenced by the New.

The adoption of Caucasian-influenced straight hair styles may be read as an acknowledgment of the "white side" that all Western blacks have – but are sometimes somewhat reluctant to admit to – and which they express in a myriad of different ways. We eat Western food, we buy Western clothes, we consume Western media, and some of us have Western-styled hair. In terms of our cultural experience here in the New World, everybody black is actually "mulatto."

In the beauty stakes for black men this has manifested itself in the style of black women they find most physically attractive. A common complaint from black women across the diaspora is

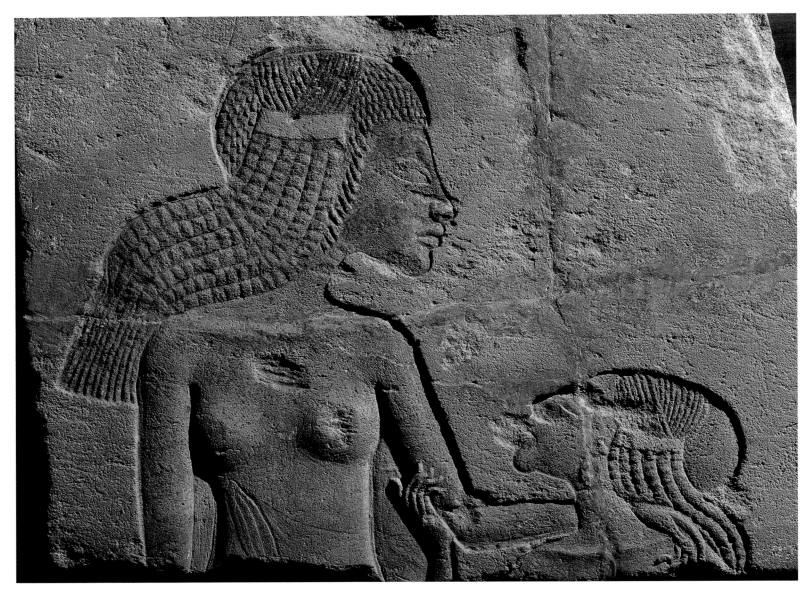

HAIR APPARENT
Relief of two young
Egyptian princesses
with elaborate
braids, from the
18th Dynasty,
1352–1336BC.

that many black males prefer women of color who are the closest approximation to white – that is, with lighter skin and straighter hair. From the all-black colleges to the Hollywood lot, these girls still top black beauty's league table, with blue-black, Afro-headed Alek Wek-types at the low end, as possessors of the beauty image both blacks and whites least like to relate to.

Today's woman of color demands the same aesthetic freedoms as her white counterparts, for whom the only relevant hair issue is whether a particular style looks good on them or not. They want apolitical hair. Fun hair. Historically, consciousness and cosmetics have been so tightly linked that you'd be hard pressed to slip a sheet of paper between them. The central question surrounding the issue is, can one remove the politics from black beauty? Can black people have, say, blond hair and black pride?

162 | black beauty

The answer is, of course they can. Aesthetics has always been an unreliable gauge of black consciousness. The contention that a processed head denotes a processed mind is harsh in its sweeping generalization. It goes without saying that any evaluation of black consciousness should be about a person's words and deeds as opposed to their beauty choices. The century has produced countless examples of blacks with processed heads but politicized minds. In the 1950s for example, like many other black artists, Josephine Baker boycotted a number of her own shows because white promoters wouldn't sell tickets to Afro-Americans. On one hand, this move suggests an active and conscious mind, and yet at the same time, this was the same woman who straightened her hair, lightened her skin, and wore a skirt of bananas.

The Nationalists of the 1960s put too much faith in hair. Ethnic styles were proud expressions of race pride, and politics, but they were also fashion statements, and fashions are not built to last. The Afro lost its political power the day it was appropriated as "style," and, symbolically, the movement seemed to lose something, too. Hair could not be trusted. By marinating the black follicle in the sauce of politics, the question that always arises is, what happens to those politics when the hair changes? When it falls out, gets dyed, or restyled?

Over the course of the last century, cultural preference is not the only reason why black women have adopted white beauty values. Singers and models have been directly and subtly oppressed into assimilating these styles by white powerbrokers. "Black has always been beautiful, but you had to hide it to be a model," said the 1940s mannequin Ophelia DeVore. Ever since the first black beauties began to trickle into the fashion mainstream they have been told to adopt straight hair by an industry that has waged war against the Afro follicle. "If the business weren't so geared toward being white basically, then it wouldn't be such a necessity to have this kind of hair," said the model Stephanie Roberts. Crucially, forcing blacks to straighten up was not and is not viewed racially or as an act of institutionalized aesthetic oppression, but simply as the business – a routine part of a black model's specification – an addendum to having good bone structure, clear skin, and being a size eight or ten.

This attitude was epitomized by Kevin Aucoin when he gave Grace Jones a blond makeover in his book *The Art of Makeup*. The key question here is why does Aucoin – widely regarded as one of the world's best and most creative make-up gurus – have to turn a black woman white in order to work with her? Why are her own beauty values not rated? By subsuming black beauty within a Euro-centric frame of reference, he demonstrates that it is whiteness that dominates.

Pulling black beauty into line with white sensibilities has been a feature of the music business since the first horsehair wigs were worn by the early vaudeville entertainers of the late nineteenth century. Today it is a matter of course for record company marketing departments to despatch their new R&B artists directly to the hairdressing salon to get "fixed." Meanwhile, throughout the black diasporas of the West, career professionals adopt straight styles they would not otherwise care for as part of a uniform of acceptance.

In cases such as these, straight hair becomes the physical signifier of the oppressive act. To the naked eye, it may just look like beautiful, lustrous hair, but it is really oppression

masquerading as beauty, undetectable to the untrained gaze. Inevitably, as "oppressed hair" filters down to influence blacks at street level, oppression becomes fashion. But the fashion decision, because it is once removed from the source, cloaks the marker of oppression so that the wearer has no idea that their so-called "freedom of choice" is linked to his or her source.

But who really cares about institutionalized aesthetic oppression? A fashionista telling a black model to "get straight" is no big deal within fashion. Its instigators do not even recognize it as oppression. How important is this, after all, when compared to "real" oppressive acts such as denial of educational or employment opportunities?

In truth, though, all forms of oppression are segments of the same whole. Where you find one, the others are usually not far away. Racism goes hand in hand with beauty discrimination like smoke and fire.

And in the light of all this active coercion, how can the "good hair, bad hair" debate be over, as some blacks claim it to be? How can it be dead when white and black-owned cosmetics companies continue to make billions of dollars out of the notion that Afro hair is bad and that a black woman cannot be sexy or successful unless she straightens herself out? How can it be dead when wearing dreadlocks, cornrows, or braids to work might lose you your job – if indeed you are hired in the first place? "Good hair vs bad" is still very much alive – only Afro hairstyles are losing, and the pressure for black women to conform to white beauty values is intense.

These conditions require a redefinition of the "good hair, bad hair" question, which updates the state of play and rationalizes the current plethora of styles. Thus "good hair" is whatever hair you choose for yourself, and "bad hair" is whatever hair you are told to choose, through either direct or subtle messages.

The issue of skin-lightness privilege has set people of color against each other in a long-standing "civil war" that has driven an aesthetic wedge deep into the community. Throughout the century individual light-skinned blacks have been cruelly attacked for the mere fact of their genetic inheritance, while at the other end of the tonal spectrum others have been discriminated against for being "too black." Of course, a quick scan of the world's ethnicity-related conflicts and micro-wars reveals that intergroup tension is not a specifically black problem, but a sad defect of the human condition.

And what of the ethnically obscure Michael Jackson, his face a great American tragedy? Cute in the 1970s, with a button-nose, chocolate-skin, and a basketball Afro, then a caricature in the 1980s and 1990s? The king of pop's physiognomic meltdown shocks because his alterations suggest the ultimate in racial denial. The shock factor is further enhanced by the apparent extremity of the alterations to his facial composite. Jackson didn't simply opt for straightening his hair and calling it quits – the standard procedure for so many black stars – he dared to go all the way. He did everything – hair, nose, face – he took it to the line. His was a face too far.

And in going all the way he stands accused of setting a bad aesthetic example to the world and all those fans who look up to him, of seeing blackness as an undesirable and correctable condition. He is black beauty's principal flawed hero, living proof that being happy with who you

are is no longer the thing. Being happy with who you can become is the thing. He is the ultimate representative for the supernatural possibilities of the cosmetic age. The result is ethnically nondescript – neither white nor black.

From a record-industry perspective, his outrageous image has proved an excellent marketing device. In daring to mess with race, he violated one of society's most volatile codes, which, along with sex and religion, forms America's "heavy trilogy." Any artist who messes with any of these three sacred cows is guaranteed to attract heat – and make sales. If Jackson proves anything, it is that racial denial provides the most shocking image of all. More shocking than popstars shooting heroin, more shocking than swastika rock, more shocking than hip-hoppers with guns, more shocking than Ozzy Osborne biting the heads off bats, more shocking than Grace Jones in a cage with a "Do Not Feed The Animal" sign, more shocking than Madonna hitch-hiking naked by a freeway.

But if the king of pop sets a bad aesthetic example, what of his other black contemporaries? Is he anymore of a construct after all, than the ultra-cosmeticized rapper Lil' Kim – a black woman who passes as a pale-skinned, blue-eyed blond? And just how "ethnic" is Naomi Campbell, with her fake Pocahontas-hair and multi-colored contact lenses? And let us not forget that as early as the 1920s Josephine Baker rubbed fresh lemons into her face each morning to lighten her skin. How Afro-centric a beauty move was that? Within this context, Jackson's facial composite suddenly seems not so outrageous after all, even though he continues to bear the cross for the cosmetic indulgences of a whole generation of black artists.

In light of all this, is it time to re-assess Michael? Should we call him in from the cold and tell him that his face is really OK and that we're sorry? Either that, or we should judge his equally "unblack" counterparts by the same aesthetic criteria.

CROWNING GLORY
South African songstress Miriam Makeba wears an adaptation of the Fouta Djallon Peul hairstyle from Labe, Guinea.

The writings of the seventeeth century English sea captain Richard Jobson provide some of the earliest recorded references to the myth of the oversized black phallus. But certain questions about Jobson's "sightings" remain unanswered. Namely, what exactly did he see 400 years ago when he made these statements about the African penis? Did he deliberately sensationalize and exaggerate what he saw, as Europeans routinely did in deriding black sexuality during this period? More to the point, what was Jobson – a sea captain, as opposed to a scientist or anthropologist – doing "studying," and indeed visually measuring, the penises of black slaves? The narrow specificity of his gaze has a strong homo-erotic resonance. Was the myth of the oversized black phallus that has resonated powerfully through four centuries of Western civilization started by an English closet homosexual?

History has suggested that marking African men as "monstrously endowed" and hyper-libidinous was one of the devices used by white males to dehumanize them, thereby making it easier to justify slavery, while simultaneously deterring white women from thoughts of "crossing." But was this really going to deter lustful white ladies? Certainly, when one considers the role that size plays within the erotic imagination, this seems a bizarre strategy, as a large penis and a big libido are obvious turn-ons for heterosexual women, as well as gay men.

A CENTURY OF
PROCESSING
A customer gets the
straightening
treatment at a hair
salon in Brixton,
London, April 1957.

The promotion of Alek Wek into beauty's mainstream was the century's most significant happening, although for the fashion industry, her significance veered into the model twilight zone of "the freak." Wek was chosen for the same reason as Kate Moss and Sophie Dahl: each represented the single orange in a barrel full of apples. Alek Wek was there because she was shockingly African; Kate Moss because she was short, scrawny, and skinny as an X-ray; and Sophie Dahl because she was unusually large. They are fashion anomalies – decoys selected for reasons of contrast and because they give fashionistas something different to say, not because of any lasting commitment to feminine aesthetic equality. Editors, on the whole, are not promoting these girls because they think it is right.

Unlike fashion's usual rejects – the fat, the old, and the ugly – ethnic beauties are the only group denied opportunity purely on the grounds of race. But how shocked can we really be when a white-dominated industry based solely on looks decides it doesn't like the look of black skin, Afro hair, or an African face? To put it even more coldly, fashion's first duty is to the majority of its customers, who are white, so the images used to sell the products follow this line. As far as the industry is concerned, this is less about racism and more about cold business. Black beauties ask for equality in a market in which there is none.

Having said that, the thinking that maintains that white faces must be used to sell to white audiences, particularly in urban conurbations, is now outdated. The twenty-first century-marketing shift means that multi-ethnicity sells across the board, especially to "the new young," for whom vibe and attitude matter more than race.

The contention that black faces don't sell the covers of mainstream magazines is one of the key agendas for black beauty. Currently, depending on the face, magazines report a drop of anything between five and 20 per cent on their black cover editions. This is generally put down to the uncommerciality of blackness, when in reality what we are seeing is readers reacting to the unwelcome shock of change. It stands to reason that any magazine founded exclusively on white beauty values will experience a knee-jerk reflex from its readers when it suddenly presents them with an image that deviates from the editorial norm. This is why the mainstream fashion titles demand that the black covergirls they promote once or twice a year adhere to white beauty values. It is an attempt to minimize the reaction to exposing a black face. To contain the ripples of unease. Conversely, Afro-American lifestyle magazines have also been known to lose readers or incur angry mail when they feature black cover models who are simply deemed to be "too white."

While these publications are trapped within their own narrow aesthetic channels, those founded on multi-culturalism – such as London's *I-D* – are less affected by such scenarios. The way forward for the new titles of the twenty-first century is to incorporate the diversity of global beauty within the startup editorial mission statement.

Throughout the first half of the twentieth century blacks had little or no control over the representation of their aesthetic and sexuality within the media. The subsequent winning of

many of these controls and the evolution of black specialist medias did not necessarily remove the existing stereotypes, but in many cases preserved and replicated them. This was due to the fact that often the image-makers themselves had ingested white beauty values, and also because they recognized that their black audiences had done likewise, so Europeanized imagery would therefore appeal to their sensibilities as consumers.

Within a twentieth-century cinema controlled by Caucasian executives, it was predominantly the white male view of black beauty that was represented. This cast black male leads as dark-skinned and African-featured, with little beauty content and females as cinnamon-skinned and straight-haired, as the archetypal mulatto diva. Much can be read into the black aesthetic types excluded by white selectors. Black male leads of mixed-race are absent, suggesting that Hollywood remains uncomfortable with any possible male racial ambiguity. "Not black enough" is the familiar refrain. And for black women, dark-skinned, Afro-featured actresses with non-European hairstyles – the typology least attractive to white powerbrokers – also remain out of the running.

This discrimination is not in fact a conspiracy, but rather the result of a subliminal set of preconditioned "taste responses" controlled by prevailing Western ideals, and which ensures that the same physiognomical architectures continue to be recycled. It also illustrates the manner in which whites, too, have been socialized by their own beauty standard.

Caucasian males have been labeled the chief agents in discrimination against black beauty. This has been a historically attractive view for blacks, as it frees them of any responsibility for their predicament. But in reality they have shown themselves to be complicit in their own oppression. They may not have created the stereotypes that so degrade and marginalize them, but they have done an excellent job of perpetuating them for money, particularly within the cosmetics industry and the black lifestyle press.

Current demographic trends indicate that Western beauty may soon have a different face, as the size of the ethnic communities continues to expand. "The world will go to lines of color – there's no question about it," predicted Diana Vreeland. "It won't be just the Africans and it won't be just the Arabs and it won't be just the Chinese – it will be every part of the world that has any streak of color other than white. The Western world will go." Already, the Latin community is increasing six times faster than the rest of the American population, and current estimates predict that by 2005 they will have surpassed blacks as the largest minority, making up 25 per cent of the total population by the middle of this century. The media and ad campaigns of the future will have a lot of different ethnic groups and sub-ethnic denominations to satisfy within the world of beauty.

But in terms of race, how will future beauties define themselves? There are signs that ethnic identification is becoming more complex. This has been reflected by the American Census Bureau, which for the first time has allowed people to classify themselves in more than one racial category in the latest polls. For several years Modelling has been a universe of "bi," "tri" and "quadruple" racial mixtures from every corner of the globe. And what was Tiger Woods's

racial homebrew term, "Cablinasian" if not a metaphor for global beauty's new state of racial independence? Perhaps the new zeitgeist curve will eradicate purist racial labels altogether. Like Woods, many of the latest generation of bi-racials, far from suffering an identity crisis, feel at ease as "combination ethnics," rather than claiming one heritage or another. Ultimately, though, we are not heading for a "raceless" world as much as for one where labels matter less, and attitude matters more.

There will always be an identity crisis within black beauty as long as women are taught that in order to be somebody, they must first abandon their blackness. The fact that so many have been affected by the weight of oppression or cultural habit suggests that people of color are actually lacking in narcissism.

Twentieth-century Western beauty has indeed proved itself to be within the eye of the beholder; these beholders are predominantly straight-haired and white, and their influence has narrowed the bandwidth of black beauty's periscope. Black has proved to be beautiful – as long as the skin is not too black, as long as the hair is not too curly, and as long as the features are not too African. The cold facts are that ethnic diversity is not the primary concern of the dominant culture. The majority white values are where that majority's allegiances lie, and so the central aim of people of color – being accepted as themselves – remains to this day a counter-culture maneuver.

Of course, the real meaning of beauty should be an individual's true expression of the self. It should be about aesthetic autonomy – of being one's own person. But in a world governed by aesthetic conformity this mantra is strictly for dreamers who float above the crunch of reality.

Most of all, the past century has illustrated the extent to which so much of our taste and so-called "free choice" is shaped and controlled by the dominant culture, sometimes in ways so subliminal that we remain unaware of the creep of its influence. Perhaps understanding the history of beauty will allow us to recognize the forces that are perpetually at work on our hearts and minds, and in doing so, help us come to terms with who we are.

AFRICA AESTHETIC
A section of the lid
of the casket of
Tutankhamun,
depicting Queen
Ankhesenamun.
Egypt, 18th Dynasty,
1357–1349BC.

bibliography

AFRICAN AMERICANS – A PORTRAIT by Richard A. Long. Prion/Multimedia Books Ltd, 1993.

AFRICAN HAIRSTYLES – STYLES OF YESTERDAY & TODAY by Esi Sagay. Heinemann, 1983.

ANGELA DAVIS – AN AUTOBIOGRAPHY by Angela Davis. Random House, 1988.

AUTOBIOGRAPHY OF MALCOLM X with the assistance of Alex Haley. Penguin, 1965.

BEING BLACK – SELECTION FROM SOLEDAD BROTHER & SOUL ON ICE by Roxy Harris. New Beacon Books, 1981.

BELAFONTE – AN AUTHORISED BIOGRAPHY by Arnold Shaw. Pyramid Books, 1960.

BLACKFACE – REFLECTIONS ON AFRICAN-AMERICANS AND THE MOVIES by Nelson George. HarperCollins, 1994.

BLACK AMERICANS OF ACHIEVEMENT – TYRA BANKS by Pam Levin. Chelsea House Publishers, 2000.

BLACK AMERICANS OF ACHIEVEMENT – MARCUS GARVEY by Mary Lawler. Chelsea House Publishers, 1988.

BLACK AMERICANS OF ACHIEVEMENT – SIDNEY POITIER by Carol Bergman. Chelsea House Publishers, 1988.

BLACK ART & CULTURE IN THE 20TH CENTURY by Richard J. Powell. Thames & Hudson, 1997.

BLACK MACHO & THE MYTH OF THE SUPERWOMAN by Michele Wallace. Verso, 1990.

BLACK WOMEN FOR BEGINNERS by Saundra Sharp. Airlift Books, 1993.

BLACK WOMEN IN WHITE AMERICA – A DOCUMENTARY HISTORY edited by Gerda Lerner. Vintage Books, 1973.

BLACK WOMEN IN AMERICA edited by Kim Marie Vaz. Sage Publications Inc., 1995.

BLACK WOMEN IN AMERICA – AN HISTORICAL ENCYCLOPEDIA edited by Clark Hive, Barkley Brown, Terborg-Penn. Indiana University Press, 1994.

BLACK WOMEN IN ANTIQUITY. Journal of African Civilisations Ltd, 1988.

BOB MARLEY – CONQUERING LION OF REGGAE by Stephen Davis. Plexus, 1993.

BOBBI BROWN BEAUTY – THE ULTIMATE BEAUTY RESOURCE by Bobbi Brown and Anne-Marie Iverson. HarperCollins, 1997.

BROWN SUGAR – EIGHTY YEARS OF AMERICA'S BLACK FEMALE SUPERSTARS by Donald Bogle. Da Capo Press, 1980.

BULLETPROOF DIVA – TALES OF RACE, SEX AND HAIR by Lisa Jones. Doubleday, 1994.

CATWALKING – A HISTORY of the FASHION MODEL by Harriet Quick. Hamlyn, 1997.

COVERING THE SIXTIES. GEORGE LOIS – THE ESQUIRE ERA by George Lois. Monacelli Press, 1996.

CINEMAS OF THE BLACK DIASPORA by Michael T. Martin. Wayne State University Press, 1995.

DECADES OF BEAUTY – THE CHANGING IMAGE OF WOMEN 1890S–1990S by Kate Mulvey and Melissa Richards. Hamlyn, 1998.

DIVIDED SOUL – THE LIFE OF MARVIN GAYE by David Ritz. Da Capo Press, 1985.

DREAMGIRL – MY LIFE AS A SUPREME by Mary Wilson. St. Martin's Press, 1986.

D.V. by Diana Vreeland, Weidenfeld & Nicolson, 1984.

EBONY KINSHIP – AFRICA AND THE AFRO-AMERICAN by Robert G. Weisborg. Greenwood Press, 1973.

ESSENCE – 25 YEARS CELEBRATING BLACK WOMEN by Patricia Mignon-Hinds. Essence Communications Inc., 1995.

FASHIONS OF A DECADE – THE 1920S by Jacqueline Herald. B.T. Batsford, 1991.

FASHIONS OF A DECADE – THE 1926OS by Yvonne Connikie. B.T. Batsford, 1990.

GARVEY & GARVEYISM by Amy Jacques Garvey. Octagon Books, 1986.

HAIRCULTS – FIFTY YEARS OF STYLES & CUTS by Dylan Jones. Thames & Hudson, 1990.

HOW TO BE A TOP MODEL by Naomi Sims. Doubleday & Company, 1979.

I DREAM A WORLD – PORTRAITS OF BLACK WOMEN WHO CHANGED AMERICA by Brian Lanker. Stewart, Tabori & Chang, 1989.

IN MY OWN FASHION – AN AUTOBIOGRAPHY by Oleg Cassini. Simon & Schuster, 1987.

JAMES BROWN by Geoff Brown. Omnibus Press, 1996.

JAZZ CLEOPATRA – JOSEPHINE BAKER IN HER TIME by Phyllis Rose. Vintage, 1990.

JOSEPHINE by Josephine Baker & Jo Bouillon. Harper & Row, 1976.

JUNGLE FEVER by Jean-Paul Goude. Quartet Books Ltd, 1982.

LIVING IN AMERICA – THE SOUL SAGA OF JAMES BROWN by Cynthia Rose. Serpent's Tail, 1990.

MEMOIRS – SECRETS OF A SPARROW by Diana Ross. Headline, 1993.

MEN OF COLOUR – FASHION, HISTORY, FUNDAMENTALS by Lloyd Boston. Artisan, 1998.

MICHAEL JACKSON – UNAUTHORIZED by Christopher Andersen. Simon & Schuster, 1994.

MODEL – THE UGLY BUSINESS OF BEAUTIFUL WOMEN by Michael Gross. Bantam Books, 1995.

MOTOWN – THE HISTORY by Sharon Davis. Guinness Publishing Limited, 1988.

MUHAMMAD ALI – HIS LIFE & TIMES by Thomas Hauser. Robson Books, 1991.

NOVA – 1965–1975 by David Hillman and Harry Peccinotti. Pavilion, 1993.

RADICAL RAGS – FASHIONS OF THE SIXTIES by Joel Lobenthal. Abbeville Press, 1990.

RASTAFARI – ROOTS & IDEOLOGY by Barry Chevannes. Syracuse University Press, 1995.

Sixties Source Book – A Visual Reference to the Style of a New Generation *by Nigel Cawthorne*. W.H. Allen & Co., 1989.

Skin Deep – Inside The World of Black Fashion Models *by Barbara Summers*. Amistad Press, 1998.

Survival of the Prettiest – The Science of Beauty *by Nancy Etcoff*. Little, Brown, 1999.

The Art of Make-up *by Kevin Aucoin and Tina Gaudoin*. Prion, 1994.

The Bluest Eye *by Toni Morrison*. Triad Grafton, 1981.

The Face of the Century – 100 Years of Make-up & Style *by Kate De Castelbajac*. Thames & Hudson, 1995.

The Jimi Hendrix Story *by Jerry Hopkins*. Sphere Books, 1984.

The Life & Times of Little Richard – The Quasar of Rock *by Charles White*. Harmony Books, 1984.

The Problem of Slavery in Western Culture *by David Brion Davis*. Oxford University Press, 1966.

The Wolf By the Ears *by John Chester Miller*. MacMillan, 1977.

The World Beauty Book *by Jessica B. Harris*. Harper Collins, 1995.

Toms, Coons, Mulattoes, Mammies & Bucks – An Interpretive History of Blacks in American Films *by Donald Bogle*. The Continuum Publishing Company, 1989.

Welcome to the Jungle – New Positions in Black Cultural Studies *by Kobena Mercer*. Routledge, 1994.

Wishing on a Moon – The Life & Times of Billie Holiday *by Donald Clarke*. Penguin, 1994.

White On Black – Images of Africa & Blacks in Western Popular Culture, *by Jan Nederveen Pieterse*. Yale University Press, 1992.

Magazines:
Allure, Arena, Ebony, Elle, Essence, gq, Harper's Bazaar, Honey, i-D, Interview, Newsweek, Source (September 1999), The Face, The New Yorker, Time, Trace, Vanity Fair, Vibe, Vogue.

Newspapers:
The Guardian, The Guardian Weekend, The Independent, The Independent on Sunday, The Observer, The New York Times, The Sunday Times.

index

Page numbers in italics refer to illustrations.

picture credits

The publishers would like to thank the following agencies and photographers for their kind permission to reproduce their pictures in this book. All efforts have been made to trace the copyright holders of all photgraphs featured. The publisher apologises for any possible omissions and is happy to rectify this in any future editions.

Front cover: Anthony Barboza
Page:
1 Alek Wek by Gerald Forster/Outline/Katz
3 Nat King Cole by William Gottlieb/Redferns
10 Josephine Baker/ Ronald Grant Archive
11 Veronica Webb by Peter Lindbergh
12 Wesley Snipes by Dan Winters
13 Halle Berry by Mitchell Gerber/Corbis
15 Love and Beauty – Sartijee the Hottentot Venus 1810 (coloured engraving) by English School (19th Century)/ City of Westminister Archive Centre, London UK/Bridgeman Art Library
18 The Black Virgin given by Louis XI by French School (18th Century)/Musee Crozatier, Le Puy-en-Velay, France/Bridgeman Art Library
19 Queen Charlotte/Courtesy of the National Portrait Gallery, London
22 Afro American minstrels/Ronald Grant Archive
24 Black dandy/Ronald Grant Archive
25 Gauguin/Bridgeman Art Library
27 Aunt Jemima/Bettmann/Corbis
29 Madame C.J.Walker/Underwood & Underwood/Corbis
30 Ma Rainey/Frank Driggs/Magnum Photos
32 Madame Walker Advert/Schomburg Center, NYC
33 Jack Johnson/Bettmann/Corbis
34 Marcus Garvey/MPI Archives/Hulton Getty
35 Birth of a Nation/ Ronald Grant Archives
36 Chorus Girls/Bettmann/Corbis
37 Josephine Baker/Hulton Getty
38 Bessie Smith by Cilla Huggins/Jazz Index
39 Florence Mills/Ronald Grant Archive
40 Duke Ellington by Max Jones Files/Redferns
41 Billie Holiday by Bob Willoughby/Redferns
42 Ethel Waters/Ronald Grant Archive
44 Hattie McDaniel/Kobal Collection
45 Nina Mae McKinney/Hulton Getty
46 Fredi Washington/Bettmann/Corbis
47 Paul Robeson/Associated Press PBS
49 Dorothy Dandridge/Kobal Collection
50 Nadinola Ad./Vinmag Archive
51 Eartha Kitt by Philippe Halsman/Magnum Photos
52 Sammy Davis Junior by Philippe Halsman/Magnum Photos
53 (top) Photo courtesy of Dorothea Towles
53 (bottom) Dinah Washington by Max Jones Files/Redferns
54 (top) Chuck Berry/Frank Driggs/Magnum Photos
54 (bottom) Little Richard/Ronald Grant Archive
55 Ophelia DeVore by Peter Basch/reproduced by kind permission of Ophelia DeVore
56 Woody Strode/Kobal Collection
57 Harry Belafonte/Bettmann/Corbis
58 Lena Horne/Bettmann/Corbis
60 *Island in the Sun*/Kobal Collection
61 Dorothy Dandridge by Philippe Halsman/Magnum Photos
63 Helen Williams/Schomburg Center, NYC
64 Guess Who's Coming To Dinner/Vinmag Archive
65 Muhammed Ali & Malcolm X/Associated Press

66 The Supremes/Hulton Getty Archive
67 (top) Ike & Tina Turner/Michael Ochs/Redferns
67 (bottom) Jimi Hendrix by Gered Mankowitz
68 Marvin Gaye by David Redfern/Redferns
69 James Brown/Rex Features
70 Martin Luther King & Malcolm X/Associated Press
71 Stokely Carmichael/Bettmann/Corbis
72 Black Panthers by Hiroji Kubota/Magnum Photos
73 Marsha Hunt by Patrick Lichfield/Camera Press
74 Sly & Family Stone/Michael Ochs/Redferns
75 (top) Nina Simone by Guy Le Querrec/Magnum Photos
75 (bottom) Bob Marley/Michael Ochs/Redferns
76 Issac Hayes/Michael Ochs/Redferns
77 Pat Evans by Anthony Barboza
78 (top) *Vogue* cover by David Bailey/Courtesy Condé Nast Publications Ltd.
78 (bottom) *Life* Cover by Yale Joel/Life Magazine/ ©Time Pix/Katz
79 Donyale Luna by Charlotte March/Rheinisches Bildarchiv, Koln
80 Diahann Carroll/Archive Photos/Image Bank
81 *Harper's Bazaar*/Courtesy of Harper's Bazaar
82–83 Muhammed Ali by L.Trievnor/Hulton Getty
84 *Nova*/Courtesy of Nova Magazine/IPC
85 *100 Rifles*/Kobal Collection
87 Sidney Poitier/Kobal Collection
88 *Vogue* by Francesco Scavullo/Courtesy of Condé Nast Publications Inc.
89 Richard Rowntree/Kobal Collection
90 (top) Cicely Tyson/Kobal Collection
90 (bottom) George Clinton by Ian Hooton/Retna
91 (top) Stevie Wonder by Neal Preston/Retna
91 (bottom) Jackson 5 by David Redfern/Redferns
92 Wanted Poster/Bettmann/Corbis
93 Bob Marley by David Corio/Retna
94 Donna Summer/Ronald Grant
96 Billy Dee Williams/Bettmann/Corbis
98 Iman by John Swannell/Camera Press
99 Toukie Smith by Anthony Barboza
100 (top) Bruce Lee/Photofest/Retna
100 (bottom) Pam Grier/Ronald Grant Archive
103 Vanessa Williams by Brad Bower/Colorific!
104 Michael Jackson (top) Alex Berliner/Visages/ Colorific!, (middle) Rex Features, (bottom) Steve Sands/Outline/Katz
106 Whoopi Goldberg by Mark Seliger/Outline/Katz
107 Jennifer Beals by Don Flood/Visages/Colorific!
108 (top) Larry Blackmon by Steve Speller/Retna
108 (bottom) Spike Lee/Ronald Grant Archive
109 Grace Jones by Anthony Barboza
110 Sade by G.de Roos/Sunshine/Retna
113 Prince/Prince appears courtesy of Warner Brothers Records
114 Naomi Campbell/Buckmaster/Retna
115 *Vogue* by Patrick Demarchelier/Courtesy of Condé Nast Publications
116 Sugar Ray Leonard/Associated Press
117 Florence Griffiths Joyner by Robert Barber/Retna
118 Carl Lewis/Rex Features
119 Cosby Show/Associated Press NBC
121 Elle/Courtesy of Gilles Bensimon and Elle
123 Lil' Kim by Colin Bell/Retna
124 O.J Simpson/Topham Picturepoint

acknowledgements

125 MAC Advert/Courtesy of MAC Cosmetics
126 Skunk Anansie by Bernhard Kuhmstedt/Retna
127 Michael Jordan by Andrew Eccles/Outline/Katz
128 Lenny Kravitz by Harry Borden/IPG/Katz
129 Williams Sisters/Reuters New Media Inc./Corbis
131 Ru Paul by Matthew Jordan Smith/Outline/Katz
132 Erykah Badu by Perou/Camera Press
133 Dennis Rodman by Gregory Heisler/Outline/Katz
134 Whitney Houston/Ronald Grant Archive
135 Jennifer Lopez by Menin/MPA/Retna
136 Janet Jackson/Outline/Katz
137 Lauryn Hill by Marc Baptiste/Outline/Katz
138 Mariah Carey by Uli Webber/Katz
139 Tyrah Banks by Daniela Federici/Colorific!
141 Tupac Shakur by Chi Modu/Redferns
143 Tyson Beckford by Timothy White/Outline/Katz
144 *Vogue* by Peter Lindbergh/Courtesy of Condé Nast
Publications Ltd.
147 Naomi Campbell by Fabrizio Ferri/Sipa Press. Photo of
Naomi Campbell published by English GQ. All fees resulting
from the publication of the feature have been donated to the
Nelson Mandela Children's fund (Tel. 020 7344 7531).
148 Mike Tyson by Michael Brennan/Corbis
149 Halle Berry by Marion Curtis/Rex Features
150 Denzel Washington by Steve Double/Retna
151 Will Smith by Dave Hogan/Rex Features
153 Wesley Snipes by Marcel Hartmann/Retna
155 Oprah Winfrey by Karen Kuehn/Matrix/Katz
157 Princess Nefertiabt/Werner Forman Archive
158 African hairstyles by Pablo Menfasawe-Imani/Mckenzie
Heritage Archive
159 African hairstyle by Mbeke Waseme/Mckenzie Heritage
Archive
160 Platinum hair by Flo Alalade/Mckenzie Heritage Archive
162 Egyptian princesses/Werner Forman Archive
165 Miriam Makeba/Camera Press
166 Hair salon by Lee Tracey/Hulton Getty
169 Queen Tutankhaman/Werner Forman Archive
Back cover: Muhammed Ali by Thomas Hoepker/
Magnum Photos

Special thanks to:
the Arogundade family
(Sade, Seye, Juwon, Taiwo, Kemi, Olu, Ronke)
Chidi Achara
Amy 'Shadowboxer' Bailie
Peter 'Renaissance Man' Barratt
Ozwald Boateng
His Excellency Judge Bola Ajibola
Varon Bonicos
Deborah Brand
Cedric Brandt
Lisa Brinkworth
Tom Carty & Walter Campbell
Carolyn Drummond-Hay
Gregory Gray
Roy Greenslade
Rosie Harkness
Eve Hirigoyen
Sarah Hirigoyen
Jessica Jones
Jeremy Keith
Alexia Kondylis
Martin 'Rooster' Kelly
Lizzy 'is the lady' Kremer
Claudette Laws
David Lindo & Marvellous Marco
Dej Mahoney
Natascha McElhone
Maxine McCaghy
David Mignon
Kia Miller
Angie Parker & Marley
Neil Ortenberg
Rafique & Carol
Noreen Taylor
Cathy Temple
Mark Thomson
Karl Vandenbossche
Heather Vickers
the marvellous Ed Victor
Colin Webb & all at Pavilion.